MASTERING
LIGHTING & FLASH
PHOTOGRAPHY

A DEFINITIVE GUIDE FOR PHOTOGRAPHERS

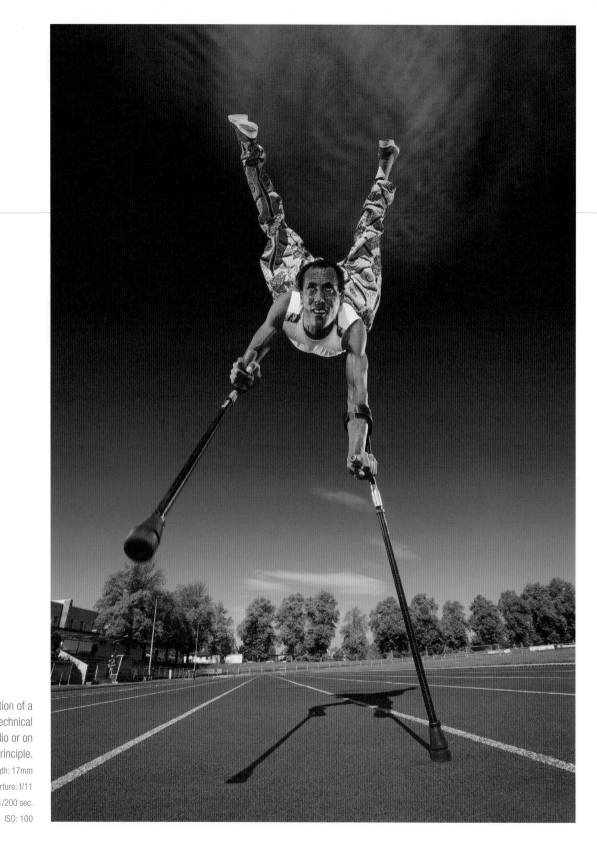

Right: The essence of a great image is a combination of a good subject, a great idea, and of course excellent technical knowledge. A mastery of lighting either in a studio or on location is at the very heart of that principle.

Focal length: 17mm

Aperture: f/11

Shutter speed: 1/200 sec.

ISO: 100

MASTERING
LIGHTING & FLASH
PHOTOGRAPHY

A DEFINITIVE GUIDE FOR PHOTOGRAPHERS

RICHARD BRADBURY

AMMONITE
PRESS

First published 2021 by
Ammonite Press
an imprint of Guild of Master Craftsman Publications Ltd.
Castle Place, 166 High Street, Lewes, East Sussex, BN7 1XU, United Kingdom

ISBN 978-1-78145-419-0

British Library Cataloging in Publication Data: A catalog record of this
book is available from the British Library.

Publisher: Jonathan Bailey
Designer: Robin Shields
Editor: Rob Yarham
Models (p91–101): Izzy French and Nancy Ridley (cover) at Ugly Models

Typeface: Helvetica Neue
Color reproduction by GMC Reprographics
Printed in China

Contents

Introduction

Try to imagine a world without light—the world around us would be impossible to define.

In fact, without light, life on our planet would simply cease to exist, so it is hard to imagine a more fundamental aspect of human existence. We live in a world that is governed by light. We wake up when the sun rises and we go to sleep when it sets. Light brings us warmth, growth, happiness, and, ultimately, life itself. It is the method we use to mark time and our gauge for measuring distance and space.

In 1826, Joseph Nicéphore Niépce produced a vague, chemical-based image which was later called a "photograph"—a word made up of the Greek "phos," meaning "light," and "graphé," meaning "drawing." So "photography" literally means "drawing with light."

Capturing the beauty of the world around us using the medium of photography is only possible if we can develop a profound understanding of the source, nature, and qualities of the lighting we choose to use. This has been the ultimate goal of every visual artist since humans first scratched images on cave walls, layered paint onto canvas, or rendered images on digital screens. But photographers are a special type of artist— we have taken the understanding of light to a whole new level.

Bending and shaping the light we use, photographers are able to create images that are more beautiful, more expressive, and more realistic than in any other art form. With the click of a button, we can capture the world around us as it is or mold and change it, choosing to express a subject as we would like it to be.

There is nothing more essential to photographers than the light we use. If the camera is a photographer's brush, and the studio the canvas, then light is the paint we choose to use. It is the medium that allows us to create every image. Nuanced and detailed in its nature, light and the art of lighting is at the very heart of what it means to be a great photographer.

Light is an endless source of creative inspiration, and learning the mechanics of light and lighting is the most fundamental skill in photography. It can take less than a thousandth of a second to fire a flash and capture a photograph, but it takes a lifetime to master the art of lighting.

Let there be light!

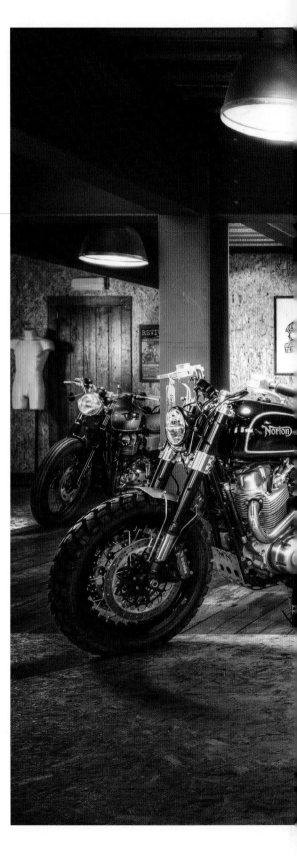

Right: Command of the mechanics of light and lighting is the most fundamental skill in photography and only acquired after a long quest for perfection.

Focal length: 28mm

Aperture: f/10

Shutter speed: 3/5 sec.

ISO: 400

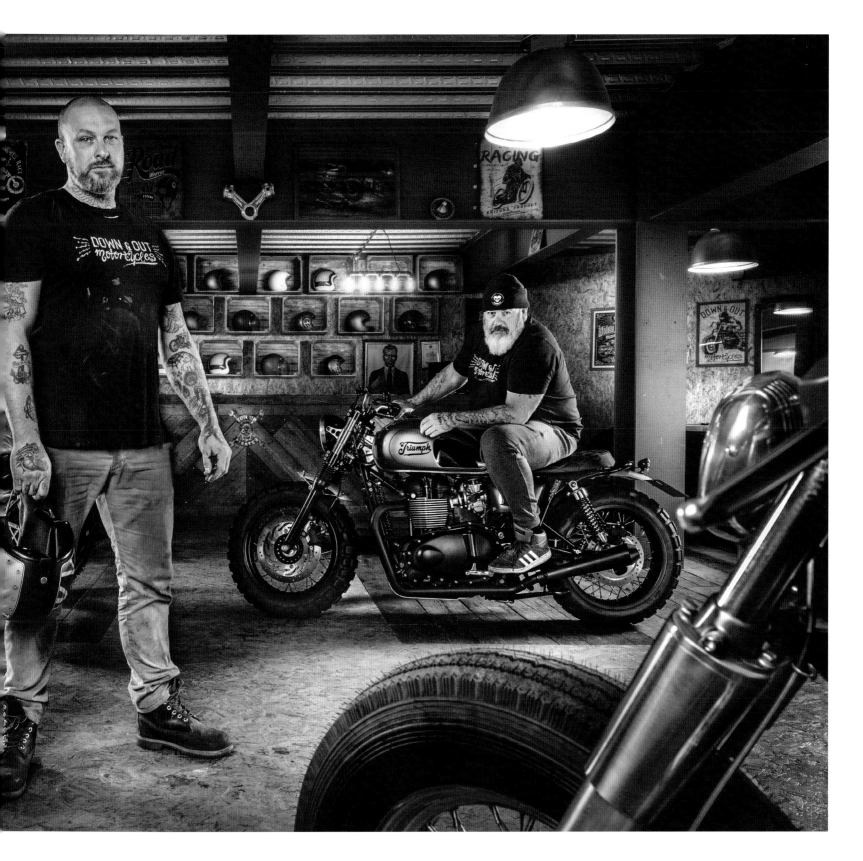

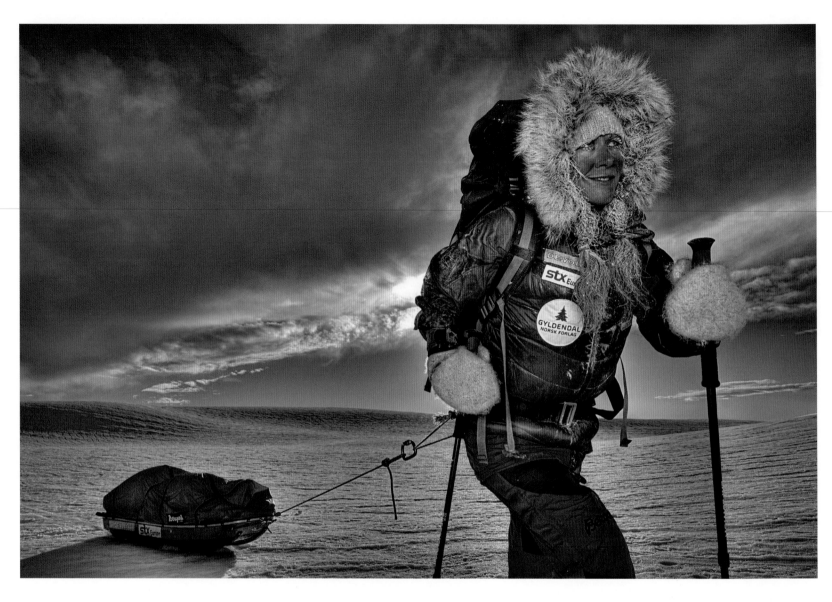

Above: Using flash on location is pretty much guaranteed to enhance the quality of your final image. Modern location flash units can work in the most extreme of environments. This image was shot in Norway, mixing flash with daylight at temperatures as low as 7ºF.

Focal length: 35mm

Aperture: f/5.6

Shutter speed: 1/200 sec.

ISO: 400

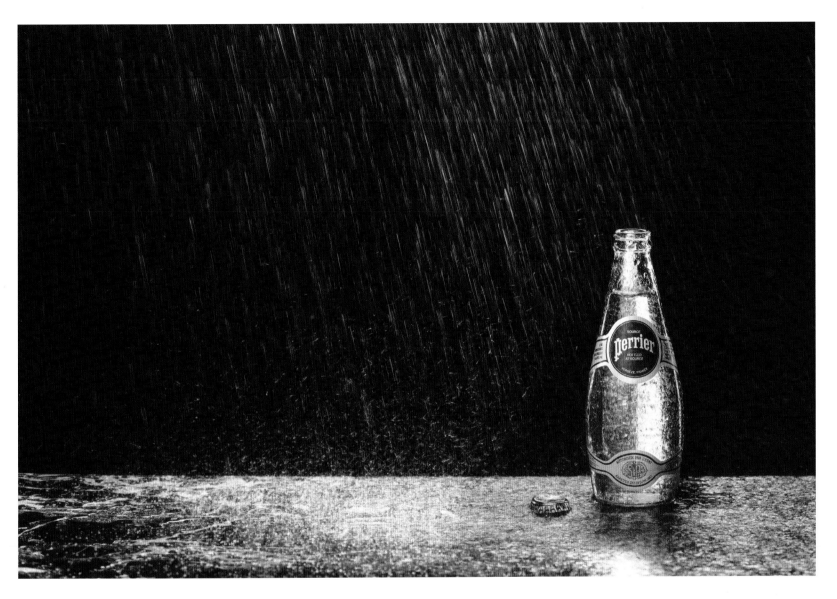

Above: There is a long tradition of still-life imagery in both painting and photography. This image was created entirely in camera with flash, using a combination of red, green, and blue-colored filters to break up the light.

Focal length: 100mm

Aperture: f/11

Shutter speed: 1/160 sec.

ISO: 50

Chapter 1
What Is Light?

The science of light—visible light being defined as "A form of electromagnetic radiation of a wavelength detected by the human eye"—has fascinated scientists and philosophers for centuries. As photographers, we are interested in the effect of light on the subjects we photograph—we are constantly bending and manipulating it to create beautiful imagery. Light is our medium of choice, so it pays to understand it.

Natural light comes from the Sun and it is so readily available that we don't normally pay it too much attention. From the multicolored dance of the Northern Lights to the warmth of an early-morning sunrise, the Sun presents us with endless creative possibilities.

But lighting options are not just restricted to sunlight. There are many artificial light sources available—tungsten, LED, and flash lighting systems enable photographers to capture images in just about any situation. It's important to understand how light works, its laws, and its characteristics. Only then can you truly master the art of lighting.

Right: This stylish image was shot in two parts and then combined in Adobe Photoshop. The subject was lit with flash in situ and then combined with a separate background image. This technique allows you to capture the ambient lighting and still light the subject without compromise.

Focal length: 24mm

Aperture: f/16

Shutter speed: 1/160 sec.

ISO: 100

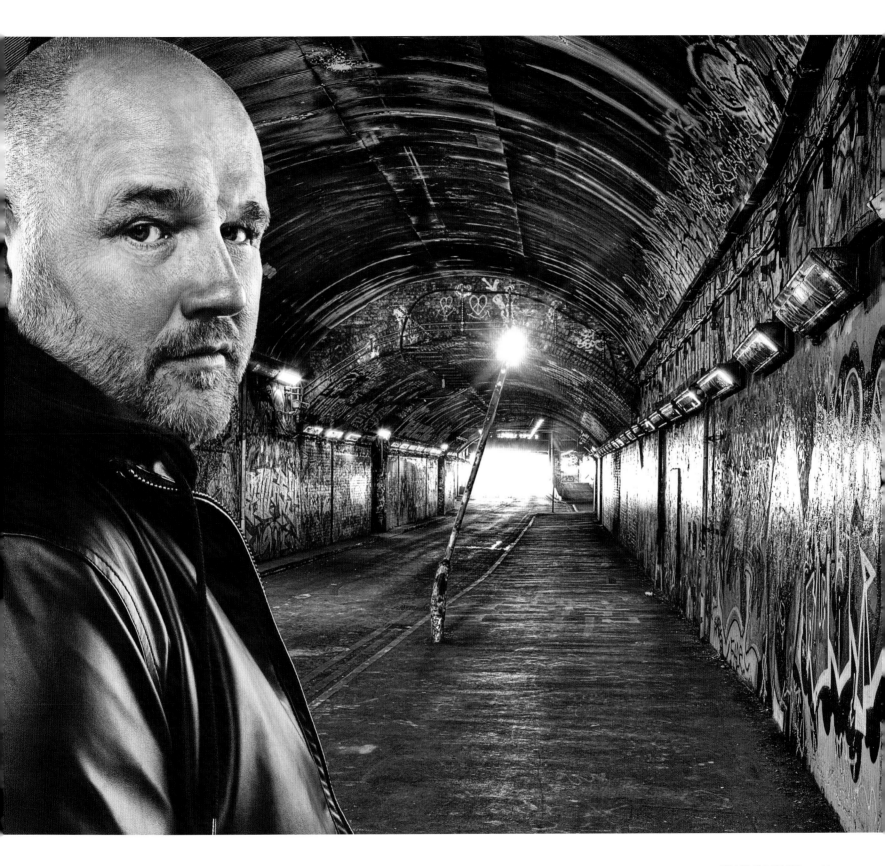

Color Of Light

Understanding the color of the light, or "color temperature", is critical if you want to shoot an image that accurately represents the scene in front of you. Measured in Kelvin (K), the color temperature or color balance of a light source, sometimes referred to as white balance or WB, varies significantly in different situations. A light source measured above 6000K is regarded as "cool", appearing blue, and light below 5000K is "warm", appearing yellow.

Regular daylight is normally rated at 5600K, so on an average sunny day a mid-gray wall should appear neutral when the camera is set to 5600K. However, daylight can vary from as little as 3200K at sunrise or sunset to 12,000K on extremely clear, blue-sky days.

Flash tubes are generally set to match daylight, but color temperature can be affected by additional, artificial light sources such as street lamps, car headlights, or reflective surfaces, so don't be surprised if your beautifully composed daylight-balanced subject appears to be a bright orange if it was photographed at the end of the day under a street lamp.

If not corrected, fluorescent tubes provide a green hue, but their color temperature can vary quite significantly as they age. Indoor tungsten lighting has a warm yellow hue when compared to natural daylight. Images taken underwater appear green-blue depending on how deep you are.

Trying to assess these color differences by eye can be difficult because our eyes quickly adapt to the subtle color variations presented by different light sources. A camera, on the other hand, can only record what it is set to record, so it is important to set your camera to the appropriate color balance before you shoot in order to avoid unsightly color shifts. The easiest way to do this is to set the camera to auto white balance, or AWB, for most situations, letting the camera's on-board color meter do the work. However, there will be occasions when the camera is fooled—such as in changing lighting conditions, in dappled lighting under tree cover, or in lighting from different sources—so it pays to know the basics of color balance, as well as the color shifts you will expect to get from different light sources.

Above: You can change your camera's white balance to one of several different settings depending on the situation.

Above: Auto white balance, or AWB, will cover you for most natural environments.

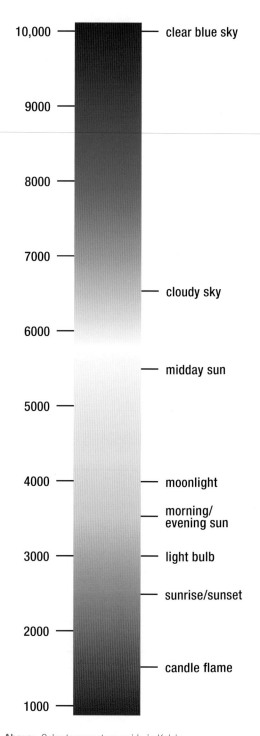

Above: Color temperature guide in Kelvin.

Choosing the manual settings of Daylight, Shade, or Flash in the right situations will give a much more consistent balance to your images. With the more advanced professional cameras, you can even adjust the white balance to a precise value and then store it as a custom setting for a specific set-up or effect that you want to repeat. Some advanced cameras also have white balance bracketing, which enables you to shoot each image at several different WB settings in sequence.

In the days of film cameras, a dedicated color temperature meter was essential when working in mixed light conditions. It's still a useful piece of equipment today, particularly if you are photographing color-critical subjects such as colored garments for a commercial client, for instance. A color meter allows you to calculate the exact color temperature of any given lighting set-up and then use color adjustment filters to get a precise, neutral camera setting.

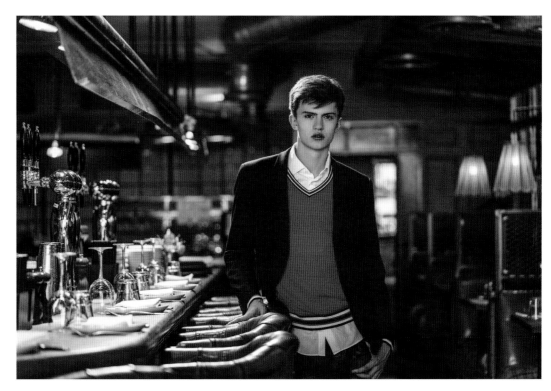

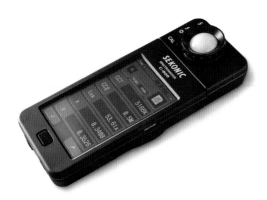

Above: Sekonic color meter.

In general, it pays to have your camera set to a neutral color balance as standard to avoid unsightly color casts. Don't forget, though, that you can adjust and dial out most unwanted minor color casts using your postproduction software—shooting your images in Raw format will ensure you have a lot more options. Software such as Adobe Lightroom and Phase One Capture One can help with this. They are very good companions to Adobe Photoshop, which of course has its own Raw converter and which you can use to adjust an image for your own color balance requirements.

Above: Mixing flash with daylight and tungsten can give some interesting results.

Focal length: 97mm

Aperture: f/2.8

Shutter speed: 1/150 sec.

ISO: 400

Tip

You can use color temperature to add colored effects to your images without the need for filters. If you are shooting indoors with a window as your main light source and are using flash to complement it, try turning on the household tungsten lights in the background to allow the background to go yellow, adding a warm, intimate effect.

Golden Hour

"The golden hour" is the short period of golden light at the start or the end of the day when the sun is rising or setting. This warming of the natural daylight is caused by the interaction of particles in the atmosphere—some natural and some caused by pollution—and is known as the "Tyndall effect". This effect gives you beautiful, golden, warm sunlight, with a color temperature of around 3500K, and it is loved by photographers the world over. But it is not just the color of the light that makes it so special. The position of the sun low on the horizon produces a directional cross-light that is very desirable for fashion and portraits in particular… It's worth waking up early for.

Unless you are shooting within the polar circles, the golden hour is likely to last around 40 to 90 minutes so it pays to be ready if you want to capitalize on its magical effects. This means that pre-planning is essential if you want to guarantee good results. Despite the availability of numerous apps that predict the sunrise in any given place at any time of year, you should arrive at a location at least an hour before you need to be there if you want to capture a specific shot.

The alternative for those who don't enjoy a 4.30am alarm call, is to shoot as the sun goes down at dusk. The light at dusk is not quite as reliable because the air quality is usually not as good at this time and it lacks the purity of a morning sunrise.

Above: There is nothing quite like golden-hour light.

Focal length: 105mm

Aperture: f/6.3

Shutter speed: 1/30 sec.

ISO: 400

Dynamic Range

When we look at a scene, our eyes are able to quickly adjust from one exposure to another, allowing us to see detail in the shadows and the highlights. For instance, when you walk from a sunny garden into a dark room, you will at first find it difficult to see, but your eyes will soon adapt so that you can see everything clearly again.

Cameras can't react in this way as their sensors are static and have a limited dynamic range—they can only resolve image detail within a particular range from highlight to shadow, and this range will vary with different models. It is therefore important to understand exactly what your camera is capable of in any given lighting situation. Modern digital sensors typically have a range of around 10–14 stops of light, with the more expensive professional models offering a little more. As technology moves forward, increasing dynamic range is something that will improve, but for now the best available is around 15 stops at 100 ISO. This means that even the best cameras can resolve a maximum of 15 stops. Remember also that your ISO setting will change the effective dynamic range of your camera as the image takes on more contrast, so don't expect a dynamic range of 15 stops if you are working at a high ISO of 3200, for instance.

When shooting any image, it is important to try to choose an exposure that captures enough of the detail in both the highlight and shadow areas, as is appropriate to your image. A well-exposed image should have only the very darkest parts showing as solid black and the very lightest as pure white. You can brighten the darker areas of the image using any number of lighting techniques. Lightening the darker areas to a point that is nearer to the mid-tones of the image will enable you to resolve more information in the extreme highlights. This will increase the view-ability of the image by rendering more detail throughout the tonal range.

Most good digital cameras allow you to add a warning that areas in an image will be outside the dynamic range. The warning usually takes the form of flashing blocks of red on the preview image where the totally black or totally white areas will be. These areas cannot be adjusted in postproduction as they will contain no visual information, so you should make adjustments to your exposure or the lighting to avoid them whenever possible.

Ultimately, it is the relationship between light and dark in your images—the highlights and shadows—that will define the quality of your "light-craft". Many photographers learn to work specifically with a reduced tonal range to create high-contrast images, creating drama and a sense of mystery. It can also be a great way to express emotion and tell stories. Don't be afraid to embrace the limitations of dynamic range as part of your creative toolbox. Work within its confines but always with an understanding of what is possible.

> **Tip**
>
> A quick way to assess the dynamic range of a given scene is to squint at the subject. Your eyes will show an increased contrast that mimics the camera's view.

High Dynamic Range (HDR)

Whilst reflectors, filters, and artificial lighting can help to even out your lighting, there is another technique to create a greater dynamic range, known as "high dynamic range" or HDR.

In the early to mid-1900s Ansel Adams began shooting black-and-white landscape images that contained a level of detail that had never been seen before. He did this by analyzing the dynamic range of both the film and the paper he was using and shooting carefully within those limits, using a technique he called the "Zone" system. He then developed each piece of film and produced every print by hand using extensive dodging and burning to bring out the detail in highlights and shadows alike. Effectively, he exposed the shadow areas more and the highlight areas less, combining them within a single image. These extraordinary prints are now some of the most sought-after photographic artworks in the world. Today we are able to replicate this high dynamic range technique digitally and in full color using HDR software.

This technique is only suitable for static subjects, such as landscapes and interiors, as it involves shooting multiple exposures. Set up your camera on a tripod and measure the correct exposure. Pre-focus and set your focus mode to manual. Now shoot the scene using exposure bracketing of between 3 and 5 stops to provide a range of images, with the brightest image being overexposed and the darkest being underexposed. Be careful to use only your shutter speed to vary the exposure, keeping the aperture constant—as the aperture changes the actual size of each image, they will never merge correctly.

You can then use specialist HDR software to merge all the exposures, creating an image with a dynamic range that far exceeds a single exposure taken with the camera's sensor. Adobe Photoshop includes an HDR option, but other specialist software is available, such as Photomatix.

Above: High dynamic range techniques can enhance the natural lighting of a landscape to show incredible detail. This is a composite HDR image from three files, with exposure compensation of -1, 0, and +1.

Focal length: 24mm

Aperture: f/16

Shutter speed: 1/15 sec.

ISO: 100

Tip

Be careful not to push the effect too far when using HDR as the image can end up looking very artificial if handled insensitively.

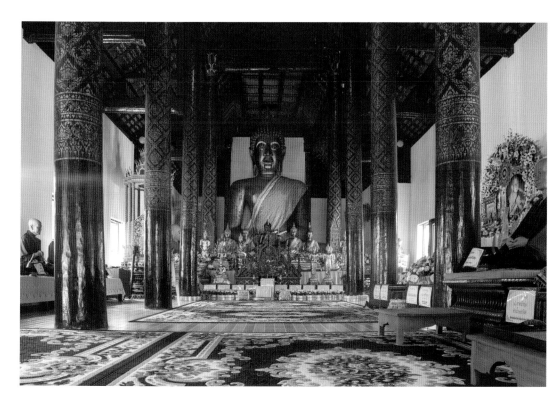

Left: This image was taken in very difficult lighting conditions.

Focal length: 28mm

Aperture: f/11

Shutter speed: 1/10 sec.

ISO: 640

Left: Again, this is an HDR composite image of the same interior as above, from three files, with exposure compensation of -1, 0, and +1.

Hard & Soft Light

The nature or quality of light—whether it is "hard" or "soft"—will define how the light will affect any given subject, both in terms of texture and contrast. Hard light is bright and will produce bright highlights and very dark shadows. This is similar to the effect you get on a bright sunny day when you are standing in direct sunlight. Hard light can be effective in certain situations, but it must be carefully controlled. By contrast, soft light is usually easier to deal with as it is more forgiving—a cloudy day or a shady area will create soft light. It generally provides a more subtle effect, with less contrast, including soft highlights and graduated shadow areas.

The same effects can be observed with different types of artificial lighting. For instance, you will often find a reflector or light shaper for a flash unit described as providing a hard light, but no light source is intrinsically hard or soft as it depends what you are lighting or, more precisely, the size of your subject.

There is a simple rule with hard and soft light, which is that the further away and/or smaller your light source gets, the harder its light will be. Conversely, the closer and/or larger your light source gets, the softer its light. This ratio is determined by the physical size of the subject in relation to the physical size of the light source. Therefore, if you take a standard "hard light" reflector and place it on your light stand 8ft (or 2.5m) from your subject, it will provide hard light. But take the same light and reflector and place them a couple of inches away from a small insect and they will create soft light. It's all a matter of size, scale, and distance. Likewise, a 3ft- (1m-) square softbox placed 32ft (10m) away from your subject becomes a hard light source despite its "softbox" characteristics.

Above: Direct sunlight creates hard light with high contrast and dark shadows.

Above: Shooting in the shade gives a much softer, more pleasing effect.

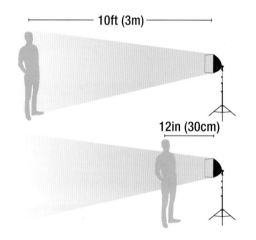

10ft (3m)

12in (30cm)

Above: The same light source can create hard or soft light depending on the size and distance of the subject.

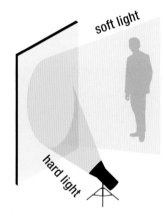

soft light

hard light

Above: Bouncing a hard light off a large reflector will create a soft light effect on the subject.

Tip

Remember also that a hard light source bounced off a large white board or directed through a large translucent sheet will become a soft light. The size and nature of the light is always determined by the final exit point, not the original source.

High-Key & Low-Key Photography

Combining the effects of dynamic range with hard and soft light sources will enable you to create very different kinds of images. Taking portraiture as an example, images are often referred to as "high-key" or "low-key". These are stylistic terms and they describe different genres of photography.

A high-key image uses a clean, bright, high-contrast approach to photography. A crisp white backdrop is the norm but it could also, and usually does, involve prominent use of primary colors. A high-key image is usually created with light sources set up at a greater distance to light whole areas within a studio, including the subject and the backdrop. This style of photography expresses a bright, positive emotion and is popular for clean, colorful portraits.

Low-key portraits are the opposite of high-key—they are subtle in color and generally quite dark. They include deep shadow areas and are usually created with close-up lighting techniques, with every light source being carefully controlled. The result is intimate and serious, making low-key portraits the choice of "fine art" photographers.

As you produce more work you will find that your images have a certain signature that you alone are recognized for. Many photographers have spent their entire careers producing just one type of image—that is, not the same subject matter but the same "look". It is sometimes difficult to define exactly what it is about a photographer's work that makes it identifiable, but high-key and low-key approaches to lighting are often at the heart of individual styles. Choosing to create your work using high-key or low-key principles is often seen as an expression of your own personality as an artist—you may find that you are naturally drawn to one style over the other.

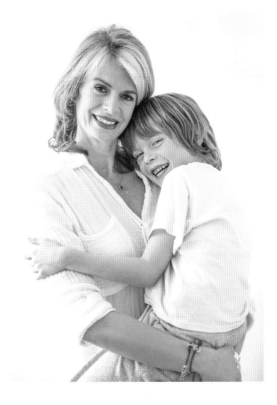

Above: High-key portraits look bright and happy.

Focal length: 40mm

Aperture: f/2.8

Shutter speed: 1/160 sec.

ISO: 200

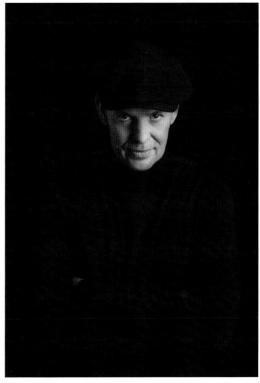

Above: Low-key portraits are dark and subtle.

Focal length: 70mm

Aperture: f/10

Shutter speed: 1/200 sec.

ISO: 100

Inverse Square Law

There is one piece of mathematics that is probably worth understanding when shooting regularly in a studio or with any form of artificial lighting. It is logical to think that if you moved a light twice as close to the subject—halving the distance between the light and the subject—the power of that light would double in intensity. In fact, this is not the case.

In physics, any force that spreads its influence equally in all directions at once (just as light does) will obey the inverse square law. Light will increase in power in inverse proportion to the square of the distance from the original source. In simple terms, if you halve the distance between the source and the subject you will increase the power by four times, not by two. If you have a light meter you can measure this, but it's enough to understand the basics so you know what effect a light will have on the exposure if you decide to move it.

The other important aspect of the inverse square law is the effect it has on the "fall off" of light—the reduction in the power of the light the further away it is from the source. Because of the inverse square law, light does not fall off in a linear fashion with an increase in distance. If you are cross-lighting someone's face there will be a difference between the brightest point (nearest to the light) and the darkest point (furthest away from the light). This difference will be greater when the light source is closer to the subject. So, if you want a more gradual fall off from the lit to the unlit side of your subject, you need to move the light source further away from the subject. Remember we are not just talking about the loss of light over a distance but the relative loss of light changing as the light gets further away. You can compensate for the loss in the overall amount of light by either turning up the power of the light or changing your camera settings. This can be very effective if you want to control the level of detail in the shadow areas relative to the highlights.

Basically, as with most lessons in photography, you need to try it out for yourself. No one in the real world is calculating the figures when they are in a studio situation, but if you understand the basic equation it will help you to make the correct creative decisions.

Below: The inverse square law means that with each doubling of distance the light decreases by a factor of 4, or 2 f-stops.

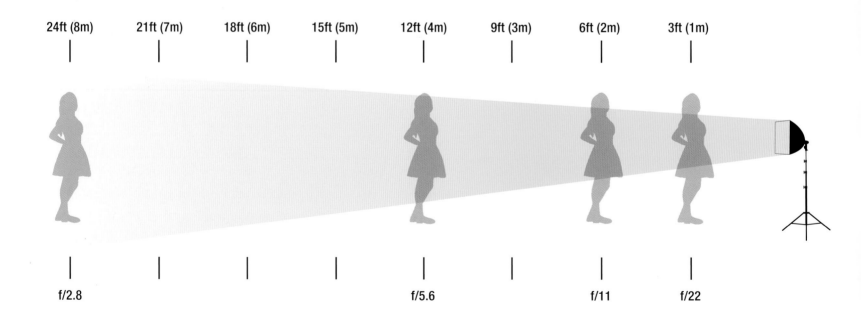

24ft (8m) 21ft (7m) 18ft (6m) 15ft (5m) 12ft (4m) 9ft (3m) 6ft (2m) 3ft (1m)

f/2.8 f/5.6 f/11 f/22

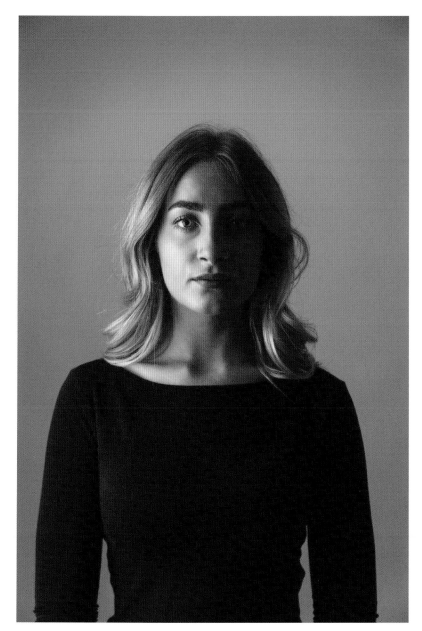

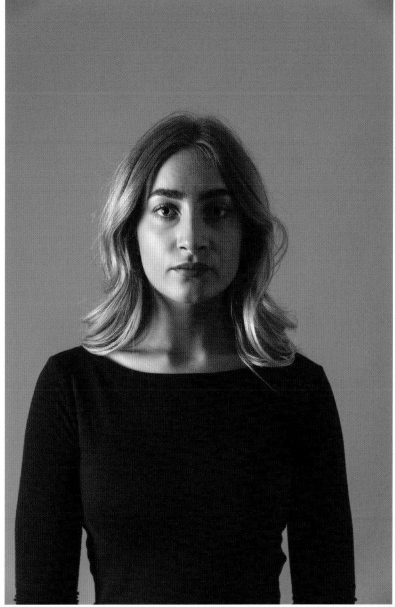

Above: Here, a 3ft- (1m-) square softbox is positioned 2ft (61cm) from the model's face. You can see the extreme fall off of the light with darker shadow areas. The light is set at low power.

Focal length: 75mm

Aperture: f/2.8

Shutter speed: 1/160 sec.

ISO: 200

Above: This is lit with the same 3ft- (1m-) square softbox, this time positioned 8ft (2.5m) from the model's face. Although the light is harder, the light ratio is less, so there's more detail in the shadows. The light is set at high power.

Focal length: 75mm

Aperture: f/2.8

Shutter speed: 1/160 sec.

ISO: 200

Chapter 2
Choosing The Right Light

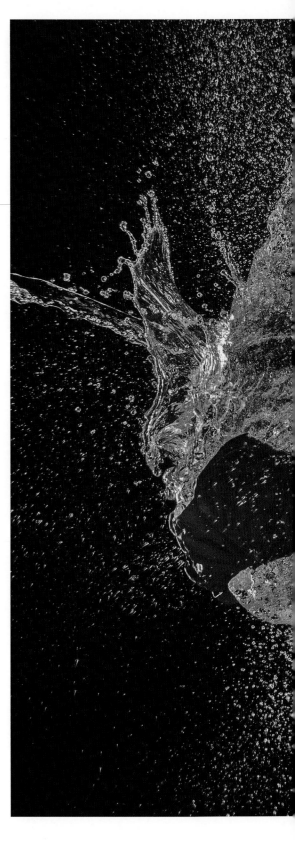

For most photographers, the natural light provided by the sun is the most accessible and easiest form of lighting to use, and it's more than adequate for many applications. However, in the search to create better images, you will inevitably want greater control over the lighting, and that means learning to use artificial light sources. There are plenty of options and making the right choices can be tricky. This chapter will guide you through them.

Mastering the use of artificial light sources can take a lifetime, and the problem with teaching lighting techniques is that they can be so personal. But there are guidelines that can help you to get the best from your lighting and we will explore those later in this book.

Right: To capture these "water statues" as water-filled balloons were popped required very fast flash. I used super technical, programmable Broncolor studio lights to freeze the action at flash durations of up to 1/14,000 sec.

Focal length: 50mm

Aperture: f/13

Shutter speed: 1/200 sec.

ISO: 100

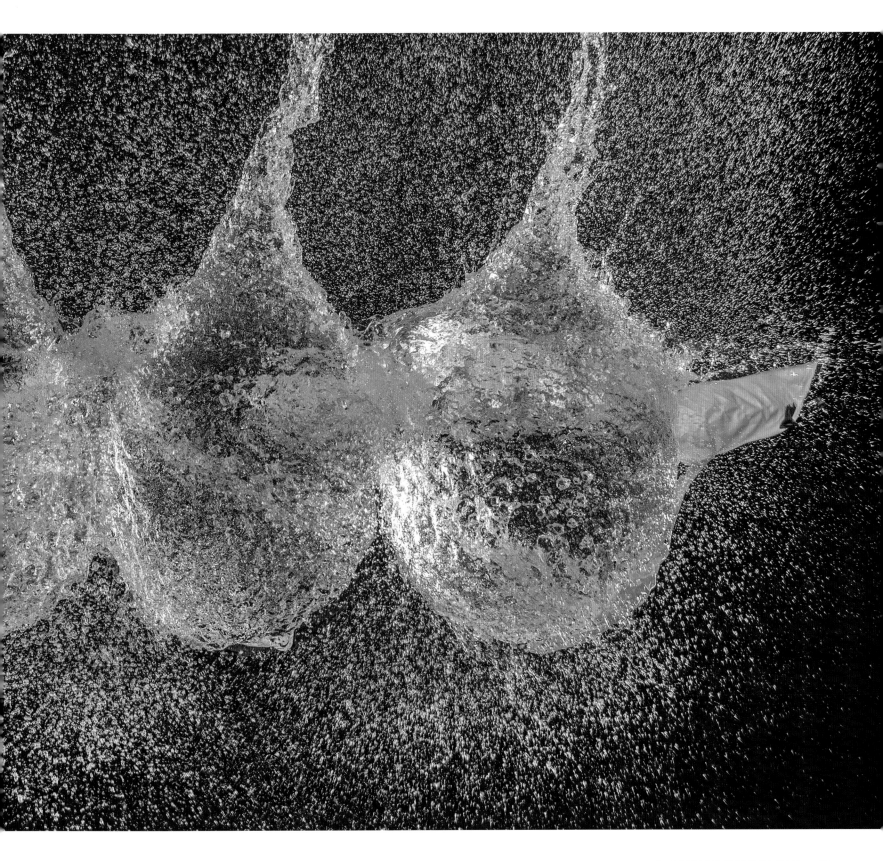

Natural Light

The sun is where all good lighting courses should begin, and for many photographers it will remain the most important light source of all. There are a host of helpful devices designed to be used on and off the camera, bending the sun's power to your will. To enable you to get the very best from natural light, it's important to understand what your options are, and how different devices can affect your finished results.

Lens Filters

Some might say that lens filters are not relevant in a book about lighting as they are connected to the camera rather than to the lights, but they are one of the most effective ways of adjusting the available natural light in any situation.

There is an extensive range of filters available and manufacturers such as Lee, Hoya, Cokin, and B+W supply both glass and plastic filters for just about every situation. For color temperature changes you can choose several degrees of red, blue, and green, or cyan, magenta, and yellow— all of which you can combine to create the perfect neutral lighting. They are a great way to enhance natural colors or make subtle color corrections.

Next on your "must-have" list are neutral density (ND) filters. These can be used to reduce the overall exposure where there is too much light on a subject and they are graded in one-stop increments. You can buy ND filters at set ratings (of -1 stop, -3 stops, and so on) or you can buy a variable ND filter that can be twisted to give different ND ratings.

Above: A wide range of lens filters is available.

Tip

If you want to mix daylight with location flash then ND filters are a great way to adjust each element separately for complete creative lighting control (see page 12).

Below: A graduated neutral density filter can transform your landscape photography.

Focal length: 24mm

Aperture: f/22

Shutter speed: 1/30 sec.

ISO: 200

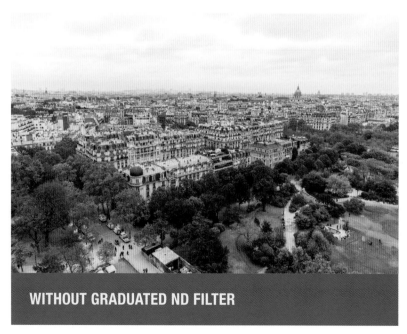

WITHOUT GRADUATED ND FILTER

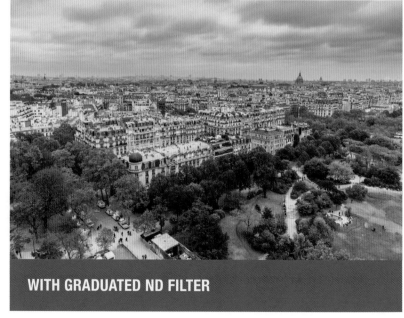

WITH GRADUATED ND FILTER

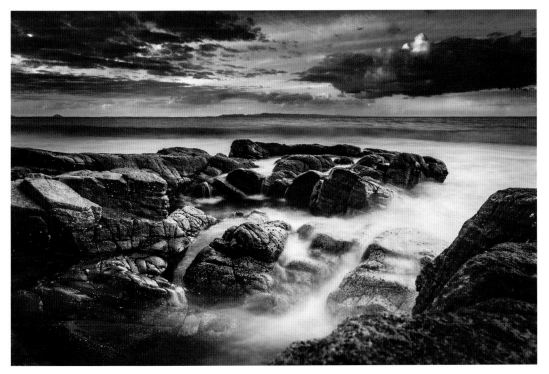

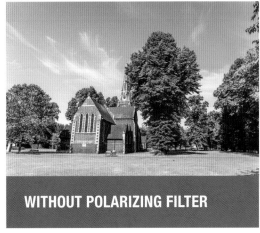

WITHOUT POLARIZING FILTER

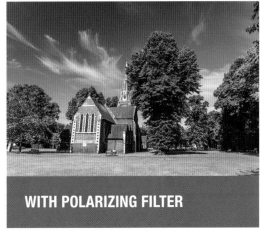

WITH POLARIZING FILTER

Graduated filters are another great tool to have by your side, especially if you want to shoot stunning landscapes. The huge difference in the exposure values required for a bright sky and a solid dark landscape in the same image have long presented problems to photographers in the field. Our eyes adjust to these two extremes with such speed that we are able to see detail in both the sky and the landscape. But a camera can only expose one or the other correctly at any given moment, not both. Graduated filters enable you to balance that exposure and are available in gray for a neutral look, or subtle colors to provide dramatic sky effects such as blue or warmer tones.

The final essential filter that every photographer should invest in is a polarizer. The polarizing filter has a magical effect. Once attached to your lens, the filter can be turned on a rotating bezel to achieve the best effect at different angles. It reduces glare in water, skin, and other surfaces

Above: You can combine different filters to enhance an image. Here I used a 10-stop ND filter to slow down the exposure plus a tobacco filter to color the sky.

Focal length: 24mm

Aperture: f/22

Shutter speed: 3 min.

ISO: 400

to create a rich, colorful image. When positioned in the correct orientation, the polarizing filter will turn the sky a dark blue by reducing the atmospheric glare. It also enhances colors to accentuate the rich greens of grass and the deep turquoise blue of the ocean.

Remember to check the thread diameter of your lens before buying any filter as they come in different sizes. Alternatively, you can buy a filter holder system with various attachment ring sizes and simply slide the filters into it as required.

Above: The use of a polarizing filter turns the sky deep blue, cuts through reflections, and enhances colors.

Focal length: 16mm

Aperture: f/8

Shutter speed: 1/80 sec.

ISO: 200

Reflectors

There is a huge range of reflectors available on the market of many different designs. Using reflectors to bend and bounce light is one of the simplest and cheapest ways to take stunning professional images. In its simplest form, a reflector is a light-colored surface (normally white or silver) positioned to reflect the available light back onto the subject. Still-life studio photographers sometimes use tens if not hundreds of small reflective cards to get the exact lighting set-up required for the perfect image, but photographers in the field tend to use simpler, more general handheld reflector set-ups.

Larger reflectors require a little more organization but they can obviously reflect light onto larger areas. The simple act of filling in the shadow area on a subject can transform an image, and shiny surfaces can be controlled to create a clean, bright look. Very large pop-up reflectors are now available, as well as light walls that can be assembled such as the California Sunbounce.

In extreme circumstances, you can build a light tent around your subject, which will enable you to have complete control over harsh light. This technique is used in commercial fashion shoots, especially when shooting in a location such as a desert environment that offers little or no shade.

Reflectors can of course be used with any type of light source, whether natural light, artificial continuous light, or flash. There are many specialist reflectors available on the market offering solutions to every possible problem. You can buy reflectors that have cut-outs in the center so that you can surround your model while positioning your camera centrally to them. Other popular solutions include reflectors that bend around the subject's face or open like a fan to provide a beautiful catch light around the base of the eyes.

Most commercial studios are equipped with 8x4ft (2.4x1.2m) polystyrene insulation boards. These are lightweight, cheap, and universally available from most building supply stores, and make superb reflectors for large areas.

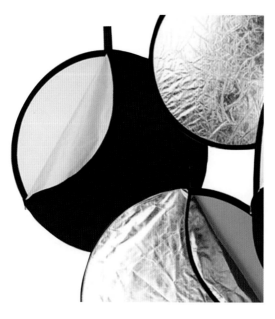

Above: Reflectors come in many shapes, sizes, and colors.

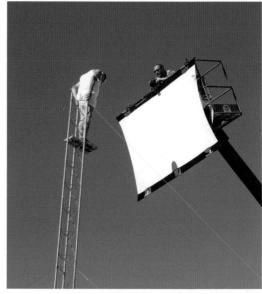

Above: The California Sunbounce is a giant reflector.

Above: There are several specialist reflectors available, such as this bowed reflector which is ideal for adding a fill light under the chin in studio portraits.

Translucent fabric

Above: Set-up for a light-tent shoot.

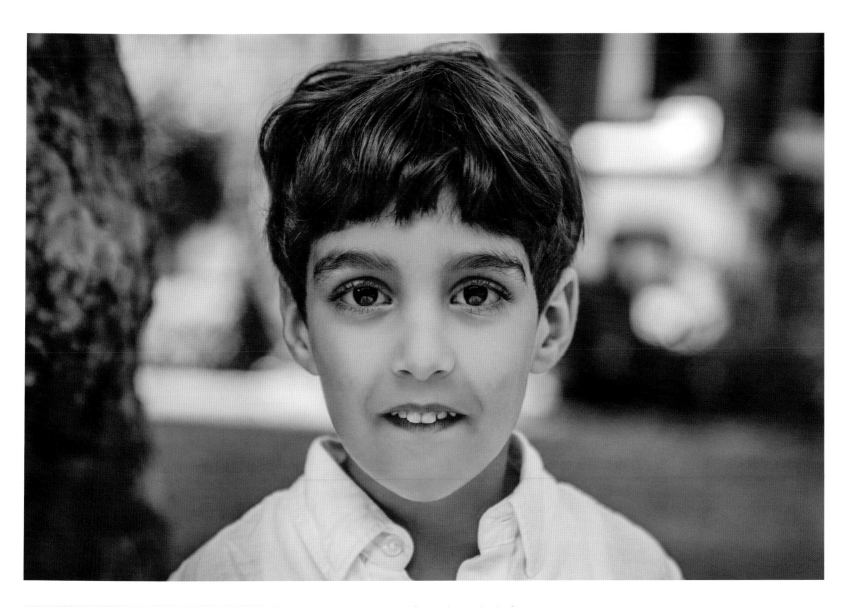

Above: Using a circular reflector close under the face of a subject creates a soft glow but also gives beautiful reflections in the eyes.

Focal length: 70mm

Aperture: f/2.8

Shutter speed: 1/1000 sec.

ISO: 400

Tip

You can make your own reflectors from white, silver, or gold cardboard, which you can buy from your local art supply store, and these will enable you to create a custom set-up for every possible application.

Artificial Continuous Lighting

There are several different types of artificial continuous lighting and photographers will have their own favorites. The starting point for many young photographers is the standard household lamps that all of us have around our homes. These can be a great way to begin learning how to use continuous lighting but you will soon realize that they are not powerful enough—they lack the power and color consistency required for a decent exposure.

The most obvious advantage of using continuous light sources is that you can preview the effect in-camera, just as you do with natural daylight. This gives the photographer ultimate creative control in pretty much any situation.

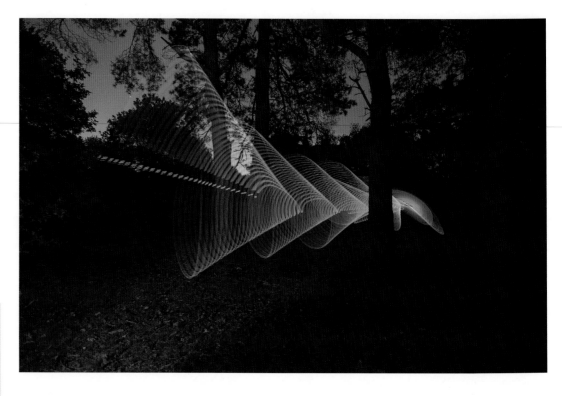

Tip

The artistic technique of "light painting" is the only exception to the rule of being able to preview the results before you press the shutter release. To create a light painting, the photographer moves one or more light sources, such as flashlights, during a long exposure to create a pattern of light lines in the final image. It requires a great deal of experimentation and experience to achieve the desired results, but they can be spectacular.

The first feature to look into when choosing any continuous light source is the power output of the light. Continuous light sources are not as powerful as flash so you need to spend big money to be able to use small apertures. Light output—the brightness of a light—is measured in lumens and most manufacturers will label their professional units with the lumen rating.

The next factor to consider is color temperature (see page 12)—different types of unit provide different colors of light, from warm (with tungsten lights, see page 29) to cool (with HMI and LED lights, pages 29 and 30). This can be an issue if you are mixing artificial lighting with an existing light source, such as household lights or natural daylight, so be aware of this if you want natural-looking images.

Another important issue to watch out for is the color rendering index (or CRI) rating. This indicates a light's ability to record perfect color matching across the spectrum compared to a perfect natural light source. All continuous lights are rated up to 100 CRI, with anything over a rating of 90 being generally regarded as acceptable. You will find that cheaper equipment often doesn't mention this information because the units are poorly rated.

For serious continuous light photography, you need to invest in professional equipment. It pays to understand the differences between what's on offer before investing.

Above: Using a handheld torch to "paint" with light has become a popular art form.

Focal length: 11mm

Aperture: f/2.8

Shutter speed: 30 sec.

ISO: 800

Tip

If you're using large tungsten or HMI lights for the first time, check that your power supply is up to it. You will normally require a professional three-phase power outlet to run them efficiently.

Tungsten Lighting

Tungsten lights have been the baseline for all continuous lighting set-ups for many years. They are fundamentally the same as standard household bulbs but they are a lot more powerful, using a halogen cycle with pressurized halogen gas to increase light output. They put out a warm light that can be selected as "Tungsten" on your in-camera white balance settings.

Tungsten lights come in two basic forms— open-faced or Fresnel. An open-faced light consists of a bulb with a reflector behind it and provides a source of hard light (see page 18). You can add any number of light-shaping devices and it's often a good idea to place a soft-frosted screen (either clipped to the light itself or set away from the light independently) to cast a soft, even light

on the subject. The Fresnel light is basically the same as a tungsten light unit but it comes with a special lens attachment known as a Fresnel lens. This consists of a series of concentric glass circles that concentrate the light into a more even beam of light. The beam can be changed from a flood to a spot light by adjusting the distance between the bulb and the lens using a dial.

Tungsten lights are readily available in different power ratings and are dimmable, although at lower settings they may require additional color correction. They are suitable for mixing with most indoor tungsten lighting set-ups. Beware, though, as these units do get very hot and require a lot of power.

Above: ARRI tungsten Fresnel light.

HMI Lighting

If you need to light large areas with a light that mimics the characteristics of sunlight then hydrargyrum medium-arc iodide (or HMI) lights are the very best choice. These lights are generally very large and extremely powerful. At 6000K they are a close color match to natural sunlight but they do require a lot of power and need some time to warm up. The heat they produce also makes it very difficult to move them after they have been set up.

These lights are not designed for amateurs and it's advisable to have three-phase power and an experienced lighting assistant on hand to help set them up. They are very expensive and so photographers tend to hire them rather than purchase them outright.

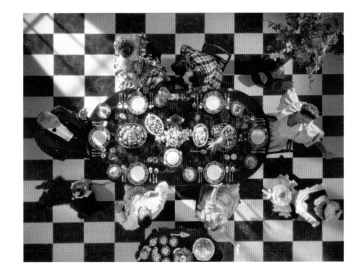

Above: This scene was lit with one large HMI light, mimicking the effect of strong sunlight shining through a window. Tungsten side lights add a warm interior feel.

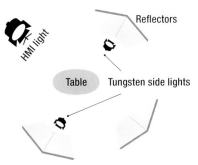

Above: Lighting set-up for the image on the left.

Fluorescent Lighting

Fluorescent tubes are more efficient than incandescent bulbs and are capable of generating a similar power output to HMI lights at up to 100 lumens per watt, and the best units have a CRI rating of up to 99, making them a very accurate light source. Fluorescent tubes are usually set up in banks of several tubes. They can be made tungsten- or daylight-balanced and are often mixed within a bank to produce the overall desired color balance. The units provide a naturally softer light and produce far less heat than tungsten or HMI lights. However, they can have an imperceptible flicker that means they are difficult to work with at certain shutter speeds, especially when mixed with domestic fluorescent tubes.

Tip

It's fair to say that it pays to invest in the best lighting equipment you can afford. As with all things in life there are many products that can appear to offer the same features but when it comes to using them you will quickly discover they are not all equal. Don't believe everything you read in the online description, read plenty of reviews, and discuss the options with photographers you trust to help you buy wisely.

Above: Large fluorescent bank of lights.

LED Lighting

All the light sources covered so far are widely used in the movie industry as well as for stills photography, but they all have several disadvantages that are difficult to overcome— they get very hot, use lots of power, and tend to be very expensive.

Light-emitting diode (LED) lights come in a multitude of options and it is their versatility and ease of use, as well as their increasing brightness and efficiency that have made them the most popular continuous lighting choice for professional and amateur photographers alike. The technology required to make an LED light is relatively simple, and there are now so many companies producing LED lights for photographic purposes that the price of the units has come down in recent years.

There are many different levels of quality and many different styles of LED, so you need to give yourself some time to consider what is the right choice for you. Unlike the other forms of continuous light, LEDs are made up of a collection of small individual light sources, so it's easier to create different color balances using a combination of LEDs of different colors. On many units you can do this simply by turning a dial to change the balance of the panel. Many panels come with both daylight and tungsten LEDs and can be mixed to match any specific lighting condition. Some are even able to output a range of RGB colors, so the creative possibilities are endless.

Above: LED lights come in many different shapes and sizes. There are even flexible panels that can be rolled out to form a large lightweight panel.

Although LED lights are generally not as powerful as the older, more established tungsten and HMI options, they are getting more efficient and it's only a matter of time before they catch up. They produce very little heat, so when used in large panels it is possible to place the light very close to the subject. This creates a very powerful, even light effect.

They are also the flattest of any light source, mainly because they don't need cooling. LEDs are available in many different shapes, including ring lights, circular units, and light bars, as well as the more common rectangular panels. You can even buy some lights that are paper-thin and can be rolled up in a tube for easy storage. These can be hung on a wall or inside a small cupboard to light subjects in almost any tight spot.

For less than $100 (or about £80) you can buy a very usable light, which you can mount on the camera, with a remote control for off-camera versatility. A small unit like this is part of most photographers' general kit as it is small and can be packed neatly into a camera bag.

LED studio lights come in two forms, either as large, flat panels with multiple small LEDs making up a large area, or a more traditionally shaped light using larger individual LEDs. The advantage of the latter unit is that you can attach the same light shapers and modifiers used for flash units, so you can integrate them into your kit pretty seamlessly.

Tip

If you have flash and LED lighting, try to buy units with the same reflector fitting so you can use all the same modifiers on both kits.

There are several ways to work out how powerful an LED panel will be when looking at the specifications. The first is the physical size of the unit. As they consist of individual bulbs or diodes, the larger the units are the more diodes they will have, and so the brighter the light will be. Having said that, the diodes on some cheaper devices are spread out with gaps between them, so be aware of this.

The best way to work out the output of the light is reading the name of the unit—the numbers, such as "480" or "160", refer to the amount of individual diodes on the unit, so the higher the number the more powerful it is. Once again, though, this can be deceptive as a variable-color light will include separate diodes for daylight and tungsten settings, for instance, meaning a "480" panel has 240 daylight LEDs and 240 tungsten LEDs.

The only true measurement of the power of an LED light is its lux (lx) rating. This is the measurement of the actual light output at a given distance and is usually quoted at 3.3ft (1m) from the source, but always check this as some are rated at 1.6ft (0.5m).

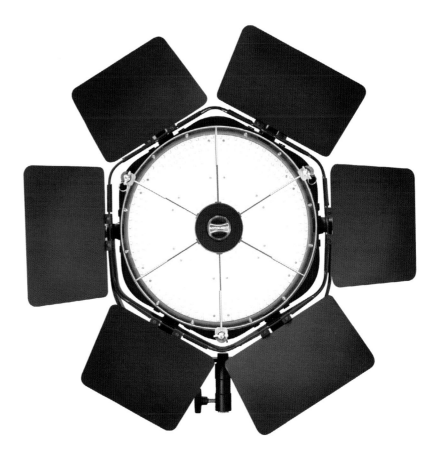

The larger LED units are designed for mains power use but one of the defining features of LED lights is that they don't require much power to operate them. This in turn means that they can be battery powered and sometimes offer both mains and battery operation. Being able to power a light with a battery enables the photographer to travel just about anywhere with a full complement of continuous light units.

Above: Rotalight Anova Pro 2 LED light with built-in flash.

Tip

These days, there are even some LED lights with flash built into them, such as the Rotalight Anova Pro 2. This adds an extra punch of power when you need it.

Above: Sony NP batteries are used for most battery-powered LED units.

Flash Lighting

By far the most popular form of artificial lighting for photographers is flash. It offers more power and flexibility than any other light source, and there is a huge range of options, from a small on-camera flash gun to a huge studio-based softbox. The basic concept is that a high-intensity flash goes off in synchronization with the camera's shutter. Bear in mind that you will only be able to use the flash, under normal circumstances, at a shutter speed up to the camera's given flash sync speed. This is normally around 1/200 sec.

Speedlights

For most of us, our first experience with flash lighting will be a flash gun, or "speedlight", that can be mounted on the hotshoe on top of the camera. Some cameras, mainly the less professional models, come with their own small flash unit built in and these are a great way to experience what a camera flash can do. However, as you improve your ability, you may want to try one of the many standalone separate speedlights that are available on the market. These offer more power and more advanced features.

The camera makers' own units are made specifically for their models and so are usually simpler to operate and easier to understand, with many features being accessible through the camera's own buttons and menu systems. Note that each modern digital camera brand has a different hotshoe connection, so speedlight units that fit on one do not usually fit on another brand's.

It's worth shopping around for a speedlight as there are also some extremely good independent manufacturers that make units to fit your camera at considerably lower prices. For instance, one trustworthy third-party manufacturer is Godox, who makes several different speedlight models with fittings for most brands of camera. The Godox V860 II N only works with Nikon cameras, for example, (as denoted by the "N") but the same speedlight is available to fit other camera makes as well, including Canon, Sony, Fuji, Olympus, and Lumix.

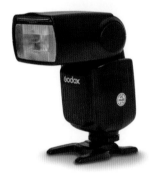

Above: Today you have a wide choice of high-quality and fully functional speedlights that will be compatible with your camera, either made by the camera manufacturer, such as this Canon 430EX III-RT Speedlite (top), or by third-party brands, such as this Godox V860 II C (above), for example.

Most modern speedlights are wirelessly compatible so they can also be operated off-camera. A "through-the-lens" (TTL) function (see page 64) is also worth looking for—this allows the unit to communicate with the camera and automatically change the flash output to achieve the correct exposure in most situations.

Ring flash units consist of a wrap-around circular lamp that encircles the lens. They are useful for close-up macro and nature photography, as well as fashion if used further away from the subject. Sigma make some of the best ring flashes on the market but many camera makers supply their own models. You can also buy more powerful ring flash units for some studio flash systems.

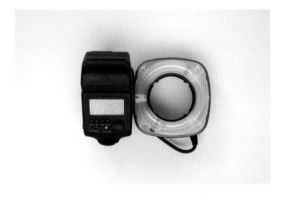

Above: Ring flash units were originally designed for close-up scientific photography.

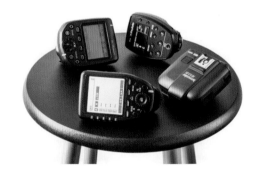

Above: Most lighting and camera makers have their own radio or IR transmitter for use with speedlights and studio lights.

Studio Flash

If you are serious about flash photography in a studio or on location, then you will need to invest in some studio flash units. To begin with, there are a few crossover flash units that are effectively very powerful speedlights (such as the Profoto A1, and Godox V1 and AD200) but are not quite as powerful as proper studio units. These are popular with wedding photographers who want a little more power but still need to move quickly and travel light. They have a limited number of reflector and modifier attachments but they are compact as well as being relatively powerful.

Studio flash units are the most powerful lighting units available. They are generally measured in watt seconds (Ws) but be aware that this is simply a measurement of the available power output of the light. What the light does with that power will vary from one unit to another, and one

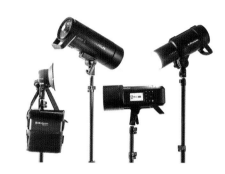

Above: You can buy studio flash units which are battery-powered and come in different styles and power configurations.

manufacturer's 500 Ws unit can give a slightly different result to another. It's also important to remember that larger flash units can be dangerous,

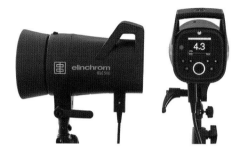

Above: Studio flash units come in different sizes and are usually mains-powered.

so it is sensible to invest in a well-known brand. With units available from 100 Ws up to 3000, 4000, and 6000 Ws, there is plenty of choice.

Monobloc Or Head-To-Pack Units

Studio flash units come in two forms—either monobloc lights in which the power pack and the flash tube are contained within one casing, and head-to-pack lights in which the flash head and the power source are separate. Both have advantages and disadvantages. Originally, all studio flash units were mains-powered but, thanks to improving battery technology, there are now many rechargeable battery-powered units which enable location flash photography without the need for expensive and bulky generators.

Mains-Powered Flash Units
All studio flash units work in the same way. They draw power from a power source and then, at the press of the trigger, they release that power through a high-intensity flash tube. They do not require a huge amount of power on a continuous

basis like a large studio tungsten or HMI light. They do, however, draw power intensely over short periods. Because of this they can put a strain on a regular household-type power supply and, in some instances, cause the power to short out. This should not cause any undue long-term damage, but it is rather annoying and can also cause data loss if other devices are connected to the power when they trip the circuit. For this reason, many mains-powered units have different settings for slow to fast recycling. This means it may take a little more time for your flash to recycle, but you will not accidentally cut off the power supply.

Battery-Powered Flash Units
Battery-powered flash units by their nature tend to be used on location. If you are traveling by air then you need to be aware of the safety regulations

relating to large batteries on aircraft. Most modern flash manufacturers now use lithium batteries. These are lighter, more efficient, longer lasting, and more powerful. The older units used lead acid batteries and some are still available. Traveling with lead acid batteries on an aircraft is fine provided they are installed within the device. You are generally required to carry any lithium battery in hand luggage and they should not be rated at more than 100 Watt hours (Wh). It is wise to check with your airline before you travel—you don't want to lose your power source before you even arrive on location.

There are several flash lighting manufacturers to consider, including Broncolor, Profoto, Elinchrom, Godox, Bowens, Paul C Buff, and Hensel. They all have different-sized units for different applications.

STUDIO FLASH UNIT BUYING CHECKLIST

- **Power output:** the bigger this is the more power the unit has, but it is important to look at how the power is delivered and in what increments you can set the variable power. Also check whether the power output can be split using several different flash heads, which provides greater versatility, as well as whether the power is consistent.

- **Flash and modeling strength:** all heads should come with two bulbs, a flash tube, and a modeling bulb. The modeling bulb shows the direction and nature of the light (soft or hard), but has no effect on the final exposure—the flash tube does all the hard work. Some modeling bulbs are now made in LED form and increasing power outputs mean that in some circumstances they can stand in for a continuous light source, although they are still pretty limited.

- **Features:** modern flash units offer more than just a one-off flash. Flash duration is important if you want to freeze action, and multiple lights can be controlled remotely in different groups and at different radio frequencies. Sometimes units also offer multiple flashing features for stroboscopic effects, as well as high-speed sync (HSS) or hypersync (HS), which allow you to shoot above your camera's maximum sync speed of around 1/200 sec. In this way you can shoot flash at sync speeds of up to 1/8000 sec. (see page 148). All these features will differ from unit to unit, so research the ones you need before making a purchase.

- **Range of modifiers:** the established manufacturers provide a huge range of reflectors and modifiers as well as additional flash units and accessories which are compatible with your lights. Many of the smaller manufacturers do not provide these accessories. Increasingly, universal connectors are available for fitting any head to any reflector, but they can be clunky and cheap, so research the products carefully.

- **Trigger:** all units are fired by a trigger that is connected by radio or infrared signal, so research the options. Some units offer more features than others, but often at much greater cost. Cable connections are normally available as well, but are now rarely used.

- **Support:** studio flash units are expensive and complicated. Most modern units will require software updates from time to time and they can also break down. It's important to make sure there is good after-sales support to help you with any breakages, breakdowns, or technical issues that arise.

Right: Essentially, the larger the set the more lighting you will need. It's important, though, not to feel daunted by this. Simply build your lighting kit as and when you need it. The main light here is a large directional top light. Various accent lights have been added to enhance the final shot.

Focal length: 50mm

Aperture: f/11

Shutter speed: 1/160 sec.

ISO: 50

Above: Broncolor make a huge range of modifiers.

Light Modifiers

There are thousands of different light modifiers available—hard, soft, large, small, round, square, long, short, and everything in between. The full range can be extremely daunting, so here is a brief explanation of the two main categories—hard and soft.

Every photographer has their own favorite types of modifier, and it's up to you to choose the right lighting for your photographic needs. Do your research, read the reviews, but ultimately your subject matter and your budget will be the deciding factors. Remember that you are building a lighting system that will need to grow and develop over time as your skills develop. You don't need to buy everything at once so purchase wisely.

The quality of your light output is determined by the physical size of your light and its distance from the subject (see page 18). Always use this equation when deciding on the modifier that you need. Modifiers can be split into two basic categories at a given distance—hard or soft, assuming they are set at a normal distance, say 10–13ft (3–4m) from a person.

Hard Modifiers

Hard modifiers give sharp highlights with deep, dark shadows on the subject. Your light with no reflector—just the bare bulb—would be a hard light source, there being nothing to soften its effect as it projects towards the subject. Hard modifiers are typically open reflectors which are fitted directly to your light. They are normally circular and have a silver inner reflective surface to help project the light. They are generally the smaller reflectors but can sometimes be a little larger for a wider spread. Your regular LED flat panel with no covering will also be quite hard as it's made up of several

individual LED lights and will give a specular feel to skin surfaces, resulting in quite harsh shadows.

Fresnel lens attachments are a great way to control hard light sources and enable you to project the light and focus it on your subject. They are often compared to the sun as they have similar rounded but hard properties. Fresnels are typically fitted to continuous light sources such as HMIs and tungsten lights, but can also be used on flash.

Another way to project and tighten the light is to fit the reflector with a "grid". This intensifies the light and reduces the fall-off at the edge of the beam—so-called "barn doors" on lights have a similar effect. A long tube known as a "snoot" cuts out any stray lighting and a focusing spot enables you to concentrate a small beam on any area for a hard, isolated light effect.

> ### Tip
>
> All lighting systems have their own proprietary modifier connector system, so check that the connectors fit your lights before you buy. It is possible to purchase converters, however.

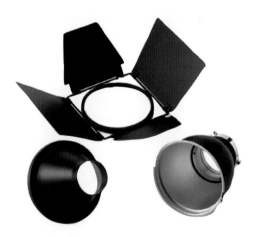

Above: Hard reflectors come in different types depending on how much you want to control the light—from a standard hard reflector, to a snoot which can focus light down to a small point, to barn doors which help to shield and feather the light.

Soft Modifiers

Soft modifiers give soft highlights and graduated shadows on the subject. They provide a similar effect to when you bounce a hard light source off a large white wall by shooting the light beam through a sheet of white translucent fabric positioned as close to the subject as possible. The larger the fabric the softer the source. Soft modifiers tend to be large—they can also be circular, square, strip-shaped, or octagonal—but they are always fronted with white translucent fabric. The softbox contains a silver fabric foil surface which projects the available light forward. There is also often an extra sheet of translucent fabric to increase the softening effect. Some of these units can be huge and are often very expensive, so it's worth shopping around.

The cheapest alternative to a softbox is an umbrella. These can be either used in reverse to bounce back the light or you can "shoot through" them. Umbrellas are a great way to get used to working with soft light sources and they are very easily transported for working on location.

Tip

The largest softboxes can be up to 10ft (3m) long or bigger. The larger ones are often custom-built and known as "swimming pools"—they are usually used as huge top lights when photographing cars and other vehicles in studio.

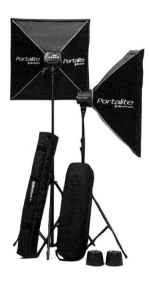

Above: Softboxes come in different sizes.

Above: You can even get mini-softboxes that fit onto your speedlight.

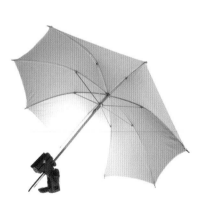

Above: Umbrellas allow you to either "shoot through" or "bounce" the light.

Above: A honeycomb grid restricts the spread of light from the light source, directing it where you want it, and can be used to create more contrast and dramatic lighting.

Profile: Tony May

BIOGRAPHY

In 2003 Tony started working his way out of a career in IT to see if he could get work as a commercial photographer. When he had to stay up all night to meet a deadline he figured it was time to go full-time. Largely self-taught, Tony went straight for his own clients rather than assisting another photographer. In the early days he shot most things but got a break when he won a job shooting ads for a jeweler. Jewelry and watch work is so specialist that once you can do a good job, the work tends to find you. One of his early images was picked up and used by Phase One for the global launch of the Phase One camera system. These days, in addition to the jewelry, he shoots other products and food.

www.tonymayimages.com

Q) What equipment do you regard as being essential for your photography?
A) Reliable and consistent studio flash is vital. I started using Elinchrom some years ago and I still have my original heads which have never let me down. I also have a range of modifiers too. For jewelry, diffusion film in panel, roll, and sheet form are essential. The product reflects its surroundings so the metal needs to be illuminated. Lights are all behind the diffusing film, with appropriate modifiers positioned to achieve the desired lighting effects, such as gradients.

Q) What do you regard as the most important aspect of your work in terms of your approach to photography?
A) Firstly, be clear what you're trying to show and achieve with the images, and who the audience is. Clients are not always clear what they are looking for. In the case of jewelry photography, because I'm the expert, I sometimes have to tell the client or other creatives that what they are asking for is not a good idea or the best use of their budget.

Q) Can you give us a tip about lighting that you wish you had known when you first began photography?
A) Highlights and shadows add modeling and drama. It's obvious but easy to overlook and so you may end up lighting products too evenly and flat when you're inexperienced.

Q) What was your favorite job and why?
A) One of my earliest, and most produced, shoots was for Jersey Pearl—product shots in the studio and then a couple of days with models, in the studio and on location. We shot at about six different locations in one long day, with client

and art director, as well as assistants and hair and make-up artists. I was in a spinal cast after an accident, so it was pretty grueling.

Q) How important is postproduction to you and do you do your own?
A) It's absolutely essential. Clients need images that reflect the value of the product and expect quality now that is only really feasible with postproduction. Apart from drawing most of the clipping paths, which I send out to a specialist, I do all my own postproduction.

Q) Which photographers or artists have influenced you and why?
A) Perhaps most significantly, I love the art deco graphic posters of Cassandre. He was a genius who could reduce his subjects to simple geometric shapes more cleanly, elegantly, and effectively than anyone else. And he designed his own typefaces.

Q) If you could shoot in any specialist field other than your own, what would you choose?
A) People on location with lighting—lifestyle or fashion.

Q) Is there anything else you would like to add?
A) Look at the images you admire and try to work out what the lighting set-ups might have been.

Chapter 3
Natural Lighting

Take a free-floating ball of light, about 864,000 miles (1.392 million km) in diameter and place it 93 million miles (150 million km) away. Make it constantly available somewhere in the world for free, with varying power and light characteristics, and you have the most useful photographic light source ever created. The Sun is employed regularly by just about every photographer on Earth. Good photographers will quickly discover that using the Sun as your primary light source is a little more tricky than it first appears.

The nature, quality, strength, and color of sunlight will vary according to the time of day, where you are positioned, and the atmospheric conditions. Creating great images with natural light requires skill and experience, but, with the correct approach, you can learn to master the nuances of available sunlight. Whether you are shooting landscapes, products, or portraits, you need to learn to read and react to sunlight.

Right: There are few light sources that can compare with the beauty of natural sunlight

Focal length: 35mm

Aperture: f/11

Shutter speed: 1/60 sec.

ISO: 100

Landscapes & Architecture

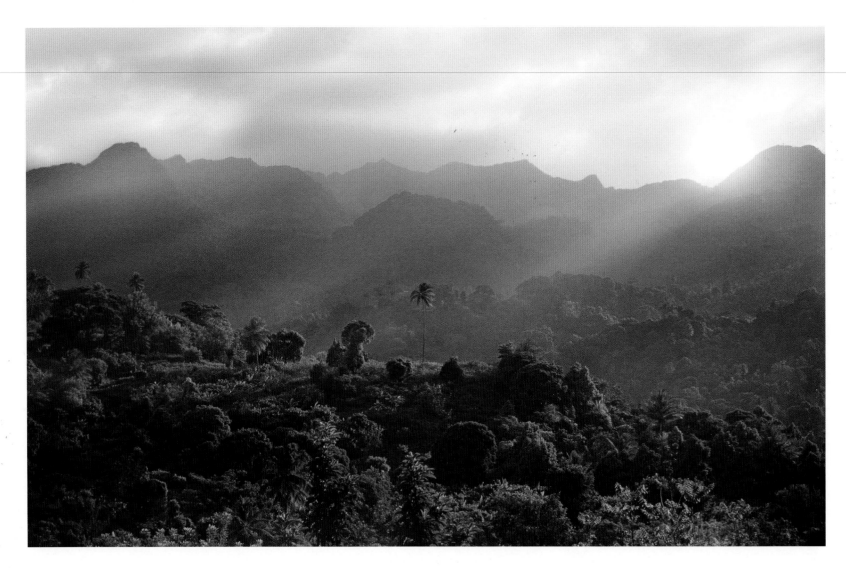

Landscape photography is, arguably, the most accessible form of photography. You don't need anything except a good eye, a camera, and beautiful light to create superb landscape images, and photography doesn't come any more purist than that.

Landscape photography is all about seeing and recording the effects of natural light on the world around us. Great photographers are able to get the very best from every available scene—whether of oceans, mountains, or even cities—using their vision and creative composition, but it is always the lighting that ultimately makes a great image.

Above: Understanding how light affects the world around us, including landscapes, is an essential part of every photographer's educational journey.

Focal length: 24mm

Aperture: f/16

Shutter speed: 1/15 sec.

ISO: 3200

Timing Your Shoot

Choose your locations carefully and plan the time of day that will provide the very best lighting. Pre-planning your shoot is really important for great results. It's helpful to know when the sun rises and sets, as well as the direction of the sunlight in relation to your scene, and there are several helpful apps which provide a host of information, including LunaSolCal Mobile and Sun Surveyor Lite. But there's no replacement for actually being there.

Think about reflections, too—they can add interest and color to your images—so look for reflective surfaces, such as water or large, glass-fronted buildings. Bear in mind that the strength and color of reflections will change during the day.

Above: Use a circular polarizing filter (see pages 25 and 45) to control the translucency and color of the water's surface, adding or subtracting reflections as you turn the filter.

Focal length: 24mm

Aperture: f/11

Shutter speed: 1/80 sec.

ISO: 800

Composition

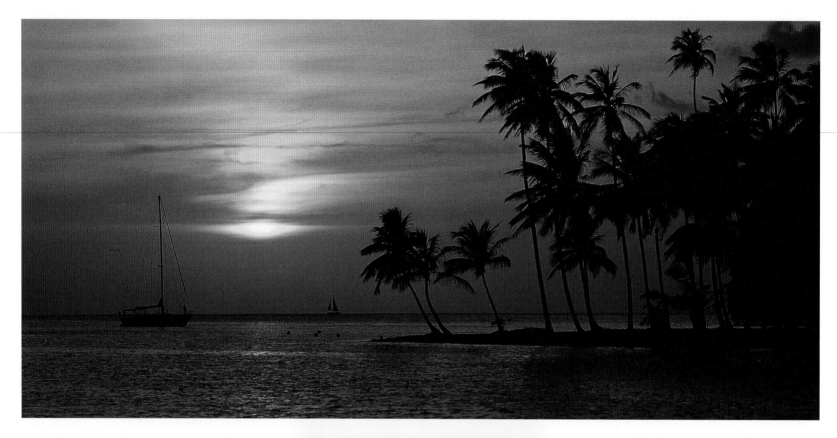

Great landscape images are usually scouted out prior to shooting so you know the exact spot you want to be in. You need to micro-manage your position because the main backdrop may not change much but the foreground is important and that will change with every foot you move. Positioning yourself with that foreground tree branch perfectly framing your skyline will make all the difference to the final image. You need to be ready to shoot the moment that the light is right. Don't forget to check the weather, too—that sunrise you experienced yesterday will appear completely different on an overcast morning.

Above: Shooting at sunrise or sunset has a magical quality. It's important to get yourself well-positioned to capture the right light at the right time.

Left: LunaSolCal is a great app to have on your smartphone if you want to find the sun's position at any given time in the future.

Polarizing Filter

If there is one filter that really is essential it is the circular polarizing (CPL) filter (see page 25). A polarizer cuts through scattered light and reduces the natural atmospheric haze. Because of this it will turn your skies dark blue and even sometimes black if you are in a particularly clear environment. Polarizers can also cut through reflected light, enabling you to see through water surfaces and reduce reflections from car bonnets and windows, and so on. If used appropriately, a polarizer will increase color saturation and enhance the detail in your images, so they are a must-have for most landscape photographers.

You attach the filter to your lens and then you need to rotate it on its bezel to see the effect. The strength of the polarization will vary depending on where you are standing in relation to the sun—it will only work fully if the sun is to the side of you, creating a degree of cross-light. It's not all good news, though, as polarizers will darken your images by about 2 stops of overall exposure, so be aware of the loss of light.

Tip

Polarizing filters are often used by car and architectural photographers as they can cut out unwanted reflections in shiny surfaces. Polarizers have a significant neutral density factor, darkening your images, so be aware that they will reduce your exposure by up to 2.5 stops, depending on the angle.

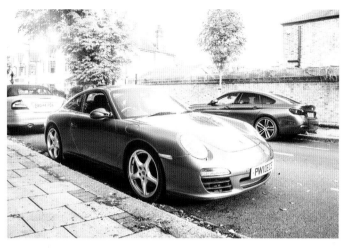

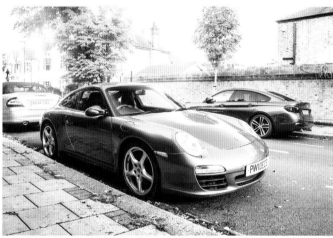

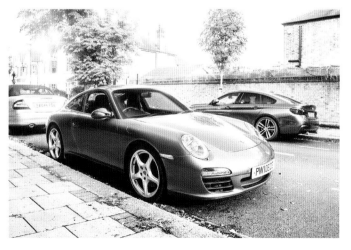

Left: When shooting cars, a polarizing filter can be used to isolate the best reflections on different parts of the bodywork. You can then combine the best of each frame in Adobe Photoshop to create a perfect final result (bottom image).

Focal length: 16mm

Aperture: f/8

Shutter speed: 1/10 sec.

ISO: 200

Perfect Portraits

Front Light

If you stand with your back to the sun in any given environment, point your camera, and shoot, you will get a very "consistent" image. This is fine but consistent images can often be bland and even boring. You need to develop the ability to control the environment and create more interesting images with descriptive lighting techniques.

Hard, direct front light is tricky to deal with at the best of times. It can create a flattening effect with little separation from the background, and it usually results in the model having to squint when looking at the camera. In her 20s, my wife modeled all over the world and frequently found herself shooting editorial or catalog jobs in desert

Above: Front light can be harsh and unforgiving but can create some dramatic results.

Focal length: 60mm

Aperture: f/10

Shutter speed: 1/160

ISO: 500

locations. There is little opportunity to avoid direct sun in these zones so, being the true professional that she was, she had her optician make up some dark contact lenses. By wearing these, she was able to pose as requested without squinting. But there is another simple technique that is useful in direct front light situations.

Position your subject for the perfect shot and ask them to close their eyes. Then, on the count of three, say "Open" and shoot. Remember that, despite the close bond that is necessary between photographer and their subject, cemented usually with continuous conversation, you only actually need a fraction of a second to get the shot, so the moment that they open their eyes, the shot is in the bag.

Tip

Involving your subject in the technical aspects of a shoot, using techniques such as eye-closing, helps to give them a sense of being part of the creative process and a member of the team. This always results in better images. There is a certain trend for direct front-lit fashion shots and they can look superb, but don't be a slave to this front-light effect as it can get dull. The moment you move the sun to the side, even by a few degrees, you will begin to define the shape of the body and the face. This effect is increased when the sun is low in the sky or in direct cloudless skies, so choose your position carefully so as not to create heavy, unwanted shadows and burned-out highlights.

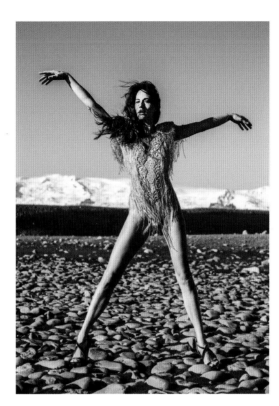

Left: Direct lighting with sunlight can be very effective. Ask your subject to close their eyes until the moment you shoot to avoid squinting.

Focal length: 50mm

Aperture: f/8

Shutter speed: 1/125 sec.

ISO: 200

Right: Full-on front light can work but be careful to choose the right subject.

Focal length: 35mm

Aperture: f/6.3

Shutter speed: 1/1000 sec.

ISO: 400

Canopy Lighting

There is one unique form of front lighting that creates an effect that is so simple and yet so beautiful that I find myself using it again and again. Canopy lighting is available in any situation where you can place your subject under cover in an outdoor environment. It can be in a doorway, a cave, or under an ancient archway, but is most commonly seen under the natural canopy of a tree.

Place your subject under cover, some way back from the lit area and with yourself in the light, facing into the covered space. The large area of open light acts like a giant soft light source, bathing the model's face in soft, even light. The front light is very even and quite beautiful, emphasizing the detail in the image. You can even use this technique at midday when the sun is directly overhead. Traditionally, this is a time that most photographers avoid because overhead light is flat, and does little to enhance anyone's features.

It's important to understand how this light creates such a beautiful effect. It is the reflected and incidental light from the sky outside the opening that acts as the light source. Focus on the subject's eyes and you will see the effect with a stunning layer of reflected skylight in the eyes. You can sometimes actually make out the silhouette of the photographer in the eyes, which adds a sense of detail to the image.

Left: Canopy lighting gives beautiful reflections in the eyes—shooting under a tree, a doorway, or a tunnel is ideal.

Focal length: 40mm

Aperture: f/2.8

Shutter speed: 1/250 sec.

ISO: 320

Back Light

Understanding how to shoot with back light is one of the first steps to mastering the challenges of natural lighting and becoming a true outdoor portrait photographer. The problem with working with back light is that you need to really understand how your camera works if you want to create great images. Front light is easy—you see your image and your camera's automatic meter settings will give you exactly what you are looking at every time.

If you stand with the sun to the side or even behind the subject, things get a little more complicated, but the results can be amazing. When shooting into the sun, you are asking your camera's meter to deal with extreme lighting conditions. Firstly, there is always the possibility of flare. Flare is caused by stray light hitting the lens surface. Generally speaking, lens flare is not desirable but there are ways to use lens flare creatively for interesting, sunny-looking images.

Left: Using back light as your main light source will transform your images.

Focal length: 30mm

Aperture: f/2.8

Shutter speed: 1/640 sec.

ISO: 320

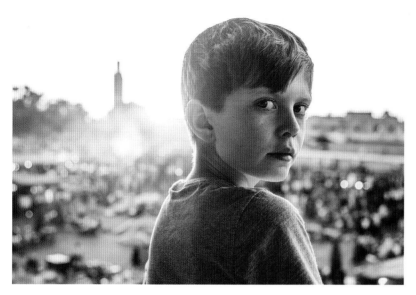

Above: Using flare creatively can add to the atmosphere of your images, as long as you control the results properly.

Focal length: 60mm

Aperture: f/5.6

Shutter speed: 1/100 sec.

ISO: 500

Above: Using a handheld circular reflector under the face of your subject will give you those perfect glassy eyes that always look so good.

Focal length: 70mm

Aperture: f/6.3

Shutter speed: 1/320 sec.

ISO: 800

Bright white highlights and deep black shadows can ruin your photographs because your camera does not have the dynamic range to cope with both extremes in one image. When shooting in back light situations your meter will assess the scene and see a huge amount of light flooding towards the camera. It will compensate for this by stopping down and so it creates a darkened image with a well-exposed sky. Obviously, it is the person in the foreground that is the subject of the image and the sky is secondary—so you need to take your meter reading from just the subject's face, and not the overall scene.

When shooting with back light, you need to take your meter reading from the shadow areas on the model's face. If you are in auto mode you can use the plus settings (+1, +2, or +3) on the camera. This will give you a perfectly exposed subject, often with attractive rim lighting around the head and hair, but it will also result in the background "blowing out", or appearing too bright. This can be a nice effect, giving a dreamy, washed-out look, but what if you want to include elements of the background in your final image?

Shoot the same image but now try holding a small handheld reflector under or to the side of the face. The result is that you even out the exposure, so the face is brighter and nearer in exposure and you don't need to compensate as much (see page 26). This is a great way of showing the face while still retaining the personality of the image and some of the background detail. The addition of the reflector will also give you that trademark highlight in the eye that looks so beautiful.

Tip

You can get an accurate shadow reading using the "spot meter" setting, if you have one, and isolating just the face for your reading.

Flare

Lens flare has always been the bane of back-lit photography. It's caused by stray light hitting the lens surface and bouncing its way to the sensor. Lens flare can have several nasty effects on your images. It causes tiny, pinpoint spots of light or even multiple large, scattered spots. It will also wash out your image, reducing detail and contrast, and sometimes even actually bleaching the subject out completely behind an explosion of white light. Pretty much every new lens will come with a lens

hood, which has been designed to stop or at least reduce the appearance of flare. You will notice that lens hoods are different for each focal length, so don't make the mistake of mixing them as this can cause unwanted vignetting, or darkened corners, as the hood intrudes into the visible frame.

Fundamentally, every lens, no matter how expensive it is, will show flare if a major light source is present within the visible frame or field of view. When the light source is just outside the frame, a good lens fitted with an appropriate lens hood should be able to deal with it. Experiment with just how close you can position the light source to the frame with different lenses and you will find they all have different characteristics.

Over the years, photographers have started to appreciate that well-controlled, "creative" lens flare can be a good thing. The purists will always dispute this, but personally I think a bit of lens flare can add a real sense of drama to an image. The difference between good and bad flare is small, though, and you will benefit from experimenting. You can create edge flare by hiding the sun behind your subject's head and then changing your position to allow it to peek out from the side. Alternatively, you can go for the full effect and have the sun in the frame. Usually better in hazy conditions, this will show the full ball of the sun. Both effects give a generally summery effect.

You will notice that the highlights created will be soft and blobby if you are set on a wide aperture, such as f/2.8. At smaller apertures, the highlights will appear star-like as the camera is able to record the shape of the lens aperture leaves themselves.

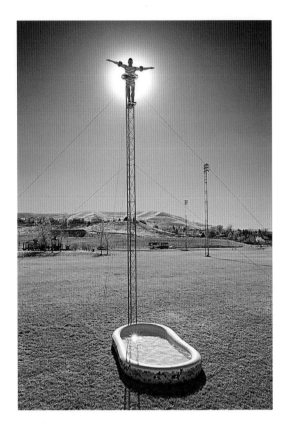

Below: Controlling the flare from the sun can create some incredible, dramatic results.

Focal length: 17mm

Aperture: f/11

Shutter speed: 1/200 sec.

ISO: 200

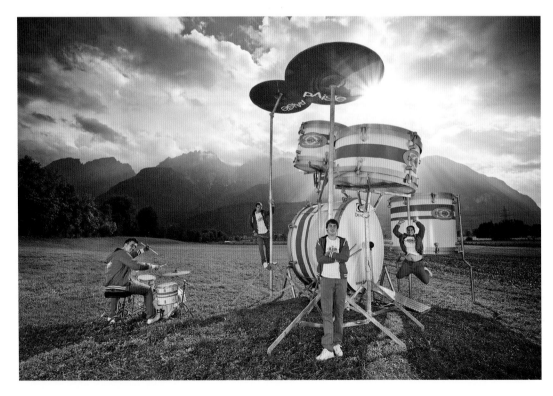

Above: It is possible to shoot directly into the sun as long as you use your subject to block the glare. You will need to adjust the exposure to compensate for the extreme back light conditions. Here, I used flash to balance the exposure.

Focal length: 27mm

Aperture: f/14

Shutter speed: 1/80 sec.

ISO: 100

Left: Architects understand how the buildings around us create unique patterns of light and shade.

Focal length: 20mm

Aperture: f/16

Shutter speed: 1/60 sec.

ISO: 3200

Reflected Light

In time you will learn how to look at a scene and instinctively see where the best lighting conditions are going to be at different times of day. Architects and interior designers know this and are always considering how the direction of light will define the spaces we live in. They bounce light around interiors and exteriors, creating beautiful living spaces. All this is done using natural reflectors such as walls, floors, and ceilings.

You can do the same when shooting outdoor portraits. It's a question of balance. You have a perfect, brightly lit backdrop with your subject standing about 6–7ft (2m) away from you in the foreground. The sun can be positioned at any point in the scene with one stipulation: it has to be behind the subject. It doesn't need to be directly behind, just somewhere within the 180-degree arc around the rear of the model. Your subject's face will be in shadow but you will get beautiful glowing "clip lights" to the right or left of their face as well as body-framing which separates them from the background.

The strength of the clip light is determined by the type of sunlight—it can be hard, direct sunlight or soft, cloudy sunlight but the effect is still there. You should expose correctly for the person's face, but in exposing for the face you will overexpose the background—the difference in exposure value between the brightly lit background and the shadowy foreground will be too much for your camera to resolve. The solution is to use a reflector to balance the exposure by bouncing the sunlight back in towards the subject (see page 26). This means the camera meters the face at a similar level of exposure to the background. You will learn that you can control the amount of reflection to brighten or darken your background exposure and balance the image for different effects.

This simple skill is the basis for most outdoor images which involve people, from weddings and portraits to fashion and advertising. Essentially, hard lighting on faces is difficult to deal with and often pretty unflattering, so keep your subject's back to the sun and then fill in the shadow.

You can buy a number of reflectors in different sizes and shapes with different finishes from plain white to silver, and even mixed gold and white. They all provide varying styles of light control—it is up to you to discover what works for your style of photography.

One of the best reflectors available is a plain white painted wall. Position your subject near the wall with the light hitting it at an angle and you'll find that the harsh shadows that are so difficult to deal with on a model are softened to a manageable degree. Look around for naturally occurring reflective surfaces as they will give you some great effects. Corrugated iron fences, large windows, a white van, or even the surface of a pond or the sea provide excellent opportunities for reflecting light. You can combine these natural reflectors with your handheld devices to bend and shape the light and create the look that you want.

Using an assistant opens up a whole host of options for reflectors because you will be able to position the reflector at different points to give

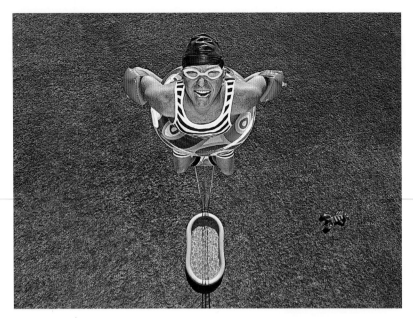

Left: You can use a bounce reflector in almost any situation to help balance the natural lighting conditions.

Above: Sometimes you have to take extreme measures to get the shot you want.

Focal length: 17mm

Aperture: f/18

Shutter speed: 1/80 sec.

ISO: 100

Above: If you place your subject near a white wall you have a natural reflector.

Focal length: 50mm

Aperture: f/7.1

Shutter speed: 1/60 sec.

ISO: 250

Above: You can add a handheld reflector to soften the light and create a beautiful key or catch light in the eyes.

Focal length: 50mm

Aperture: f/7.1

Shutter speed: 1/60 sec.

ISO: 250

different lighting effects. It's helpful to build a relationship with good assistants who understand your lighting techniques, but if you are shooting portraits and your subject's partner or parent are on hand you can quickly show them what to do. Involving your client is a great way for them to feel engaged in the shoot, so don't forget to show them the results and how they helped you to get a great shot.

Catch Lights

As we have already explained, using a small white or silver reflector in the foreground—normally positioned just out of frame under the subject's face or to the side—helps you to even out the overall exposure, and gives the background some definition. In doing this you can also create another effect: bright reflections in the highly reflective surface of the eye. This gives a beautiful effect, which is hard to match in any other way. Using a silver reflector will intensify the effect. Holding a reflector at a distance creates a neat circular highlight, making the eye look sharp and the subject alive. Holding the reflector in close changes the effect, creating a large semi-circular reflection that looks dreamy and transparent.

Obviously, the physical size of the reflector will also change the result, so experiment with different sizes, shapes, and textures and you will soon learn how to get the results you prefer. As a good starting point, I recommend a 28in (70cm) circular reflector with white on one side and silver on the other. I carry one of these in every camera bag and use it constantly.

Companies such as Lastolite produce a huge range of convenient, foldaway, lightweight reflectors, which come in different colors. Try experimenting with gold reflectors and also mixed gold and white for a softer, warmer look.

On commercial sets it's not uncommon to have huge banks of reflectors bouncing light anywhere that it's needed. These are particularly useful on car shoots when you have to control large reflective surfaces to create a beautiful liquid-like finish on the surfaces of the car.

Above: Using a silver reflector at a distance will fill in the shadow created by back light and give you a pinpoint catch light in the eye.
Focal length: 50mm
Aperture: f/2.8
Shutter speed: 1/1000 sec.
ISO: 800

Above: Using the same silver reflector close up or using a larger reflector will provide a soft, glassy effect in the eyes.
Focal length: 35mm
Aperture: f/2.8
Shutter speed: 1/400 sec.
ISO: 800

Window Light

No photography lighting book would be complete without touching on the use of window lighting. This is a popular technique because it uses the windows and doorways that exist in just about every building. The extraordinary European portrait painters of the 1600s had almost no artificial light to work with, as candles provide very little light. Instead, they developed the technique of positioning their subjects near a window, resulting in a lighting tradition that has been copied and developed ever since, and is often known as "Rembrandt lighting" today.

Essentially, a window provides the photographer with a large block of light that is consistent and usable, especially for portraiture. It can be direct when the sunlight streams through the window at 90 degrees, but often the best form of window light is either reflected light bouncing in from a courtyard, or from another building outside, or diffused light created by the addition of a blind or net curtain. It is the containment of the light source within the window frame that gives this light its unique characteristics as well as the fact that most windows are set at a level above chest height, so the light falls down onto the subject, not up underneath the face.

This is where we need to understand the relationship between the size of a light source and the subject in relation to the distance the light is positioned from the subject (see page 18). In simple terms, if you have a large window lighting a person standing very close to it, the light will be softer than if you have a small window with the person standing some way from it.

That said, there are a few basic techniques that you should try to master when working with an average-sized large window. All of the following window light effects can be adjusted with the use of a reflector to bounce general light into the shadow areas to soften them and decrease the overall contrast in the image.

It's up to you to decide how much fill light you feel is appropriate in any given situation, balancing the light and shade to create your desired results.

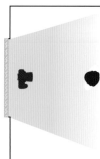

Above: Stand with your back to the window and with your subject facing toward you and the window. The subject will be well lit and the window will create a detailed reflection in the top half of the eye, interrupted only by your silhouette. This is one of the cleanest lighting set-ups you can find and provides a very natural look.

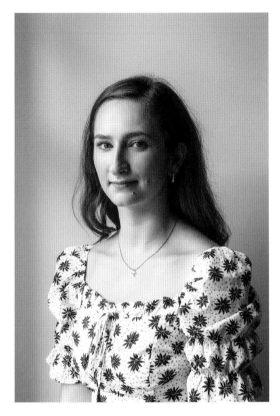

Above: Stand with your left shoulder 6in (15cm) from the wall, to one side of the window frame. Stand your subject so their right shoulder is 6in from the wall on the other side of the window frame (or vice versa). Now ask your subject to move away from you until the light washes around their face at an angle of approximately 45 degrees. This is known as "loop lighting" as it creates a shadow looping around the subject's nose.

Above: From the last pose, ask your subject to move toward you so they are about one third across the window. Ask your subject to turn their body and face toward the window at 45 degrees. This gives the light a soft effect.

Above: Now turn your subject away from the window but ask them to look back toward you with their head only. This creates drama as you are mixing light and shadow, so always ask the subject to look for the light of the window to ensure good lighting in the eyes.

Profile: David Kilpatrick

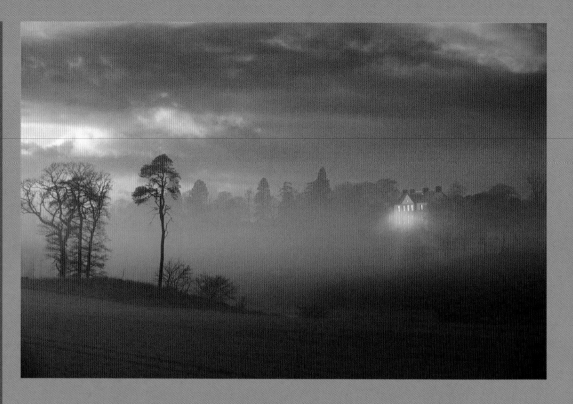

BIOGRAPHY

Despite failing spectacularly at school, David Kilpatrick was predicted to become a writer, artist, historian, or scientist. His credentials as an artist and writer are unquestionable and you get the feeling that, if he'd really wanted to, a career as a historian or scientist would have been well within his grasp. There are few fields of photography that David has not covered, having operated several successful commercial studios over the years. He now runs Icon Publications from his home in Scotland, writing, editing and illustrating specialist photographic magazines, much loved by professional photographers the world over. His mastery of the landscape and lifestyle genres helped him to build a digital library of over 50,000 images from around the globe. All were shot by David with the help of his late wife and co-photographer Shirley.

www.davidkilpatrick.co.uk

Q) What equipment do you regard as being essential for your photography?
A) I'm more about light than lighting. My eyes and my feet are my most valuable lighting accessories. I believe in lighting with your feet, moving around and, if necessary, moving your subject, too, in search of the best natural light.

Q) What do you regard as the most important aspect of your work in terms of your approach to photography?
A) I'm very precise about viewpoints and the juxtaposition of elements in a scene, and I will first visualize any subject from whatever shooting positions can be identified. I'm the photographer you see nipping across the street and going up some steps, or leaning two inches to the left before releasing the shutter. It's why I rarely use a tripod.

Q) Can you give us a tip about lighting that you wish you had known when you first began photography?
A) Easy—when I started, everyone used flash umbrellas, usually reflective. I do still own some but they are the worst form of lighting ever invented. I spent six years trying to light products and people with umbrellas before I finally owned a good-quality 3.3ft- (1m-) square softbox.

Q) What was your favorite job and why?
A) My favorite job was a "figure in landscape" calendar commission, in 1985, for a division of the UK's Central Electricity Board. It involved researching geology and finding photogenic landscapes from the Cornish clay pits to the Giant's Causeway in Ireland, working with Shirley assisting and three lovely agency models posing in challenging settings. We had to book three two-day road trips in advance to drive hundreds of miles between the locations without even a recce.

Q) How important is postproduction to you and do you do your own?
A) I do all my own postproduction but aim for a

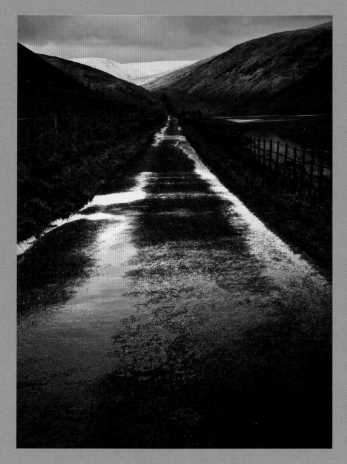

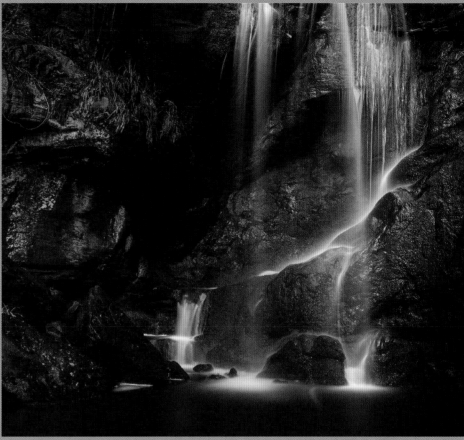

very natural photographic result, much as I would have produced when darkroom printing.

Q) Which photographers or artists have influenced you and why?
A) Henri Cartier-Bresson for his composition and timing, Walter Nurnberg for his industrial light and shade, and Don McPhee and his *Guardian* darkroom printers for their use of high-contrast paper and dodge/burn shading. I could add dozens more to this list. I have the privilege of seeing the original full-resolution repro files of photographers so I'm biased towards truly perfect work.

Q) If you could shoot in any specialist field other than your own, what would you choose?
A) I don't really have a specialization, which means I could not pick an alternative.

Q) Is there anything else you would like to add?
A) The issue with light, understanding light and using light, is that it's only seen as being really good when it's obvious. Often, it's simply not a factor the viewer recognizes in an image. A good example of this might be where a photographer deliberately shades a flower and avoids sunshine, knowing that the best garden pictures are often taken in overcast light. It will not be obvious to the viewer that the image has been "lit" in this way. Alex J Surgenor, who founded *Practical Photography* magazine, said he would print bad photographs because only by seeing bad ones identified as bad could his readers learn to recognize the good ones. Unless you can tell what bad light is, you may not even be aware of good light in many carefully created photographs.

Chapter 4

Speedlights

After obtaining a camera and lens, inevitably just about every amateur and professional photographer purchases a flash gun—also known as a "speedlight"—next. What was initially a practical way to punch a bit of light into a dimly lit area has now become a modern, multifaceted photographic tool which offers seemingly endless creative possibilities.

Speedlights are a cheap, accessible way to gain experience with flash lighting techniques. They are the natural starting point for many photographers and, with the right accessories, they can offer everything you need to provide low-power lighting for any subject.

Right: Shooting with a hotshoe-mounted flash gun or speedlight can transform an image, especially when combined with ambient daylight. If you have movement in the image you often get a slight ghosting effect that can convey energy and movement.

Focal length: 24mm

Aperture: f/11

Shutter speed: 1/200 sec.

ISO: 400

Which Speedlight?

Left: Using a speedlight on the camera does not have to yield harsh results. With the correct attachments and handling, you can combine exposures for a highly polished result. This was created using a small softbox attachment to soften the flash.

Focal length: 70mm
Aperture: f/8
Shutter speed: 1/40 sec.
ISO: 400

There are many types of speedlight available, all with different features and options. The major camera manufacturers make their own, so you can buy speedlights from Canon, Nikon, Sony, Fujifilm, Lumix, Olympus, and Leica. These dedicated units should be your first choices—you can be sure that they will work perfectly with your camera model, and be reliable and durable. Many of the functions on a camera maker's speedlight are compatible with their camera models' functions and operation, making them easy to understand and use.

You will also find several cameras, compacts, and even full DSLRs with a built-in flash. These are usually pop-up units, which are very handy for adding that little touch of frontal light in a dim or shaded situation. Unfortunately, they are rarely found on top-end cameras as they assume that professional photographers only want big, powerful, off-camera flash units. This, in my opinion, is an odd assumption as I've often found myself in many situations when a pop-up flash would make a huge difference.

Before buying a camera maker's flash it's worth having a look at some of the other options. There are some superb third-party speedlights available and, in many cases, they are as good as or better than the camera makers' units. Godox, Nissin, Metz, and Sunpak make some of the very best.

Tip

Remember that speedlights are usually camera brand-specific—always check that the one you buy is suitable for your camera model. Independent flash makers often make the same unit for different camera models, but make small changes to ensure compatibility with each brand, which are not universal.

How Speedlights Work

If you want to understand the best ways to use your speedlight, it's essential that you first understand how it operates, as well as its limitations. A speedlight provides a high-intensity flash of light which is triggered by the camera's shutter release, usually through the hotshoe connection on top of the camera. A camera's hotshoe does not just tell the flash to fire—it also carries a host of information to the flash unit and back to help the camera sync with the flash and meter accurately. You can also fire most modern speedlights using a radio or infrared signal, with a transmitter or another speedlight. This is useful if you want to position your speedlights at a distance and use them when not mounted on the camera itself.

The duration of the flash—the time it takes for the speedlight to supply its burst of light—varies from unit to unit, but is generally around 1/400 sec. at full power and 1/20,000 sec. at minimum power. For the speedlight to work properly it has

to synchronize its flash with the moment that the shutter of the camera is completely open, so the sync speed needs to be slower than the duration of the flash. All cameras, using a focal plane shutter, have a maximum sync speed and in normal operation you are restricted to using a shutter speed that is no faster than that maximum if you want your flash to fire with full effective power. For most modern DSLRs that speed is around 1/200 sec. (see page 32). Your camera may be able to operate at a slightly faster or slower sync speed than that, so check the manual or search for the information online.

Once you know that sync speed you can use any shutter speed that is slower than that maximum, but not faster. Many cameras will not allow you to change the shutter speed for anything faster once the flash unit is fitted. There are actually techniques that will allow you to shoot correctly exposed images at faster shutter speeds using high-speed sync (HSS) (see page 148).

If you do shoot with flash at a shutter speed faster than the maximum you will notice a black bar across the top of the image. Your camera's shutter works with a first and second curtain, also known as the front and rear curtain. When you press the shutter, the first curtain opens to expose the sensor and then the second curtain comes down to cover it up. They both then return to the starting point. The flash is triggered at the moment the curtain is fully open. This exposing of the sensor works like this up to the flash sync speed of the camera. At faster speeds, the second curtain begins to close the shutter before the first has fully opened, so it scans down the sensor, capturing an image of the second curtain closing—which is the horizontal black bar.

On-Camera Lighting

Although many photographers are rather scathing about the use of a flash gun mounted directly on top of your camera, master photographers such as Martin Parr have turned this facility into a style that has defined a genre of photography. No one can deny that his images would simply not have as much impact without that "on-camera flash" look.

Shooting largely outdoors, Parr uses the flash gun in its most basic form, mainly on Program mode with through-the-lens (TTL) exposure metering. His success comes not just from his choice of subject but also from the way in which he combines direct sunlight with direct flash. It is a characteristic of light on a subject that additional light will always fill in shadow areas to a greater extent than it adds light to ready-lit areas. So, if a naturally lit subject has some shadow areas, they will be filled in when an additional flash is added to the scene.

This technique is known as "fill-in flash". When the flash is used in this way it results in a strangely "produced" or artificial look. Our eyes can tell that

Above: The trick with fill-in flash is to balance the ambient light with the flash—TTL does a pretty good job normally but try to set it manually as I did here.

Focal length: 28mm

Aperture: f/10

Shutter speed: 1/500 sec.

ISO: 100

the scene is not quite "correct", and so this results in the image appearing surreal, with an oddly beautiful quality.

Dealing With Red-Eye

A common issue with on-camera flash is a spooky red reflection which appears in the eyes of the subject. This is caused when the pupils of the eyes dilate to allow more light to the retina while coping with the lack of light in a dark environment.

The flash goes off and records the reflection of the light from the back of the retina, or, more accurately, the blood-rich choroid connective tissue situated behind the retina at the back of the eye. To prevent red-eye, you can turn the lights on in the room, ensure that the subject is not looking directly at the camera, or in many cases use the "red-eye reduction" function of the flash. This fires a short "pre-flash" before the main flash goes off, thus reducing the size of the pupil for the main image.

You can also remove this effect in Adobe Photoshop with a dedicated tool.

Above: The effects of red-eye can be unsettling, but they can be easily fixed in-camera or during postproduction.

TTL

Left: Here, the camera and flash were both in Program mode, with the flash firing on TTL.

Focal length: 50mm

Aperture: f/13

Shutter speed: 1/200 sec.

ISO: 800

Through-the-lens (TTL) exposure metering, also known as evaluative through-the-lens (or ETTL) metering, is available on most modern speedlights. It is a way for the speedlight to adjust its flash output according to the settings on your camera and the distance to the subject. Once in TTL mode, the speedlight will send out a fast "pre-flash" at the moment the shutter is pressed. This pre-flash bounces off the subject and sends a message back to the unit, telling it exactly how much light is required to achieve the perfect exposure for your settings. All this happens in milliseconds before the main flash fires.

In this way you never get a wrongly exposed image. Of course, life is never quite that simple so you can apply a plus or minus exposure value to the TTL reading if you wish to adjust the amount of flash, increasing or decreasing the effect of the ambient light, and making the image look softer or harder lit. The more ambient light you use, the softer and more natural the image will look. The more flash you use, the darker the room and so the more "flash-lit" the image will look.

Tip

It's worth testing the TTL function with a static subject before you use it on assignment so you can get a feel for the effect of mixing ambient light with flash, and adjusting each to suit your style and the circumstances.

Speedlight Techniques

Full-On Flash

Speedlights were originally designed to be used on top of a camera, fixed to the hotshoe. Many photographers disagree with using a flash gun in this way and, indeed, it can be a very blunt instrument. However, for family events such as parties and weddings, direct flash from a camera-mounted speedlight offers a simple way to achieve images with well-balanced light that is seldom bettered.

This is the speedlight at its most basic and it ensures that every event can be recorded, properly lit, and with maximum sharpness. The basic flash gun points straight onto the subject with no modification. You can set your flash in Manual mode and control the amount of output by simply turning the dial up or down, but many photographers now use TTL metering to ensure they get perfect shots every time.

POTENTIAL PROBLEMS

Unwanted reflections: in addition to red-eye, direct frontal flash can cause harsh reflections and unwanted specular highlights. It is difficult to deal with these, as they can be the result of your subject having greasy skin or sweating, so ask them to wipe their face dry or use cover make-up powder if it's available.

Above right: Full-on flash.

Right: Reflections on a subject's forehead can be a serious issue.

Bounce Flash

Most people agree that direct flash has some limitations when it comes to creativity. It has a place in your toolkit, but it can look brutal and even a touch amateurish. Most speedlights are better used when they are bounced off a ceiling or a wall.

This technique effectively makes the large white surface the light source rather than the speedlight itself. It provides a softer, more pleasing light which is much more usable. Simply flip up the speedlight head and point it toward the ceiling or wall. You can also use the speedlight's focus function to project the light to control its location. Finally, many speedlights come with a pull-out white plastic sleeve in the lens. You can use this when bouncing the light on the ceiling directly above you to provide a desirable highlight or "catch light" in the subject's eye.

Above: Bounce flash.

POTENTIAL PROBLEMS

- **Loss of power:** with bounce flash you are doubling the distance the light travels to the subject and dispersing it over a large surface, so you will lose a lot of power. Either increase the power or use TTL metering to ensure an accurate exposure.

- **Uneven lighting from top light:** when lighting your subject from above, you may find that they are too heavily over-lit, especially if they are wearing a hat or have a lot of hair. You can often overcome this by adjusting the angle of your bounce. Alternatively, use a reflector below or to the side of the subject to bounce light back into the darker areas.

Right: Be careful not to overdo the bounce flash effect as it can produce a very heavy exposure, which can darken eye sockets—not a good look.

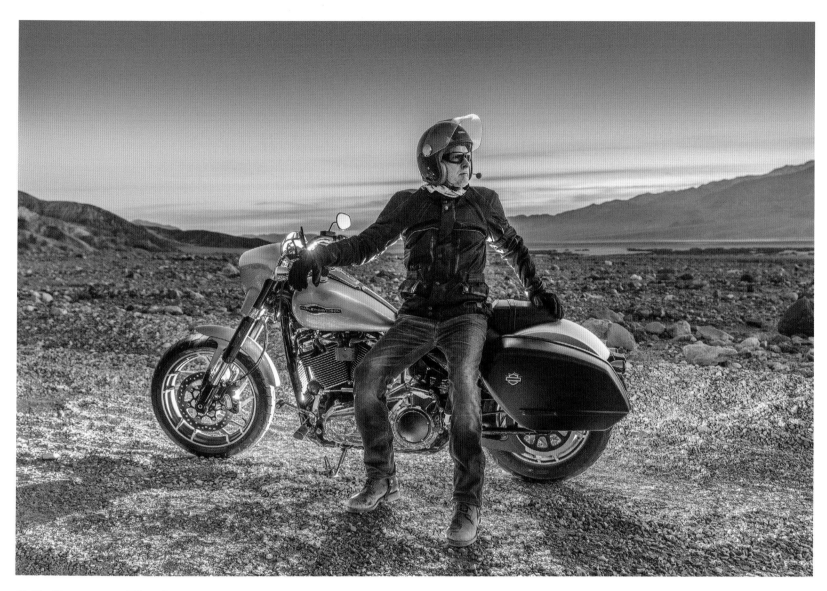

Off-Camera Flash

The moment you take the flash gun off the hotshoe you start to open up a whole raft of possibilities. Most speedlight manufacturers make some form of transmitter which you fit on the hotshoe. This transmits a signal from the camera to the flash so you can place the flash wherever you want, giving you more creative options for shaping and angling the light.

POTENTIAL PROBLEMS

Inconsistent lighting: if you are handholding the speedlight, then it can move and create different effects with every shot, so try to be consistent from one shot to the next. It might be useful to mount the external flash on a tripod or place it on a table or other stable surface so that it does not move.

Above: Once you detach the speedlight from your camera, the creative possibilities are endless. Here, I positioned the flash behind the motorcycle to create a dramatic "sunset"-type light, and fired it using a wireless trigger mounted on the hotshoe.

Focal length: 35mm

Aperture: f/3.5

Shutter speed: 1/15 sec.

ISO: 800

Multiple Off-Camera Flash

You can use a transmitter mounted on your hotshoe to control as many different lights as you need. In its most basic form, the transmitter simply fires the flash guns, which are each manually set. However, you can buy remote transmitters which control and adjust large numbers of external units to shoot either with TTL or manual metering, depending on exactly what you want to do. You can set your flash units wherever you want and there are a number of miniature softboxes and light shapers which are designed to fit speedlights to give you even more options.

POTENTIAL PROBLEMS

- **Too many lights:** lighting in this way is cheap and easy, so it can result in the overuse of lighting when it is not required. Be certain any additional lights really add to the scene.

- **Flare:** speedlights do not have any form of modeling or continuous light built in, so it is easy to set up a back light on the subject only to find that it is creating awful flare in-camera. Always test your lighting before committing to the final shot and move the lighting set-up around to eliminate flare.

Tip

In 2007, *Baltimore Sun* photojournalist David Hobby began a blog called Strobist (strobist. blogspot.com). It educated mainly serious amateurs in the art of using multiple flash guns off-camera to create some incredible shots. The blog quickly became one of the most popular photo blogs in the world with over 300,000 subscribers in 175 different countries, and it's a great place to look for advice on off-camera flash.

Left: This was shot using three speedlights positioned off-camera and triggered by a simple on-camera transmitter.

Focal length: 24mm

Aperture: f/8

Shutter speed: 1/30 sec.

ISO: 800

Ring Flash

Above: Ring flash is often used in fashion shoots to give the portraits a blunt frontal light and "caught in the moment" feel.

Focal length: 24mm

Aperture: f/11

Shutter speed: 1/60 sec.

ISO: 100

Above: When handled correctly, a ring flash unit can create the perfect beauty light with specular reflections and the distinctive central highlight in the eye.

Focal length: 105mm

Aperture: f/11

Shutter speed: 1/60 sec.

ISO: 500

A ring flash is another type of on-camera flash which consists of a circular ring of light positioned around the camera lens, and it can result in some rather wonderful results. Like many pieces of creative photographic equipment, ring flash was originally developed for scientists and medical researchers who needed a method of lighting close-up areas to show detail without any apparent shadows. They have since been quickly adopted by nature photographers to create beautiful close-up and macro images of plant and insect life.

Ring flashes are usually attached to the camera with a screw mount on the lens. They are then connected to the camera body using a cable or the hotshoe. Ring flashes are not normally very powerful as they are designed to be positioned very close to the subject. You can also buy several different types of units, some of which can be powered by large studio power packs for extra punch, so it's well worth researching which ones will suit your purposes.

The ring flash effect creates a stylish look all of its own and it's popular with fashion and advertising photographers, the blunt frontal effect giving the images a "caught in the moment" look and real atmosphere. When a ring flash is used for close-up portraits and beauty shots it can create a ring of light around the iris which provides immediate impact. It will also give skin texture but without unsightly dark shadows. Ring flash also works well for full-length portraits, its low power and directional characteristics creating a natural vignette around the subject area.

Chapter 5

Studio

For most people, it is using a studio that separates the true professional photographer, or at least the very serious amateur, from other photographers. The studio is the blank canvas where anyone with a camera and lighting equipment can create a masterpiece, provided, of course, they have the knowledge and experience to use them. It is the place where all your creative dreams can be realized and where anything is possible.

This chapter will guide you through the essentials of setting up a studio to suit your specific photographic needs. Later chapters will explain the key lighting techniques that will help you get the best out of your studio and studio lights.

Right: Large, seamless background rolls are available from most photographic retailers. Used in the studio, they can be a great way to add a blast of color to your shots.
Focal length: 70mm
Aperture: f/11
Shutter speed: 1/160 sec.
ISO: 50

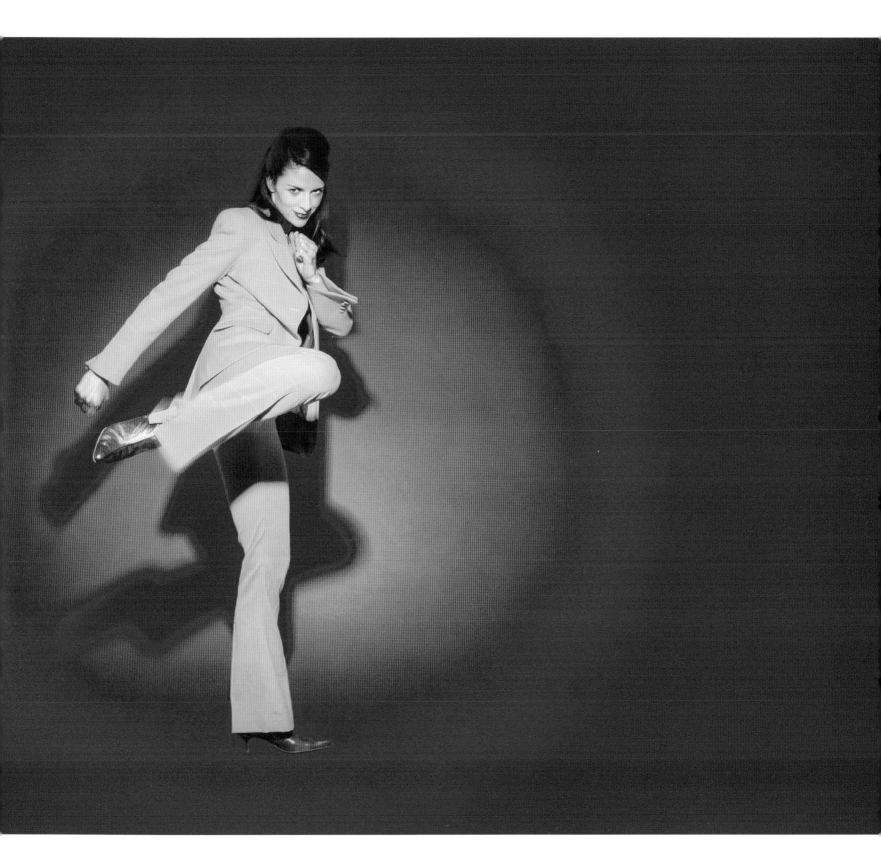

Types Of Studio

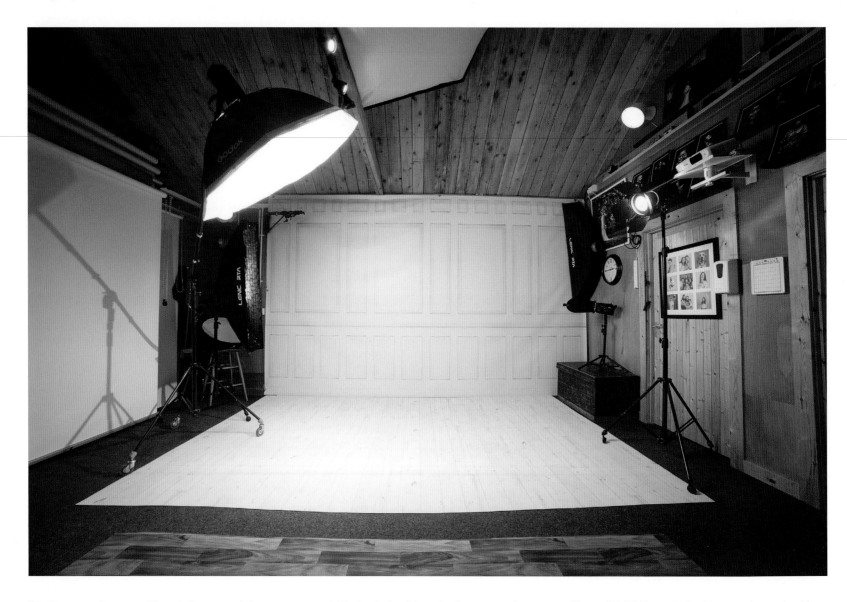

Studios come in many different shapes and sizes. Essentially, a studio is a space given over to the photographer for creating images using a camera and lighting. For most of us, space and budget are at a premium, so the first problem is finding a suitable area in which to work. It is perfectly acceptable to start out by adapting a room in your home as a temporary studio, as long as it is easy to clear and has good accessibility. That's how most of us started, and it's a good way to cut your teeth in an area of photography that many "newbies" find rather daunting.

Above: Establishing a studio of your own is an enjoyable thing to do and it's important to make the space your own.

Home Studio

 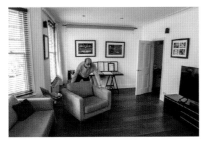

 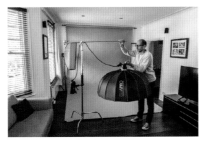 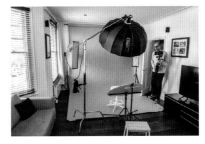 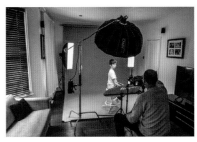

Above: It is fairly simple to convert your home into a temporary studio with a little bit of planning.

Creating a home studio does not need to be a daunting task—using lightweight, portable equipment, it can be easy to construct and just as easy to pack away. When deciding which room to use, think about how convenient it is to darken the chosen room sufficiently as you do not want stray window or door light ruining your carefully controlled lighting. It's not necessary to make your studio completely light-tight, but if you are using flash the less stray light that's intruding in the room the better.

It's surprising how quickly your studio can become cluttered with backdrops, lighting, props, and accessories, so always try to clear as much space as you possibly can. Safety always has to be at the very top of your list of priorities, especially if you are planning to photograph people, so keep the space tidy and be prepared to brief anyone who enters the studio about trip hazards and the dangers of electronic equipment.

Unsupervised children and pets do not mix well with a studio environment, so try to ensure you choose a space that can be private and does not interrupt daily living. You will want to avoid the chance of someone or something knocking over a studio light as it can be dangerous, and also very expensive, so take precautions.

Consider using a spare bedroom, converting a loft space, or using your kitchen, which is often a room that is already relatively clear. A garage or garden building are also favorite choices for a first studio. A domestic car garage is an ideal first studio but always remember that you need a dry space with a decent amount of headroom for overhead lighting. The advantage of using these types of space is that you may not need to dismantle everything at the end of the day.

There are several companies that offer very reasonably priced, ready-made or self-assembly garden buildings, and these can make wonderful studios. In most countries you don't need planning permission for a temporary wooden building but always check your local authority regulations before beginning a build project.

The height of a studio can be critical. All commercial studios will be at least 11ft (3m) high and most of them are higher than that. Imagine a 6ft (2m) person standing in an average 9ft- (3m-) high room. There is only 3ft (1m) of clear space above their head, so there is not much room to light them from above with a medium-sized softbox attached to a boom arm.

The next thing to consider is power. For most flash systems, regular household power sources will be enough, but if you are planning to use continuous lights or powerful, fast-recycling flash units then you might want to look into setting up a three-phase power supply to avoid continuously shorting out your household circuits.

Dedicated Studio Space

As you shoot more you may wish to build or rent a full-time studio. This is obviously essential if you are a full-time professional studio photographer. Looking for the right space requires some searching and there are a few must-haves that should be at the top of your list.

Flooring should be solid, not carpeted, so tiles, wood, or concrete is ideal. As previously mentioned, the height of the space is very important, with 11ft (3m) being the reasonable minimum. Good access is also essential, as people and products need to be brought in and out on a regular basis.

The next issue you need to address is the color of your studio. All surfaces—from glass to metal or skin—are reflective, some more than others. Obviously, if you work in a home studio environment then you have to make do, but if you do get the chance to choose your studio decor, think about color. If you paint the studio a beautiful, fashionable blue then all your images will reflect that hue. Of course, this can be dealt with using color correction, but it's hardly ideal.

There are three choices when painting a studio—black, white, or neutral gray—although it is also perfectly acceptable to have a warm, neutral-toned space, especially if you are mainly shooting portraits. White and gray are the most common colors. As a purist still-life photographer, in my early days, shooting largely jewelry, I once painted my studio completely black. It achieved the objective of giving me rich, controllable shadow areas, with no stray reflections and complete control over all my lighting. However, as I moved on to shoot more people and larger room sets, it did become a little difficult to work with. Having no stray light can make filling in shadow areas tough and you lose between one to two stops of general light power by painting your walls black.

If you are planning to shoot mainly still-life then most specialists would recommend painting your ceiling black as it will give you more precise control. A white ceiling, however, provides more options if you are planning to shoot a wider range of subjects. You can use your white ceiling as a huge reflective fill light by bouncing lights off it and down onto the subject.

This can be incredibly useful if you want to simply clean through the darker shadow areas in a larger set but don't have the budget or the space for a huge, soft "swimming pool" light.

There is no limit to the size of your own personal studio facility but most of us will start off small and then grow over time. A large studio is an expensive luxury, so be sure that your business can handle the studio as it grows, and don't overstretch yourself. As your business expands so will your

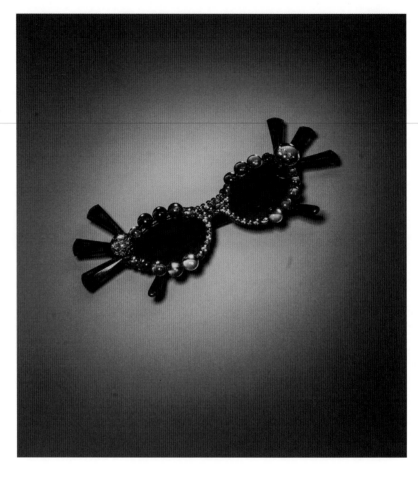

Left: When working with tricky reflective surfaces, a black ceiling will help you to control your lighting more precisely.

Focal length: 150mm

Aperture: f/16

Shutter speed: 1/60 sec.

ISO: 50

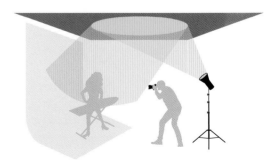

Above & right: When you need to fill in a large area with light you can use a white ceiling to act as a large, soft overhead light.

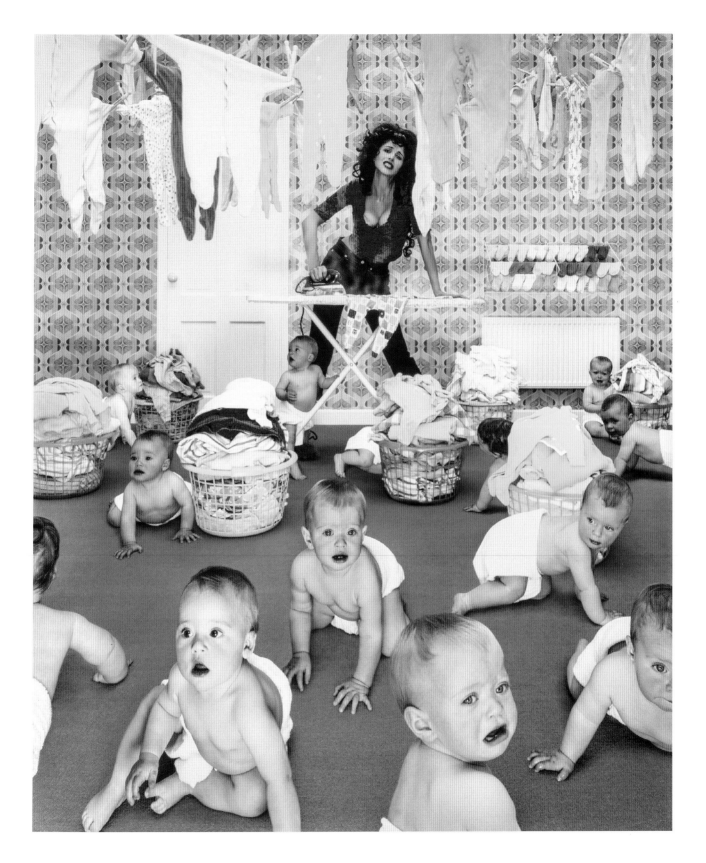

need for more space but for larger studios of 1000 square feet (300m²) or more, remember to consider access for bringing large props, or even vehicles, into the studio. Also, think about the energy usage and other monthly bills.

Ultimately, an empty studio is a very stressful investment, so be sure you can fill the space at least most of the time. If you hit a lean period then consider renting out the studio space to others, either with a permanent desk space or just on a day-by-day basis. If you either hire studios yourself or rent out your studio to others, it pays to think

long and hard about how studios for hire work, and to seek advice from other professional photographers with experience.

Above: This image was created in a small studio in two separate parts, enabling me to move the lighting in closer for a "cleaner" effect. Both were shot against a red seamless paper roll and then combined in Adobe Photoshop.

Focal length: 24mm

Aperture: f/11

Shutter speed: 1/160 sec.

ISO: 50

How Big A Studio Do You Need?

Virtually every photographer I know, professional or amateur, would agree on two things: if they didn't have a studio already, then they would love to have one; and if they did have a studio then they would love to have a bigger one. Having owned and rented studios large and small over the years, I feel very qualified to address this issue.

It goes without saying that larger studios offer more options and greater possibilities. In a perfect world, all of us would own a huge, drive-in warehouse and use it for all our needs. However, the physical size of a studio space is not always the most important factor, and indeed it can become a problem. Firstly, large buildings are expensive. They require lots of maintenance and heating and lighting them is always costly. Secondly, the bigger the space you have the more kit you need to fill it, so once again that's more expense. All this stress and financial pressure is a guaranteed creativity killer, so if you want to own a large studio then you better have deep pockets.

There are situations where you need a lot of space. If you are shooting room-sets, cars or other vehicles, or you have several photographers working continuously on commercial catalog or fashion brands then of course you need to have space to work in. But for the most part you can shoot just about any personal or commercial job in a studio no larger than 1000 square feet (93m²). I know this because I've done it and most shoots don't need any more than half that. Like so many things in life you learn to work with the facilities you have available to you. I found that, as a very busy commercial photographer in central London shooting people, still life, and even reasonable-sized room-sets, 1000 square feet was more than enough. On the occasions that I needed more space, I hired a studio but that was not that often.

It's also worth saying that, back in the days of film, a photographer's options were considerably reduced in terms of space. Basically, you had to

Left: Sometimes you simply need a large studio space. For this image we built a garden lawn set and needed enough space to set up the main light some distance away to give the impression of natural sunshine.

Focal length: 80mm

Aperture: f/16

Shutter speed: 1/160 sec.

ISO: 50

do a lot more in-camera, so your decision-making process was different. Nowadays, if you are clever about it, you can shoot most larger shots in several parts and then combine them very easily in postproduction. The added bonus to this technique is that you are able to light things closer in and in a more detailed fashion—more precise lighting, more control, less expense, and a much better final result.

Think carefully before you build, buy, or rent a massive studio space… it may be a costly mistake.

Studio Hire

Realistically, at some point you are probably going to want more space. The bigger the space, the more options you have, so don't be afraid to think big. If you outgrow your own studio space or you want to try something a little larger, then there is a huge range of studio hire options available, from small pack shot studios to massive car studios.

Research your local studios and go and see them. It's a great way to get ideas about your own set-up and, if you need some more space, then they are always there and their owners will be happy to help out. Don't be afraid to ask what deals are available, as most studios are not busy every day and so card rates will vary if you negotiate. Most studios will have a special rate for testing that is considerably lower than their card rate. It's a good idea to develop good relations with your local studios, in case you need to expand your experience or shoot for larger clients at short notice.

It's wise to get to know how studio hire normally works so that you don't incur any unexpected expenses. All studios are different but most will include power and access to suitable sockets within your hire fee, but always check what's included. Often, the hire will include a camera stand or tripod, and even lighting. If there is a white infinity cove in the studio (a white painted curved wall that runs seamlessly into the floor) then expect to be charged to repaint it after your hire.

Most hire studios will have an affiliated equipment supplier or have their own equipment list so you can normally hire any extra kit needed, including lighting, reflectors, tables, chairs, and just about everything else you need, so it can be a good way to try out new kit before you commit to buying it. Studios can also offer client rooms,

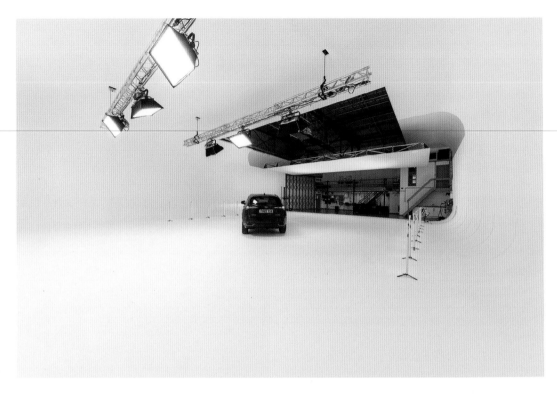

make-up facilities, and on-site catering—the sky's the limit.

Set-up and knock-down days before and after the shoot will normally be charged at a lower rate, and there will always be strict clock-in and clock-out times with heavy overtime rates, so be careful with your timing.

In the end, it is up to you to get the best deal you can, so try to allow for anything that you feel might occur, such as early starts or late finishes, and build it into your initial costs. Hire studios are a business, so expect a business-like attitude toward your hire period. Treat them with respect and ensure that your team does the same. A good hire studio relationship is a very valuable asset.

Above: Studios available for hire come in many shapes and sizes. This is the enormous Malcolm Ryan Studio, based in South London, UK.

Essential Studio Equipment

So, you've set up your studio, made it light-tight, and painted it the ideal color. What else do you need to get going? There are many other products you can buy for every specialist application in a studio environment, but I've set out some of the basics you may need on the following pages. Like so many things in photography, every one of us is different and we will have different needs and requirements, so it's up to you to assemble your own kit as you develop your own style and ways of working.

Assuming you have a DSLR or mirrorless camera, you will need the right lenses. Wideangle lenses can be useful for studio photography, but most photographers tend to use standard or longer lenses the most. If you have lens options between 50mm and 150mm, you will cover most requirements for both people and still-life images.

For still-life photography, make sure you have a macro setting on your lens as you will probably need to get in close. If not, then buy a set of extension tubes which provide a cheap way of shooting close-ups. You can also consider buying a bellows attachment or tilt-shift lens if you want to get serious about product photography. These will both enable you to control the perspective in your images—such as making your bottle shots perfectly vertical, for instance—even if you are looking down on the subject.

Tethering

Shooting in a studio is often a more considered, less frantic process than shooting on location, so it's a good idea to think about tethered shooting. This is the process of transmitting your images directly to a hard drive rather than exclusively to your camera's memory card. This enables you to view your images on a large screen, live, as you are shooting, and store them on hard drive at the same time.

Your client will also love being able to see what is happening in real time. To do this you will need a good laptop or dedicated desktop machine and, of course, a cable or wireless connection from the camera to the computer. Provided you have suitable software, such as Adobe Lightroom or Phase One Capture One, you can shoot your images and transfer them directly to your hard drive. You can even set up the software to apply a particular color profile to each image so you can see the end result as you shoot.

I don't consider wireless connections to be quick enough, currently, for viewing high-resolution files as you shoot, so I still prefer to use the cable option. Tether Tools make some superb cables at different lengths. However, be aware of the trip hazards of using cables when you're working in a studio. Safety breakers are available which will disconnect if pulled by someone tripping over them, to avoid the cable pulling the laptop onto the studio floor. Tethering and lighting cables should always be run safely from the head of the light to the floor and then taped down with gaffer tape to avoid accidents.

Above: Tethering is a useful technique when working in a studio.

Transmitters

Above: Infrared (IR) and radio transmitters make cable connections for flash a thing of the past.

If you're using studio flash, you will of course need some method for firing the lights in sync to your shutter. Cables can be used for this and I recommend that you have a couple of spare cables in case of emergencies. Most of us shoot with transmitters now, though, and there is a large range available. I always think you should have at least two of those as well, as they can go wrong, and there is nothing more embarrassing than not being able to shoot because of equipment failure on the day—especially if your client is present.

Make sure that the transmitter you have is compatible with both the lights and the camera, as many are brand-specific (see page 32). They can be infrared (IR) or radio-operated, but radio is definitely better. Radio signals do not require a line of sight to connect and they transmit much farther than IR. Read the specs of these units before hiring or buying them, as they can offer different levels of control.

Most transmitters will also offer different radio frequencies, which is useful if you are working in a hire studio alongside other photographers—you can make sure you have your own frequency so you are not tripping off another photographer's lights by mistake.

In addition to being able to fire your lights, many transmitters can also communicate with them. This is one of the most useful functions of a transmitter as it means you can control your lights without having to touch them. Once set up you can control each light, individually adjusting the power output as well as many other features, including modeling lights and flash duration, all without moving away from your camera. It is simple enough but it pays to spend a little time learning the features of your transmitter in relation to your brand of lights. Some now even offer TTL options (see page 64).

Flash Meters

You can use your camera's metering for continuous lighting but it cannot help with external flash. Instead, you may wish to use a flash meter. You will need to set the meter to the camera's flash sync shutter speed (see page 148) and it will help you to set the correct aperture. All focal plane shutter cameras are able to sync with flash at shutter speeds up to a maximum of about 1/200 sec., so you will need to set the camera to Manual mode and choose a shutter speed normally up to the camera's maximum sync speed.

Most studios will have no windows or limited natural light, so working at a high aperture, and at a recommended ISO 100, the ambient light in the room will not be enough to affect the exposure, provided you shoot at shutter speeds close to the maximum.

To use the flash meter, set it to your shutter speed and ISO, ask your subject to hold it, around the relevant focal area of the face, for instance, with the white dome facing the camera, and then press the flash button. Flash off the lights and the meter will give you the required aperture, which you then set on the camera. You will notice that if you adjust the shutter speed setting on the meter, even from 1/200 sec. to 1/30 sec., for example, it will not affect the exposure reading. The shutter speed setting on the meter is pretty arbitrary as long as there is very little ambient light in the studio. The flash is so much brighter than the

ambient light that the shutter speed doesn't have any effect. The only reason the camera's shutter speed is important is because it has to sync with the flash, providing an open window of shutter time during which the flash is fired. It has little or no bearing on the exposure.

You can shoot perfectly well without the use of a flash meter—you simply set up your lighting and shoot a test image. Take a look at the effect on the camera display and then adjust the lights as necessary. Repeat this process until you achieve the desired result. After a while, you will get used to the settings you need for any given lighting set-up in your studio.

Tripods

Above: A good tripod or even a heavyweight column stand is the workhorse of every photo studio.

Every studio photographer needs a good solid tripod which can be finely adjusted, so don't cut corners here. Companies such as Manfrotto, Gitzo, and Benbo make a huge range of tripods and tripod heads, so choose carefully. If you get very serious then you might want to consider a column stand. They are expensive but offer absolute precision, especially if you are working with large or medium-format cameras. Don't forget that you may need to get directly above a subject to shoot down onto it, so choose a tripod that can extend to a reasonable height and allow you to mount the camera in a vertical, downward position. Some larger studios have gantries for this purpose, or

even provide trap-door access to the main studio area from the floor above.

Surfaces & Backdrops

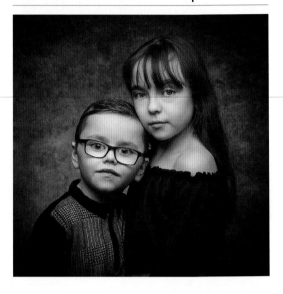

Above: Large painted canvases are available from most professional photographic equipment stores. They make a great backdrop for portraits.

Focal length: 55mm

Aperture: f/8

Shutter speed: 1/1200 sec.

ISO: 100

A good strong, flat, modular table top is essential for still-life photography—a surface of around 3x6ft (1x2m) is a good all-round starter. You will need a small and a large roll of seamless, white background paper and the stands to hold it up. Products by brands such as Colorama come in a range of colors and widths. I recommend a roll 4.5ft (1.35m) wide and another roll 9ft (2.75m) wide—you will need both. You can add rolls of different colors if you need to, including in a neutral gray, which will also be useful.

Portrait photographers might also want to consider obtaining some painted background canvases. You can buy these off-the-shelf from most equipment dealers, or arrange for a local

Above: No studio is complete without a range of silver and white bounce reflectors.

artist to paint one for you. Don't forget to get a small side table on wheels to use for your tethered laptop and other bits of kit. I use an old medical trolley, which I picked up in a junk shop, as it's made of solid metal, has useful shelves, and is on wheels.

I also recommend a roll of translucent material, such as Colorama Translum, which is useful for diffusing a light source. It can be stretched over a frame or simply draped in front of a light to create a versatile, soft light source. You can also use a large piece of tracing paper. Rolls are available in both large and small sizes.

Reflectors are essential in pretty much every studio photo shoot and there is a vast range available. You can buy reflectors from Lastolite or many other manufacturers, but don't forget you can also make your own. For still-life photography, a pack of regular 6in- (15cm-) square mirror tiles (the type used in bathrooms) are really useful, and you can make up small and large reflector cards from mirror board—matt mirror board is available from most art suppliers. These can be supported with old bottles and anything heavy, but for extra control invest in a set of laboratory stands used for supporting test tubes for experiments. They also make precise finger clamps that attach to the stands. These are ideal for holding small mirrors and reflectors on a table top.

For photographing people, you will need something larger. You can buy a huge range

of fold-out reflectors with white, silver, gold, and many other finishes but I recommend sticking to white or sliver.

A good tip is to buy 8x4ft (2.4x1.2m) white polystyrene insulation boards from your local hardware store. They are a cheap way to obtain large, lightweight reflectors—you can even buy or make floor stands to hold them upright. You will often find these in hire studios and they should be replaced when they get old and ragged, or you can repaint them white for a new lease of life. It's also a good idea to wrap a strip of white gaffer tape around the edges to protect them and give them a slightly longer life.

Stands, Booms, & Clips

Above: A boom arm can be useful for positioning lights above your subject.

You will need stands for your lights and specialist boom arms for positioning lighting overhead. I recommend buying a selection of solid heavyweight stands for most uses and also a number of cheap extra stands, so you always have something to hang equipment from. Boom arms can come in various types, from something simple for clamping lights on to sophisticated, controlled arms with winders, which enable you to twist and position your lights in position. The stands should be strong and heavy enough to hold a boom arm

with a light on one end and counterbalance weights on the other. Stands normally have wheels so they can be moved easily.

A wide selection of clamps and clips, in different sizes and types, is also essential. You can use these for everything from holding paper rolls in place to clipping back unwanted fabric on ill-fitting clothing. Specialist "superclamps" are also useful— they have convenient, built-in spigots especially for attaching lights.

Finally, a decent toolkit, including a watchmaker's screwdriver set and a selection of knives and scalpels, will be useful. It seems that there is always something that needs repairing in a photography studio, so try to become adept and fix your own equipment whenever you can.

Above: A range of clamps is useful in any studio.

Above: The ubiquitous roll of black gaffer or duct tape is always essential as there is almost nothing that cannot be stuck down, strapped back, or temporarily repaired with a piece of this miracle tape.

Recommended Studio Set-Ups

Here are my recommended studio set-up lists for three different levels of budget and photographic applications, suitable for shooting both people and still-life subjects.

BUDGET

- 1x professional standard DSLR or mirrorless camera body
- 1x 50mm f/1.8 standard lens
- 1x 70–200mm f/4 lens
- 1x medium-weight tripod
- 1x 3x5ft (1x1.5m) product table
- 1x small medical trolley
- 2x 400W second monobloc flash head (mains-powered)
- 1x transceiver unit
- 1x back-up flash cable
- 2x standard light shaper
- 2x 3ft- (1m-) square softbox/2x 3ft (1m) shoot-through umbrella
- 2x standard lighting stands
- 1x background roll support unit (crossbar and two stands or wall supports)
- 1x 9ft- (3m-) wide white background seamless paper roll
- 4x 8x4ft (1.2x2.5m) white polystyrene insulation boards
- 1x collapsible white/silver 30in (75cm) reflector
- 1x 128GB memory card (format depends on camera)
- 2x 16GB memory cards (formats depend on camera)
- 2x spare batteries
- 4x mains extension cables
- Selection of clips and clamps
- Gaffer or duct tape
- Model release forms

MID-RANGE

- 2x professional standard DSLR or mirrorless camera body
- 1x 24–70mm f/2.8 lens
- 1x 70–200mm f/2.8 lens
- 1x heavyweight tripod
- 1x laptop computer with tethering cable
- 1x 3x5ft (1x1.5m) product table
- 1x small medical trolley
- 3x 600W second monobloc flash head (mains-powered)
- 1x flash meter
- 1x transceiver unit
- 1x back-up flash cable
- 3x standard light shaper
- 2x 3ft- (1m-) square softbox/2x 3ft (1m) shoot-through umbrella
- 3x standard lighting stands
- 1x lightweight boom arm with stand
- 4x sandbag weights
- 1x background roll support unit (crossbar and two stands or wall supports)
- 1x 9ft- (3m-) wide white background seamless paper roll
- 4x 8x4ft (1.2x2.5m) white polystyrene insulation boards
- 1x collapsible white/silver 30in (75cm) reflector
- 1x wrap-around clam reflector
- 1x 128GB memory card (format depends on camera)
- 4x 16GB memory cards (formats depend on camera)
- 2x spare batteries
- 4x mains extension cables
- Selection of clips and clamps
- Gaffer or duct tape
- Model release forms

ADVANCED

2x professional standard DSLR or mirrorless camera body

1x 24–70mm f/2.8 lens

1x 70–200mm f/2.8 lens

1x 85mm f/1.8 lens

1x 50mm tilt-shift lens

1x bellows extension kit

1x heavyweight tripod

1x heavyweight column stand

1x laptop computer with tethering cable

1x 3x5ft (1x1.5m) product table

1x small medical trolley

2x 1500W second power flash pack (mains-powered)

2x 3000W second power flash pack (mains-powered)

1x 3000W second flash head

4x 1500W second flash heads

1x ring flash unit

1x flash meter

1x transceiver unit

1x back-up flash cable

3x standard light shaper

2x 3ft- (1m-) square softbox/2x 3ft (1m) shoot-through umbrella

1x 6ft (1.75m) Octabox

1x beauty dish

3x standard lighting stands

1x adjustable large boom arm with stand

4x sandbag weights

1x background role support unit (crossbar and two stands or wall supports)

1x 9ft- (3m-) wide white background seamless paper roll

1x 5ft- (1.5m-) wide white background seamless paper roll

1x 9ft- (3m-) wide mid-gray background seamless paper roll

1x 9ft- (3m-) wide black background seamless paper roll

1x 6x8ft (2x2.5m) roll of black velvet

4x 8x4ft (2.5x1.2m) white polystyrene insulation boards

1x collapsible white/silver 30in (75cm) reflector

1x wrap-around clam reflector

1x 128GB memory card (format depends on camera)

4x 16GB memory cards (formats depend on camera)

2x spare batteries

4x mains extension cables

Selection of clips and clamps

Gaffer or duct tape

Model release forms

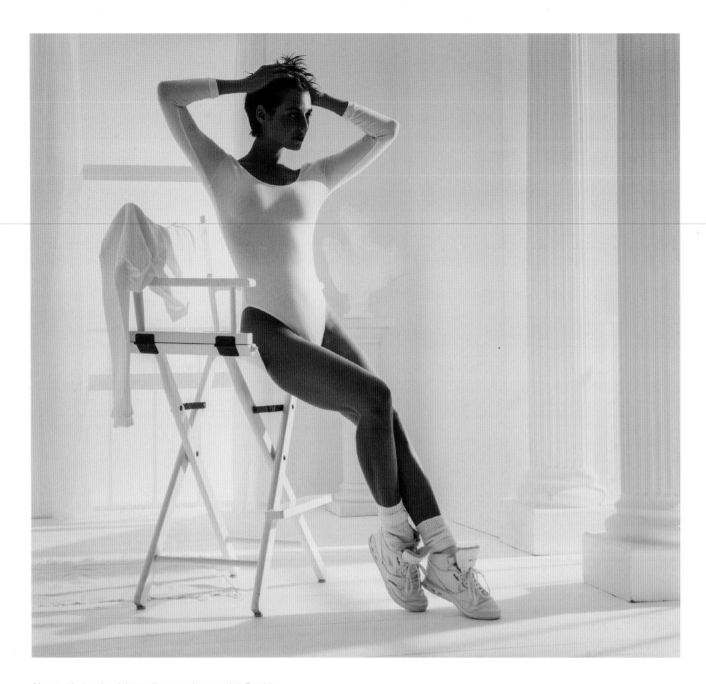

Above: Having the right studio space is essential. For this sportswear client I built a very large white set and was then able to shoot for two weeks using different angles on the same set.

Focal length: 80mm

Aperture: f/8

Shutter speed: 1/160 sec.

ISO: 50

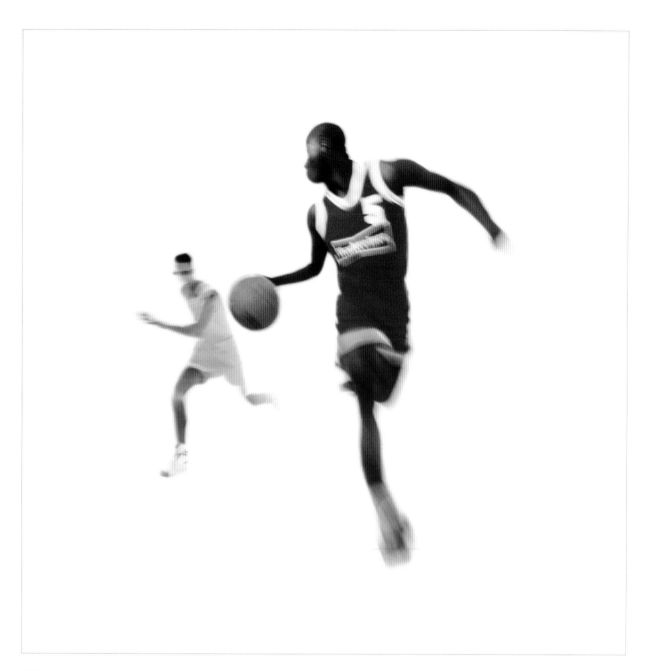

Above: Large white cove studios are not only for car shoots. Here, I used powerful continuous light sources in a white cove and shot at a slow shutter speed. In this way I was able to express the power and movement of the athletes with the subtle reference to the client's branding.

Focal length: 35mm

Aperture: f/11

Shutter speed: 1/30 sec.

ISO: 50

Chapter 6
Portraits

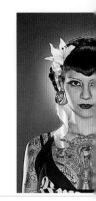

There are few photographic subjects that are better covered, both now and throughout the history of photography, than people. There are many different lighting techniques used to capture people and there are several well-researched approaches that can provide the basis for a well-lit portrait. It is these techniques that I will cover in this chapter.

However, there are no rules to great photography, so make this guide your starting point and feel free to add your own unique touches and forge your own path, and your own style. Take the time to try out your lighting techniques and find the styles that work for you.

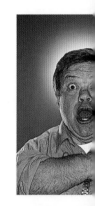

Right: The world is full of people and they are all different. The beauty of a portrait is that it captures the essence of a person, and the lighting is an essential ingredient in that process. These portraits were part of a commission for the famous Ugly Models agency to show the diversity of their models. I photographed over 100 people in one day and had to design a lighting set up that complemented them all.

Focal length: 80mm

Aperture: f/11

Shutter speed: 1/200 sec.

ISO: 100

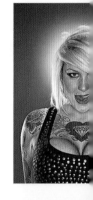

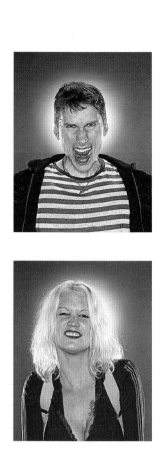
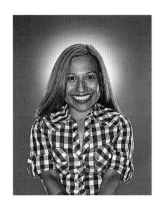
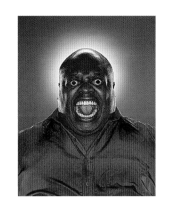

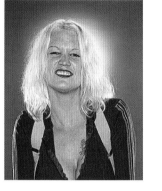

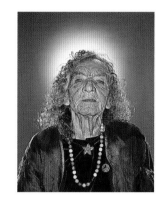

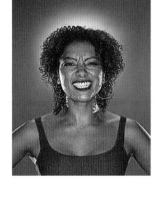

Looking Good

No matter what we admit to ourselves and others, we all want to look as good as we can when we look in the mirror. It is the photographer's job to not only understand this but carry with them the tools to ensure that the images they take show that person at their very best in every situation. If you learn these techniques you will have gained a valuable skill that your friends, family, and clients will come to appreciate.

Below: Making your subject look good is always your priority, so it's important to build a rapport with them which will help you understand and capture their character as well as making the process easier for both of you.

Focal length: 85mm

Aperture: f/22

Shutter speed: 1/160 sec.

ISO: 200

What Lighting Do You Need?

You can obviously use as many lights as you like, but I'm going to concentrate initially on single-light set-ups. The main light source in any lighting set-up is known as the "key light" so we will start by working with just that and nothing else. Later, we will explore multiple lighting sets but all of them are based around the same simple rules.

All of these key-light set-ups can be carried out effectively with continuous lighting as well as flash. The thing to be aware of with continuous lighting is that you will need a lot of power as people are moving subjects. You will need to be shooting at no slower than 1/60 sec. most of the time, and probably faster if you are using a long lens. Remember the handholding rule—your shutter speed should always be a figure equal to or greater than the focal length of your lens. So, for instance, if you are shooting on a 50mm lens then you need a safe shutter speed of at least 1/60 sec., and if you are shooting with a 200mm lens then you need a shutter speed of 1/250 sec. This will stop any camera shake affecting your final results.

For this reason, I would recommend using studio flash for all serious portrait and fashion photographers. You can of course also use a standard speedlight, shooting off-camera with a transmitter if you can't afford to invest in studio lights. There are plenty of modifiers available to fit standard speedlights, so you don't need to spend a lot of money to get started. Remember that speedlights give you the same flash as a studio light but are simply less powerful.

You can sync your focal plane shutter (on most DSLR and mirrorless cameras) with any shutter speed up to the maximum sync speed (see page 148). All cameras are different but this will normally be around 1/200 sec., which is more than enough to capture most relatively still subjects.

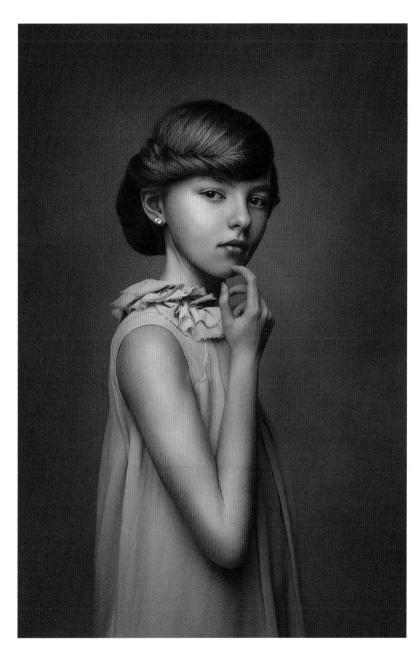

Left: This fine art portrait was shot using just one single light. You don't need lots of lighting to create beautiful photographs.

Focal length: 50mm

Aperture: f/5

Shutter speed: 1/125 sec.

ISO: 100

Choosing A Mood

Above: High-key portraits are bright and happy.

Focal length: 40mm

Aperture: f/2.8

Shutter speed: 1/160 sec.

ISO: 200

Above: Low-key portraits are dark and subtle, sometimes.

Focal length: 70mm

Aperture: f/10

Shutter speed: 1/200 sec.

ISO: 100

Above: The art of studio portraiture is all about choosing the right lighting style for your subject.

Focal length: 67mm

Aperture: f/18

Shutter speed: 1/200 sec.

ISO: 50

The purpose of photography is to tell stories, and every face has a story to tell. So, before photographing a person, it is important to decide on a mood for the image. To a large extent you will tend to do this naturally whenever you take a photograph—if it's a spontaneous shot you may be reacting to an event and will want to capture the moment as you remember it, such as the happiness of a family birthday or wedding.

Lighting is one of the ways that a photographer expresses the mood of the moment, and this is as true when shooting in a studio as on location. There are a few easy, basic rules to remember. To begin with, use high-key lighting for bright, happy subjects and low-key lighting for thoughtful, intellectual, and serious subjects.

Obviously, the subject's expression and the choice of clothing and props will also have a bearing on the mood, but it is the lighting that is the key to the look of an image.

Working With One Light

Various lighting techniques have been developed over the years which form the basis for good people and portrait photography, so it pays to learn about them. You will see that they are designed to flatter the subject, making them look thinner and more attractive, or to cover up any obvious blemishes. They have become standard set-ups, used by photographers the world over, because they all provide effective ways to light the body and face to help the subject look beautiful in any situation.

If you are starting out on your studio lighting career, I recommend you begin with just one light and experiment with the techniques below. This is a great way to hone your skills—see how the small positional changes affect the way the light falls on the face and then try different sizes, shapes, and styles of reflector. The size and shape of your subject's face and body will determine the exact positioning of the lighting and reflectors, as will the size of their nose, depth of their eye sockets, and dominance of certain facial features.

Note that all of these techniques work with both hard and soft lighting—try them out and see which you prefer. I have chosen to show most of them using a relatively soft light as provided by a 3ft- (1m-) square softbox positioned fairly close to the subject. The power of your lights is up to you, but remember it will affect which ISO and aperture you choose.

Right: This full-length portrait was shot using a single ring flash.

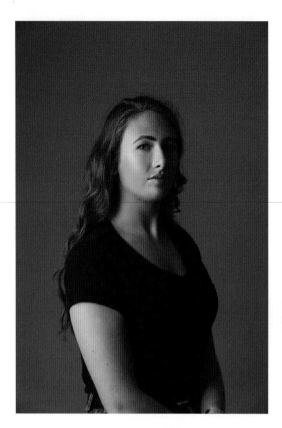

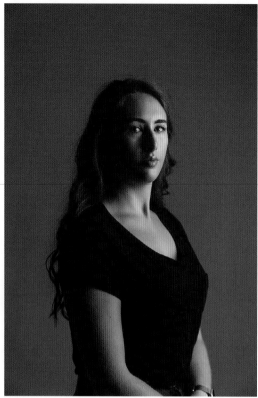

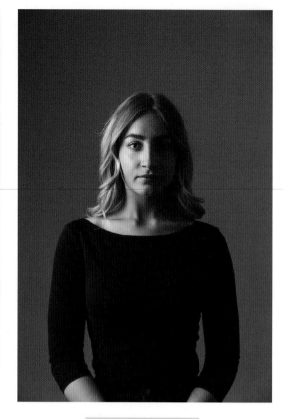

BROAD LIGHTING

With your subject sitting at a slight angle to the camera, there will be one side of the face that is larger and another that is smaller. If you place the light on the large side of the face, the "short" side will fall into shadow. This will make the subject look broader-faced and so tends to suit people with thinner faces. You can also use this technique if someone has a facial scar they wish to cover up—the lit side will bleach out and flatten, making any marks less noticeable. The darker side will show more texture and this will emphasize any imperfections.

SHORT LIGHTING

With the subject in the same position, now place the light on the opposite side, lighting the smaller or "short" side of the face. This will create shadow in the broad side of the face and gives a much more dramatic effect. It will also make the sitter look thinner.

SPLIT LIGHTING

With the subject now facing directly into the camera, move your light source around to the side. One side of the face is now bright and the other in shadow. Again, this will create a dramatic effect, shows character, and helps to "tell a story."

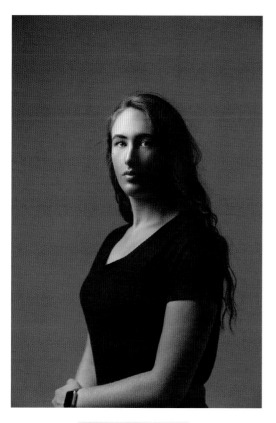

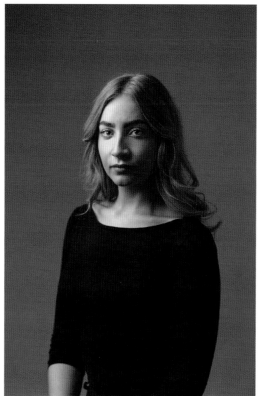

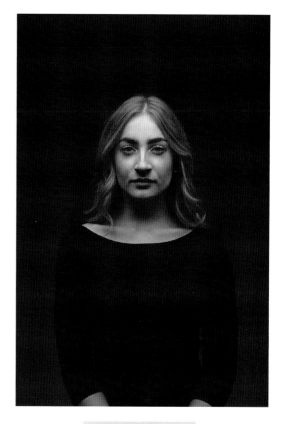

REMBRANDT LIGHTING

One of the most popular techniques in portraiture, this technique mimics the lighting favored by the artist Rembrandt van Rijn in his 17th-century paintings, from a large, high window. Place your large light source high up, at about 45 degrees to your subject. Look for the triangle of light created by the shadow of the nose as it joins the shadow of the cheek and you have the classic combination. This provides a good, even light, showing a highlight in each eye as well as texture across the skin.

LOOP LIGHTING

Loop lighting is similar to Rembrandt lighting but the light is positioned slightly closer to the camera and usually a little lower as well. It differs because the shadow of the nose does not connect with the cheek shadow. Instead, it creates a "loop" of shadow around the nose, which is a little less dramatic than Rembrandt lighting and more forgiving as it provides less texture.

BUTTERFLY LIGHTING

Place your light high above the camera, between the camera and the subject. Positioned centrally, it should provide a soft, even light over the whole face. The angle of the light creates a butterfly shape just below the nose. Butterfly lighting gives a contemporary fashion feel to the shot and will also flatten skin pores for a flawless look. Butterfly lighting is also called "Paramount" lighting after the film studio because many early Hollywood actresses insisted on this technique for their portraits.

TOP LIGHTING

Here, the main light is positioned high up, pointing straight down on top of the subject. It gives a filmic, theatrical effect. It can create harsh shadows with the wrong subject, so beware when using with subjects who have large noses, but it can also provide fabulous, dramatic-looking portraits.

FRONT LIGHTING

This really is the most basic type of lighting but it is often overlooked. Simply place your light pointing directly at the face of the subject from the camera position. We have all seen similar effects with on-camera flash, but in a studio you can be more subtle. If you have a very large softbox or a reflector wall, place it behind your camera and facing the subject. You will see a silhouette of yourself in the subject's eyes but the effect can be beautiful—it gives a fresh, natural feel to images. This technique is very popular with fashion photographers as it gives the model a lot of room to move within the set.

RING FLASH LIGHTING

Ring flash is covered on page 69, but don't forget that you can use on-camera flash in a studio. You can also get ring flash attachments for many studio lighting systems, which provide ring lighting for your subjects. This type of lighting is particularly popular with fashion photographers. Close-up, it produces a slightly eerie but beautiful ring-shaped reflection in the eye. In full-length shots it helps to capture a vital "caught in the moment" feel.

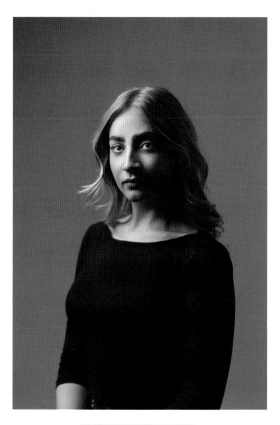
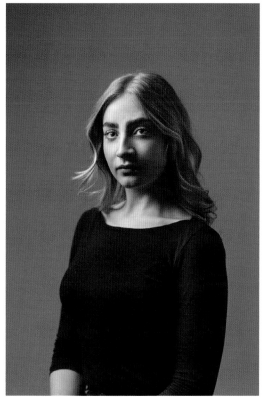

REFLECTORS

It's worth noting that all of the techniques mentioned can be subtly adjusted by using a "fill-in" board or reflector. White or silver reflectors are preferred as they produce different levels of harsh light. The reflector should be placed on the opposite side (the shadow side) of the subject to reflect the main light, softening the effect of the set-up and filling in the shadow areas—see above left, without a reflector, and above right, with a reflector. Dark shadows can look intense and give drama to a face, but they can be too dark for your sensor to record fully, resulting in deep, dark blacks that have little or no detail. Reflectors can solve this problem, but you will need to adjust their size and distance to control their effect. Always consider using a reflector rather than an additional light. The reflector will add a subtlety to your key lighting and enable you to introduce another light source without adding a powered light.

Multiple Light Set-Ups

The moment you introduce another light source into your set, things get very interesting. People can be intimidated by this but the trick is to build your lighting slowly and carefully. Introduce one light at a time, testing as you go to see the effect, and then you will have a better understanding of what the lights are adding to your image.

Try positioning your light, then turning it up to full power and then down to its lowest power. Take a look at the difference the power and the position make to the image and you will build up your knowledge of lighting as you go. In time you will develop a natural instinct for lighting and be able to pre-conceive your lighting before you place the individual units.

Using the basic one-light or key-light set-ups as a basis, we can now start to add additional lights. The first question to ask yourself is: "What are you trying to achieve?" This is fundamental as there is no advantage to adding lights unless they are needed. Try to keep your lighting to the bare minimum. Fewer lights are easier to handle and less expensive.

Your starting point should always be one of the basic one-light set-ups to create your key light. Use reflectors to soften the effect where needed (see page 95), then begin to add lights to suit your needs. The following are circumstances when you should consider adding another light to your set-up.

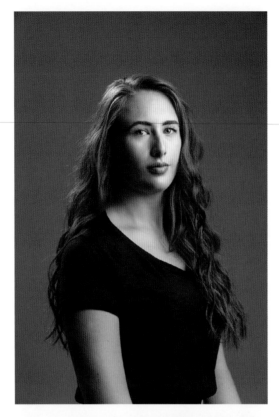

ACCENT LIGHTING

Using accent lighting, also known as hair lighting, on top of the head of your subject is a good way to add beautiful effects (above left, with hair light, and above right, without). All basic one-light set-ups involve your key light being positioned to the front (or to the side and front) of your subject. By positioning another light behind the subject, either above or to the side, you create a highlight reflection off the hair which makes it look shiny and glamorous. You can do this with a hard or soft source to vary the effect and use one, two, or more lights to do it. Be careful not to position the lights too close to the frame as they will create flare in the camera which is difficult to deal with. Hair lights can give images that Hollywood star quality.

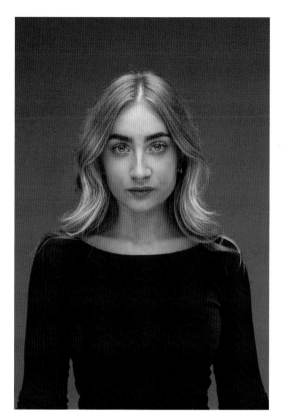

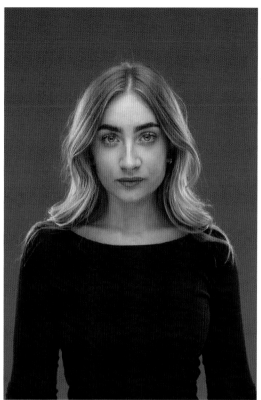

CLAM SHELL LIGHTING

Using the butterfly light set-up (see page 93), slide a large reflector around waist height, under the subject's chin, and you have the beginnings of what is known as "clam shell" lighting (above left). Add lighting from behind (above right) for accent or hair lighting. You can use a circular reflector or a curved reflector for different effects. Replace the reflector with a light and the effect is intensified, giving you ultimate control over how much light is used to fill in the deep shadow under the nose and chin. This technique also gives beautiful reflections in the eyes. However, you will need to adjust how much power you use with the lower light. If you overdo it, the result will look rather "spooky," with dark shadows being cast up the face. Using a 50/50 split of power between the two lights is a good starting point, after which you may need to reduce the lower light a little to get the effect you want. If you just want to use an under-eye reflector, there are many specialized products you can buy which provide different effects in the eyes.

MOCK SUNLIGHTING

This is a great technique for achieving a natural, sunny feel to your images. Position your main light with either a 3ft (1m) softbox or a very specialized Fresnel reflector at a distance, allowing it to spread light over the entire set, including the model. Set it at a frontal angle as your key light. To soften your shadow and provide detail, you can fill in with a closer, softer light on low power. You might want to add a hair light to this for added glamor. A Fresnel reflector is an expensive accessory but it has a focusing lens that enables you to mimic the effect of the sun and project it over a distance.

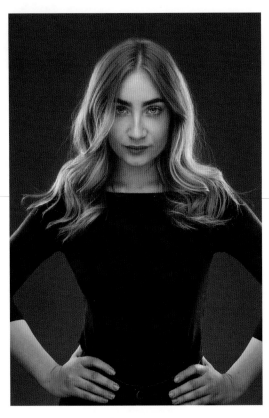

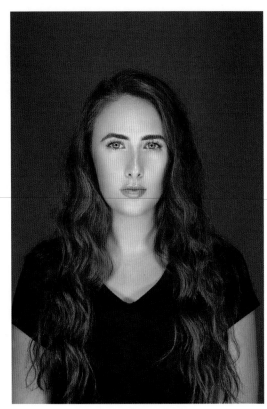

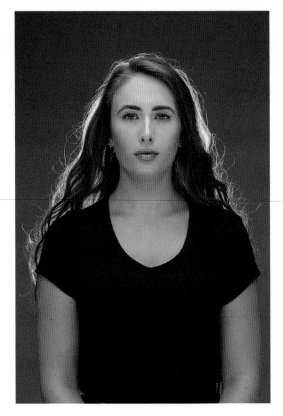

SIDE LIGHTING

Side lighting is used to light the entire side of the face or body. A hard source adds to the intensity of the effect and a soft source reduces it. Place the light, or lights, behind the subject, just off to the side of the frame and point them either toward the subject or turned away from the subject and toward the camera and beyond. Turning the light away from the subject is called "feathering" and ensures no stray light falls on the background. You can turn the light farther to increase or less to decrease the amount of light. Using an "egg crate" fitting on the softbox will also help to direct the light and reduce flare.

MULTIPLE CATCH LIGHTS

Strictly speaking, the "catch light" refers to any light that is catching a reflection in the eye. This is normally a single source. It is possible, however, to have a series of catch lights, evenly spaced to give a strong fashion and beauty effect. Here, I'm using six equal-powered lights.

RIM LIGHTING

Another popular effect in portraiture is rim lighting. This is an extreme version of accent or hair light in which you place a light directly behind the subject, pointing directly at the back of the head. It creates a clean, sharp rim of highlight around the entire hair line for a dramatic cut-out effect. Take care with this set-up as the hard rim highlight can become too bright for your camera sensor to resolve, even if it has the widest dynamic range.

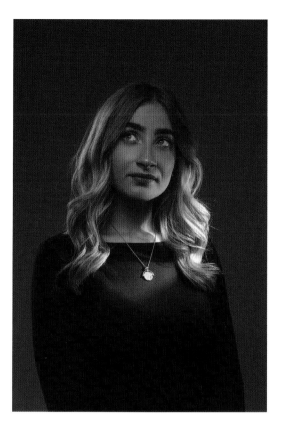
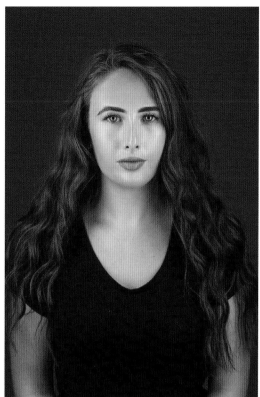
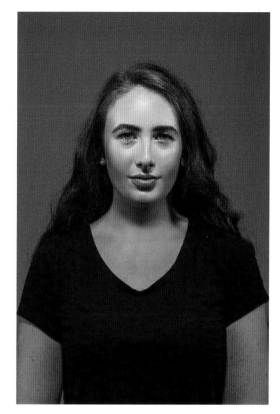

DETAIL LIGHTING

This is used to fill in shadow areas, usually on the face, such as the eyes (see page 101). You can use as many fill lights as you wish to lighten areas that require more emphasis. If the subject is wearing dark clothing made of matt material, for instance, position a small light source close-up to provide definition. You might also want to highlight a particular feature, such as part of a garment. Take great care to maintain the overall lighting balance while doing this. To add more light to just the area that requires it, you can feather or flag the light (see opposite page), use a snoot, or focus a spotlight.

DUAL LIGHTING

Some master photographers disagree with using just one catch light to light a face, and have made dual catch lights their signature look. Andrew Zuckerman, for example, uses two evenly powered catch lights—one above and one below the camera—with dual reflections to make the subject "pop out" of the image. Using vertical strip lights either side of the camera will give a slightly other-worldly look to a portrait. The resulting light is clean on the skin with a sharp specular feel and creates two vertical reflections either side of the pupil.

CEILING LIGHTING

Ceiling lighting is another clever technique which is often overlooked. It can be used in a studio or even on location in someone's home. A ceiling is almost always painted white, and is clean and uncluttered, so it makes the perfect giant reflector to add beautiful soft fill-in light in almost any situation. Point your flash head up to the ceiling and adjust it until you get a large pool of light. Use a clip-on "barn door" or a "flag" to stop the edge of the light hitting the subject directly. This creates the equivalent of a giant softbox or "swimming pool" which you find in studios and are very expensive.

Things To Avoid

As you become more adventurous and experiment with your lighting you will inevitably make mistakes and create some horrible results as well as some great ones. Making mistakes is probably the most effective way to learn new techniques, and it shows that you are starting to push the boundaries and try new things. However, some lighting issues should be avoided for very good reasons.

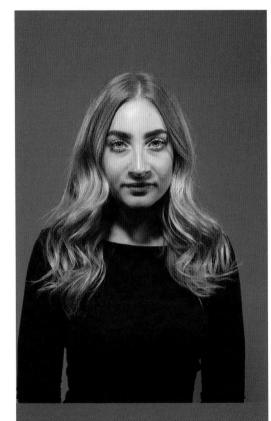

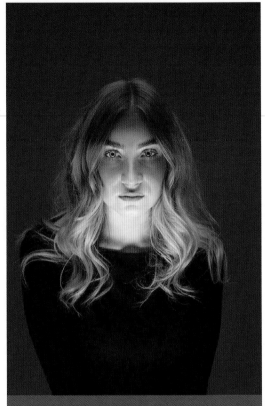

DOUBLE SHADOWS

When you introduce more than one light directed towards the front of the subject you risk getting the double shadow effect. This never looks good as the viewer notices the lighting rather than the subject. To avoid this, experiment with the power and position of the lights to make one more dominant than the other, or switch to a much softer light source.

TOO MUCH CONTRAST

Contrast creates drama and adds a richness and density to the colors of an image. But if you do not control the contrast and end up with too much, you will have huge problems when you come to developing and printing the image. Most modern cameras allow you to set your screen to display bright highlights and dark shadows, so use this feature to help you see how your images will look in print. You should aim for both your highlights and shadows to have at least some detail—you can then always adjust them in postproduction. Another useful tool is the histogram, which shows the amount of light and dark in the image—aim for an even level across the graph. If there are gaps at one end of the graph or the other you have lost detail which can never be recovered.

SCARY UNDERLIGHTING

When setting your clam shell lighting (see page 97) be careful not to overuse your upward lighting. Dark shadows running up the face from the nose, lips, and eye sockets are never attractive. This technique is actually used extensively in horror movies to intentionally create a sense of tension and strangeness, so, unless you want to shoot portraits for Halloween, take care with your upward fill light.

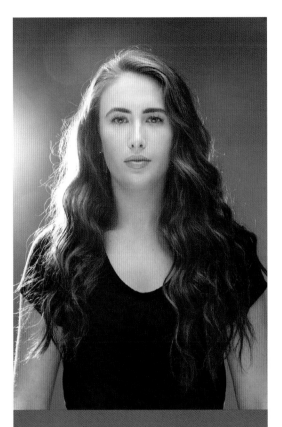

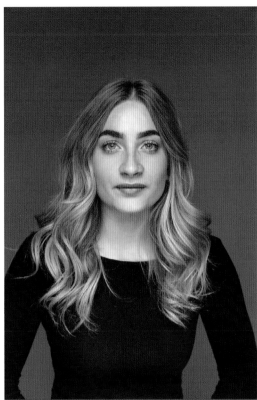

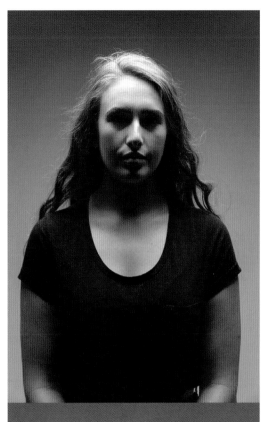

FLARE

Any lighting behind the subject and facing toward camera will create the risk of flare. It can be sharp and specular, showing up as rings or dots, or it can be soft, producing a whitening effect across the whole image. There are a couple of ways to combat this. A good lens hood will stop most flare, but not all. You can also try fitting an "egg crate" grid or a "flag" to your light. A flag is a piece of dark card or material that "flags off" the light source from the camera lens but does not stop light falling on the subject. You can clip a 10x8in (25x20cm) piece of black card to the light to create a barn door-type effect, or clip it to a separate stand positioned between the light and the lens, and then adjust it to shade the lens from the light.

FOREHEAD REFLECTIONS

One of the most common problems for beauty photographers is unwanted reflections on the skin of their subject, often seen on the forehead as a result of the top light used in clam shell lighting. Some people have greasier skin than others, which will exacerbate the problem.
To deal with this you can move your top light to another slightly less frontal position, change the nature of the light, or angle it down to feather the light. In some cases, you may need to use powder to make the skin more matt and less reflective.

DARK EYE SOCKETS

Dark eyes can look beautiful on some subjects, especially if they are the result of smoky eye make-up which has been professionally applied. Some people will have naturally dark eye sockets, or eyes set deep in their face. In these cases, use a reflector below the chin or an additional light to push a little more light into the eye area. Don't overdo it, though, as you don't want the results to look spooky. You can also use make-up or a little retouching in postproduction—but be careful not to make the face look unreal or plastic.

Profile: James Musselwhite

BIOGRAPHY

James Musselwhite is a UK-based portrait photographer whose influence is worldwide. His Portrait Of A Wrestler project gained him several national and international photographic awards and he is now a respected judge for many of the world's top photographic competitions including MPA, SWPP, and WPPI. During the Covid-19 lockdown James launched The Honest Photographer Facebook group delivering weekly video interviews with top photographers as well as tips, technical information, and James' own musings on the world of photography. James is a talented educator and communicator as well as a brilliant portrait photographer.

www.portraitofawrestler.com

Q) What equipment do you regard as being essential for your photography?
A) I try and avoid clichés whenever I am asked about kit and technique. Provided you have light, you can work anywhere. I shoot with Canon, I prefer studio lighting, I've always used Elinchrom heads—the rest is really what you make it.

Q) What do you regard as the most important aspect of your work in terms of your approach to photography?
A) The most important aspect is to listen. This helps you communicate. The best photographers are good communicators.

Q) Can you give us a tip about lighting that you wish you had known when you first began photography?
A) There are no rules. When I started in photography as a teenager, I was told to "always face the sun" and "always have your back to the sun". There is no absolute right or wrong, you just have different ways to work with light to achieve different results.

Q) What was your favorite job and why?
A) I like character portrait commissions. I love it when the subject has bought into the traditional idea of a portrait shoot, and you have the freedom to create a two-way street.

Q) How important is postproduction to you and do you do your own?

A) I do my own. Postproduction is the icing on the cake. It makes it look good, gives you that initial sense of impact. But without the taste, the texture, all of the substance underneath it, it is worthless. Well handled, postproduction makes good images great, but it cannot make a poor image good.

Q) Which photographers or artists have influenced you and why?

A) Robert Mapplethorpe—just that sense of forbidden, dark tonality has unquestionably influenced my work. Storm Thorgerson as a designer and concept artist has influenced so much of my musical and artistic takes. Diane Arbus was the first photographer I was pushed to go and study. Her connection with her subjects and sense of timing are flawless.

Q) If you could shoot in any specialist field other than your own, what would you choose?

A) I've always wanted to be a pitch-side sports photographer, particularly at the Olympic games. I love the thrill of sport and it would be a great challenge to try to capture images that are different.

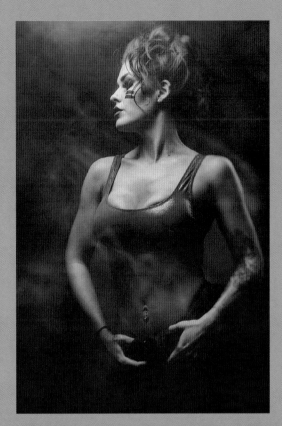

Chapter 7
Still Life

Everyone who has seen any of Van Gogh's paintings of sunflowers has surely wondered at their simple beauty. They were painted in two series, from 1888 to 1889, partly to impress his friend Paul Gauguin, who was himself a master of still life. In 1987, one of the "Sunflowers" paintings was sold at auction for nearly $40 million (almost £31 million)—so never let it be said that still life doesn't sell.

Today, still-life photography is responsible for selling just about every product you can buy. You cannot open a magazine, a recipe book, or web site without being influenced by the amazing work of commercial still-life photographers. Still-life photography is very different from other disciplines, and requires a special sensibility—and lighting is everything.

The professionals who specialize in this field are some of the finest practitioners of the art, spending hours adjusting one light with minute precision to attain the desired effect—the ratio of one light to another is more critical than in any other photographic genre. They have also developed a detailed understanding of how light reacts to the surface of an item—still-life photography is all about lighting the world in miniature.

Right: Great still life looks simple but it takes years of accumulated skills and knowledge to create beautiful lighting.
Focal length: 100mm
Aperture: f/11
Shutter speed: 1/60 sec.
ISO: 50

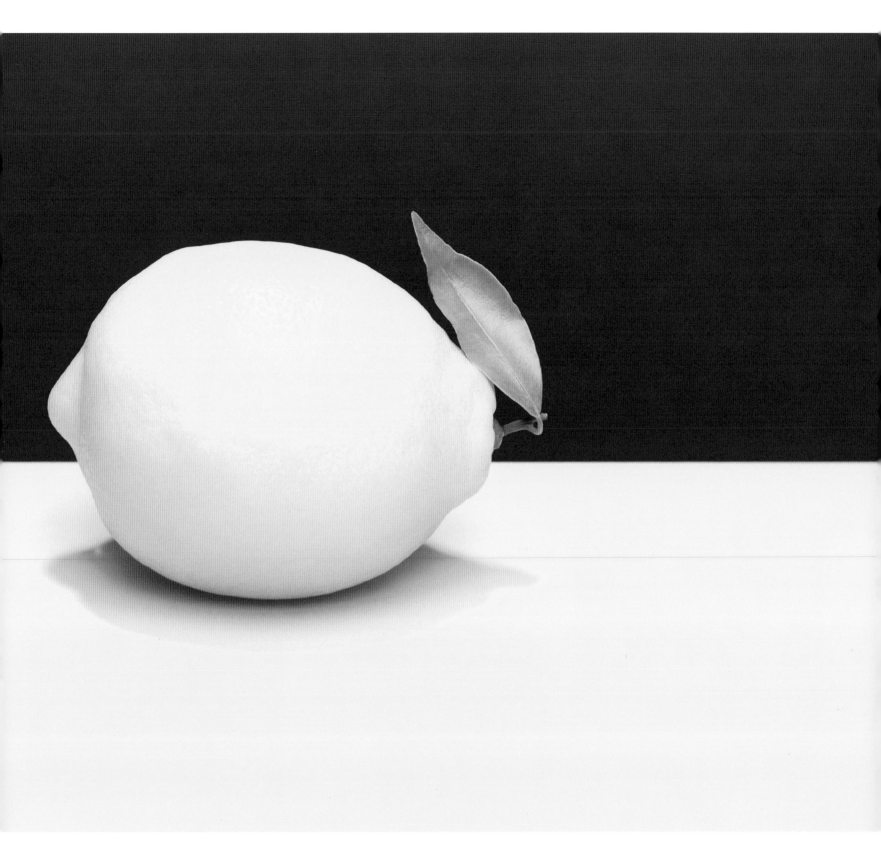

Equipment

The first important piece of equipment is a good table top. As well as strong, solid, and stable, it needs to be versatile and adaptable to any set-up. A table of 3x6ft (1x2m) is a good starting point as most household items can be contained within that size of space, with plenty of spare room for props and reflectors.

Reflectors are essential for all still-life images, and you will need to build up a good selection of every type, shape, and size of reflector. Start with the large commercially available reflectors and then customize your own with card or foam core boards—most art stores stock white, matt silver, and even mirror finishes. Remember that reflectors can be used to bounce light around your set or, in the case of bottle photography, they can create the actual reflection that you see behind the bottle itself, so they can serve two different purposes.

Another good tip is to buy mirror tiles from your local hardware store (see page 81). Many still-life photographers have huge collections of every size, shape, and texture, even down to the size of a postage stamp.

Next, you need something to support them. Light stands are useful for the larger reflectors but you need something more precise for your miniature set. Table-top laboratory stands and clamps are extremely useful and again a good collection of them can be found in every still-life photographer's prop cupboard.

A selection of backdrops is essential. Most still-life photography in the studio will be predominantly shot on a flat table-top surface. That surface is almost as important as the product as it helps to tell the story. Over time, you will learn to collect and scavenge textural backdrops of all descriptions, from marble to mock wooden floors, fabric off-cuts, and rusty metal plates.

It's a good idea to build a toolkit that includes items such as craft putty, craft knives, and tweezers of various sizes for handling small items.

You will also need a range of sprays and special effects devices that will, in time, help to create your own unique style as a photographer. For instance, in food photography, you can add what looks like condensation to bottles or a piece of fruit or

vegetables, to make them look fresh. A 50/50 mix of glycerin and water in a perfume sprayer will create blobs of "condensation" on a surface that last for longer than water droplets on their own. Available from most chemist shops, holiday face sprays, for cooling beach-goers, are a really good way to create a very fine mist on a surface. You can also buy matt dulling spray from professional camera shops designed to help reduce those annoying reflections that you can't avoid on set.

Every still-life photographer needs a good-quality, sturdy tripod, which is easy to use and allows you to make lots of very small, fine adjustments. You will also need to be able to position the camera directly over the subject. Shots from above show collections of products in a creative way and are very much in demand. You can buy big, heavyweight studio stands, which were originally designed to support large studio sheet film cameras. These offer the ultimate control over camera positioning but can be very expensive. You may also need a boom arm if you want to get serious about shots from above.

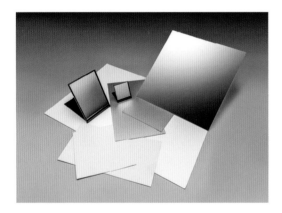

Above: You can never have enough mirrors and reflector cards on hand to help bounce light around your set-up.

Above: All still-life photographers build up their own specialist toolkit to help with every situation.

CONTINUOUS LIGHT OR FLASH?

Continuous lighting
Advantages: easy to preview, easy to mix with ambient light, and simple to use.
Disadvantages: uses lots of mains power, limited modifiers, and gets very hot.

Flash lighting
Advantages: uses little mains power, large range of modifiers, easy to shoot with high power output, and never gets hot.
Disadvantages: difficult to preview and difficult to mix with ambient light.

When it comes to your choice of lighting, the sky's the limit. You have no requirement to capture movement for the most part, so continuous light sources such as tungsten or LED lights are very popular. Flash is, of course, always very easy to use and has been the basic requirement for still-life photography, but, with the recent advances in LED units, and the fact that LEDs are a lot more affordable now, they have become the ideal choice for many. Continuous lighting is easier to assess as you photograph what you see, but be aware that your lighting will be affected by the ambient light in the room. Even a small flash unit is far more powerful, and you are able to work in a fully-lit room without the ambient light affecting the final result. Also note that any movement, such as bubbles in a glass of champagne, will be a problem when using LED lights at exposures of two seconds or more.

It's important to get a good selection of light modifiers to fit whatever lighting you have. You will have many different requirements for hard and soft lighting sources when shooting still life so build your kit up gradually.

Right: Drinks photographers often need to create the effect of condensation on glasses and bottles.

Focal length: 150mm

Aperture: f/16

Shutter speed: 1/60 sec.

ISO: 50

Pack Shot

Above: You don't need a stack of lights to shoot the perfect pack shot. It's better to bounce and reflect the light you have to get detailed effects.

Above: You can see here how this pack shot was created using just one light.

A good place to begin is the classic pack shot on a vignette background—this provides the basic set-up that acts as a starting point for most studio still-life shots. The pack shot is the everyday earner for many still-life specialists, with many large studios now set up just to shoot pack shots. You will normally be photographing a small rectangular box or a tubular bottle and it will be your job to make it look appealing as well as ensure that every detail of the design is visible to the viewer.

The basic starting point for most still-life images is the floating overhead soft light. Outdoors, most lighting comes from above so that is what is perceived as normal. The light needs to be large enough and positioned to envelope the subject in a soft, even light—so a 3ft- (1m-) square softbox is a good choice.

When using a white seamless background roll, you can use the fall-off from the top light to create a natural vignette. This can be adjusted by moving the top light toward the camera carefully or by tilting it. You will need to balance the effect of the light falling on the subject against the lighting effect of the background—both are important.

You also need to ensure you can see the surface of the product and show its details. Adding another light to the front of the set can help but this may be too harsh and ruin the soft vignette shadow on the backdrop. A better choice is to use a number of reflectors which allow you to control how you bounce the light around the set. Position your reflectors with the help of the table-top stands so they are just out of shot. The inverse square law will help to ensure that the closer they are to the subject, the less they will affect your backdrop. You can use white or mirror reflectors, and don't be afraid to try several in different positions.

You may also find that you have too much light reflecting off the top of your product, as that surface is nearest to the light source, so position a small black card above the product to counter any unwanted reflections.

There are no hard and fast rules to this type of set-up so don't be afraid to add more lights, but be sure they are subtle and do not create unwanted effects elsewhere. A small, snooted cross-light can often help to highlight a detail of a label on the product, but keep the power of the cross-light low and check to make sure the effect is what you want.

Still-life lighting is all about gradually building a series of light and shadow areas to achieve the final perfect result. It requires patience and a calm, precise approach.

Tip

Remember you can use a polarizing filter (see pages 25 and 45) to remove most unwanted reflections on your still-life product shots—polarizers are not just for landscapes.

Flat Art Copies

The art of the flat art copy is often much overlooked in photography, and there is a lot more to it than you may first think. The fundamental starting point is to ensure that you have the artwork flat and parallel to the camera.

To ensure this, position your artwork on the floor and your camera above it. Frame up the subject approximately, then replace the artwork with a large mirror. Focus on the camera's reflection in the mirror, and adjust the camera's position until the center cross-hair is directly in the center of the lens reflection—when it is perfectly aligned, you have a completely parallel set-up.

You then need to ensure your lighting is consistent across the whole subject—use a light meter to measure all four corners. Set your lights with a soft modifier at approximately 45 degrees and at a distance so there is little fall-off. Using a longer lens will ensure there are no unwanted reflections and little or no distortion. Then use the grid on your viewfinder to line everything up.

Above: Use a mirror to line up your camera before starting to shoot your flat art copies.

Jewelry

Jewelry and watch photography is a specialist area of photography, and can cause even experienced professionals problems. Basically, you are trying to photograph lots of tiny mirrored subjects that reflect everything in all directions and in just about every possible way. They are reflective, translucent, shiny, matt, delicate things and, if dropped, broken or lost, may also cost you a fortune.

Texture

Jewelry photography is all about texture. The choice of background material is extremely important as it sets the scene for the image. Jewelry specialists collect large pieces of marble and stone, as well as polished wood and silk fabrics. These are rich in colors and textures and will be photographed close-up so they must also be kept in good condition. Shooting close-up means that every detail is super-critical—for instance, the slightest speck of dust or a fingerprint will ruin an image.

You should wear cotton gloves at all times and you will need a set of long tweezers and small tools so you can handle the tiny products without marking or damaging them.

If you take a reflective flat surface, such as stone or marble, you can position your top light to reflect directly onto it, thus creating your base set-up in the normal way. Due to the small size of the object, this can look boring so a good alternative is to replace your softbox with a square frame stretcher, containing white translucent material. Rosco makes rolls of durable plastic translucent material, but regular tracing paper is a good, cheap alternative.

By placing this frame above the surface you can direct a light onto it with a standard reflector at a short distance from the back of the set. This will give a soft circular glow on the reflective surface, which can be moved and adjusted by moving the

light closer and then right to left. You can then place your jewelry in the most interesting position.

This set-up allows you to control the lights more accurately for the best overall lighting effects. Remember that, with highly reflective curved surfaces, you will pick up reflections from all directions so the unlit areas become as important as the lit area. Unlit areas will show up as dark or even black reflections, giving shape and depth to the jewelry. Each piece of jewelry—with different sizes and shapes of cut stones and precious metals—will offer a unique challenge, so try adding and subtracting lights to find the best light position for each piece.

It's a good idea to cut up some small pieces of mirror board, which can be as small as 2in (5cm) square. These can be positioned to reflect light back onto the jewelry to create sparkles and highlights.

An interesting addition to your kit is a miniature lighting set-up. A small set of tiny LED lights, such as the Adaptalux Lighting Studio Kit, can be positioned with flex arms on the set to create sparkles on the jewelry.

Photographing watches presents all the same challenges as jewelry, with the addition of the reflections in the glass surface. The first way to

Above: Stone or marble make excellent surface materials for jewelry images, as long as you can control the reflected light.

Focal length: 150mm

Aperture: f/22

Shutter speed: 1/60 sec.

ISO: 100

deal with this is to ensure that the watch face is only reflecting a dark area within the set. This can be difficult to achieve, and there are three popular solutions:

- Use a polarizing filter to try to dull the reflections—this doesn't always work but it can be a simple and effective solution.
- Cut out a circle of black card and carefully place it above the watch to block the light reflecting from the glass of the watch.
- Shoot the whole image with the reflection in it then take away the reflecting light and shoot again to reveal the detail in the watch face. Combine the two images in postproduction in Adobe Photoshop.

Tip

Place a piece of craft putty on the end of a pencil and carefully dab the whole set to remove any specks of dust that may have collected during set-up before shooting.

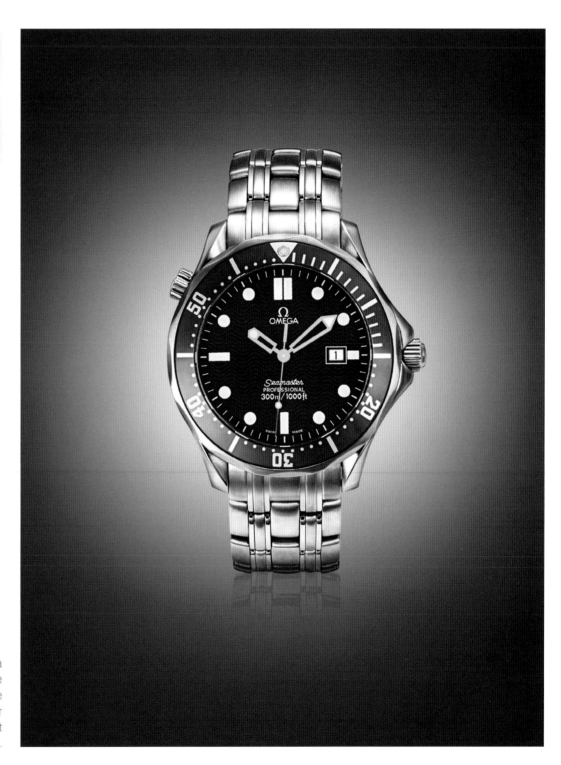

Right: Watch photography is a specialization within a specialization—it takes skill and knowledge to capture the shine and texture of the face or mechanism beneath the highly reflective surface of the watch's glass. Remember to set the watch's hands to 10.10, or 1.50, for the most esthetically pleasing composition.

Food & Drink

Globally, the food and drink industry is enormous and it needs photography. From double-page spread advertisements in international magazines to food blogs, we all have a huge appetite for the delicious-looking fare on display. Good food and drink photography always looks easy, yet it is undoubtedly one of the most complicated forms of the art—many top professionals specialize in nothing but food and drink images, and it is rare for clients to employ non-specialists.

A key part of creating great food images is in the very skilled specialist discipline of food styling, in which the foods are specially prepared and treated to make them look at their most appetizing. In fact, nearly all professional food photographers work with specialist food stylists. These are talented individuals who are part chef, part style guru, and part scientist. They usually come with their own equipment for manipulating food products and can obtain any prop, any background, and the very best food products.

Of course, food and drink photography has its own set of rules for lighting as well, so let's examine some of the basic techniques.

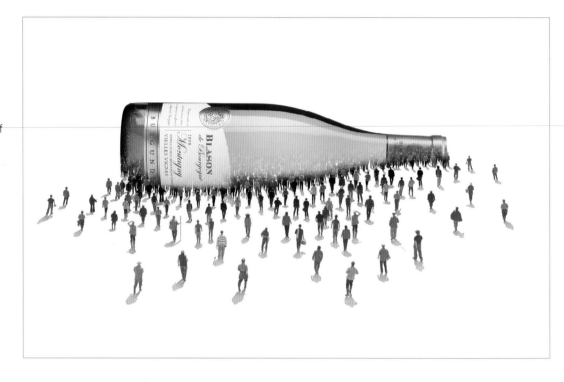

Above: The food and drink industry is one of the biggest and busiest markets in commercial photography.

Below: Food photographer Giles Christopher's studio looks more like a laboratory than a photography studio.

Food

Not all food is the same—you will need to photograph a fresh scoop of ice cream very differently from a bowl of olives or a roast chicken. Styles of food photography, just as in clothing, come into and go out of fashion. The influence of food bloggers means that most modern images at the time of writing, for instance, have a very "natural" look, largely because of the influence of bloggers photographing food as they find it in restaurants, in the home, or even outdoors. However, it's still important to be able to develop your own style of food photography—as in any photography discipline—to help you stand out from the crowd.

Having done a fair bit of food photography myself (although I am far from being a specialist), I have noticed that many of the techniques required to shoot beautiful, fabulous food were similar to those used in the fashion and beauty industry when shooting beautiful, fabulous people. Essentially, most food photography is about expressing texture. Shiny toppings, crumbly biscuits, and creamy sauces are the order of the day, but there is a certain alchemy to getting them all to look just right in a photograph.

The added problem is that you are dealing with subjects that are constantly changing and usually decaying under the lights so you have to learn to work quickly and efficiently. This is why food and drink photography is so "technique-heavy". You simply don't have time to learn as you go.

All specialist food photographers have a list of techniques—often well-guarded secrets—stored away, just waiting for the most suitable time to use them. There are even photographers who specialize in a particular type of food with some becoming well known for fish, ice cream, or desserts, for instance.

For the aspiring amateur, food photography can be fantastic fun. There's plenty of subject matter in your kitchen or local restaurant and, without the pressure of a paying client, you can build your knowledge slowly. It's a good idea to start by photographing food outdoors or using natural light from a window or doorway. Use different reflectors to bend and shape the lighting around your subject. Remember it is a very precise art—there's no room for dirty plates or unpolished forks.

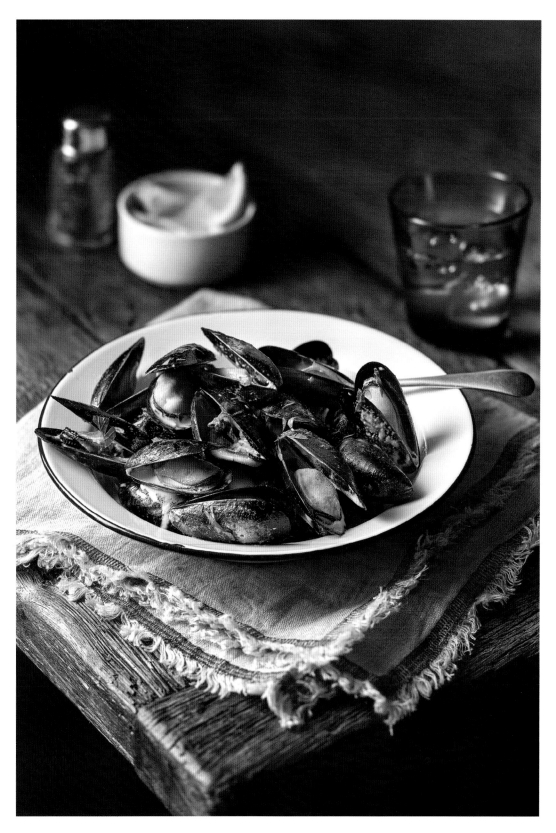

Right: At the heart of all good food photography is high-quality produce and great lighting.

Focal length: 28mm

Aperture: f/3.2

Shutter speed: 1/125 sec.

ISO: 200

On Location

Capturing food with natural lighting can be difficult. On location, the sun can be used as the main light source but it obviously moves during the day, so you will have a very brief time shooting images before the lighting changes noticeably—which makes it challenging to produce a set of images that look consistent. Remember that the color temperature may also change, as well as the nature of the light, from harsh, direct sunlight to the softer light resulting from cloud cover.

It is therefore best to use a simple lighting set-up—you will need to get everything in place quickly. If you introduce lots of reflectors, for instance, you will run out of time. Work quickly and always have the big picture in mind, allowing the details to vary so that you get the main image in the bag. Try the techniques below and find the set-ups that suit your style. Trial and error is the way forward—you will slowly be able to build up a library of experience as you go.

Most natural light food photography will be based on using a single light source. Take a look at the effect the light source has on the subject from different directions. Back, side, front, and top—with all variations between. Different directions of light have different attributes and can all be useful.

It's important to capture the details in both the highlight and the shadow areas of an image, and you can use reflectors to make subtle adjustments to the balance between light and dark, enabling a perfect exposure every time. Set your camera display to show highlight and shadow areas or use the exposure histogram to help (see page 100).

A tripod will enable you to shoot in low light with long shutter speeds. Use the lowest ISO setting that you can to increase detail—between 50 and 100 ISO—and vary your aperture depending on the style of image you're aiming for. There has been a strong movement towards using narrow depths of field recently to give the sense a "real-life" moment in time. Essentially, this is pretend "candid" food photography, which, together with the setting on location, helps to tell a story.

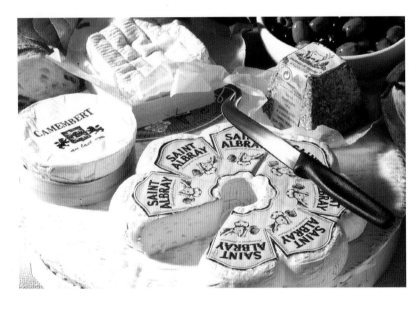

Above: Using sunlight can be the very best way to light food, giving it a bright, natural look.

Focal length: 35mm

Aperture: f/16

Shutter speed: 1/60 sec.

ISO: 50

Above: Shooting food on location is all about placing the viewer within the scene to experience the moment— shallow depth of field can help with this.

Focal length: 70mm

Aperture: f/2.8

Shutter speed: 1/640 sec.

ISO: 500

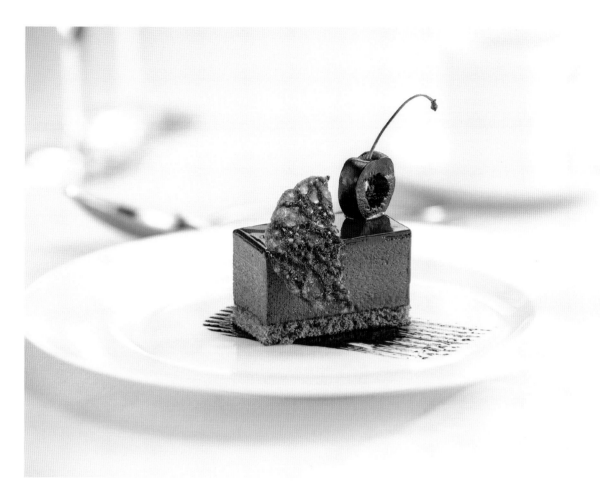

Studio

Shooting food and drink in the studio can be a daunting experience—there is a lot to think about. You need to learn to work quickly as food can lose its fresh appearance and go off if not attended to. Because of this, it is important to practice before working on a commercial project, building up your experience and skills to cope with every situation.

More and more food and drink photographers are now shooting with continuous lighting, mainly with LEDs. The subject doesn't move, so it's not uncommon to have an exposure time of five to ten seconds with an aperture of f/16 or f/22 for a good depth of field. Clients are increasingly asking for video clips of the session as well, which cannot be done with flash, so good LED lights are becoming essential. Another convenient feature of LEDs is

that, unlike the tungsten lights of the past, they don't get hot. They are versatile, affordable, and available in every size and shape.

I have used flash in the following bottle shot example, but LEDs would be just as suitable. Use whichever you prefer. You will also need a collection of mirrors and reflectors as well as frosted screens (see page 81). You are telling a story, so choose your props well and use your lighting to express a mood.

Food needs to look delicious, so it has to be attractive and inviting—this is more critical than with other still-life subjects. As a result, most lighting set-ups should tend toward the warmer side of the color spectrum.

Tip

Most LED lights can have their color changed toward the tungsten spectrum, which can be helpful in creating a warm effect.

Bottles & Drinks

Another extremely popular specialization is bottles and drinks photography. With everything from beer to wine, spirits, and soft drinks on offer, there are plenty of subjects to work with. Bottles and drinks photographers have long guarded their hard-earned tricks of the trade. The perfect frosted glass or translucent glow from the bottle, which give their images a seductive quality, can be very difficult effects to attain.

It takes years of experience to develop these techniques, so it's no wonder that the best drinks photographers are sought after by advertising agencies and clients.

There is, of course, a vast array of differently shaped and sized bottles, as well as different ideas on how to capture them. Many wine companies often ask for images of multiple bottles and glasses in one frame, and you may need to use a fully propped studio set or an outdoor vineyard setting for a backdrop. I could write an entire book on different techniques for photographing wines, beers, and soft drinks, but I'm going to explain here how to photograph the perfect simple wine bottle shot. Bottle photography is something that we all can do as long as we learn a few basic special techniques.

First of all, it's important to prepare the bottle. With the help of some standard cigarette lighter fuel, remove the rear label of the bottle to make it easier to create that golden glow when you back light the bottle. Make sure the bottle is completely clean and the front label is in perfect condition. If you are working professionally, it's a good idea to ask your client to supply spare labels as they tend to get bashed and scratched when transported.

If you want to have a consistent cold frosting all over the bottle, you can spray it with three or four thin coats of matt dulling spray or clear paint primer and allow it to dry. I usually avoid doing this, though, as it can restrict you later on in the process.

Left: This is the finished wine bottle shot as delivered to my client. Subsequent images show how it was created.

Focal length: 200mm

Aperture: f/11

Shutter speed: 1/160 sec.

ISO: 50

STEP 1

Create a raised platform on your table top to place the bottle on. This isolates the bottle from the large surface, making it easier to add lights or reflectors later on with no ugly, unwanted reflections. Place your bottle on the platform. Stand a stretched and framed translucent sheet (see page 81) behind the bottle, or use a large, square piece of translucent opal Perspex. Next, stand a light behind the Perspex with either a small softbox or a standard reflector fitted with a honeycomb grid. By moving the light nearer or further away from the Perspex you can create a different intensity of glow through the back of the bottle.

STEP 2

Position your camera parallel to the bottle, at the same height as the base of the bottle, and adjust the back light to create the glow that you want. The height of the camera and your angle to the bottle will affect the consistency of the glow, so be precise and move the camera to find the ideal position.

STEP 3

Now add a light on one side of the bottle. This should light up the bottle and create a clean, vertical reflection line running down both sides of the light. A small softbox is ideal for this, or you can use a scrim sheet with an adjustable light, similar to the back light. Try them both out and see which one you prefer.

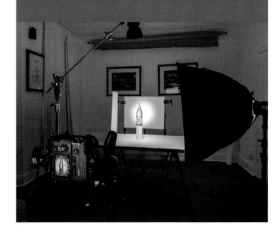

STEP 4

On the opposite side, add a vertical white reflector. This will clean up the shadow side, adding detail to the bottle overall.

STEP 5

To light the label, you can add a top light from front and above at 45 degrees, fitting it with a honeycomb grid or snoot to help isolate the pool of light. If you have a problem with reflections, you can use a polarizing filter and even a polarized filter sheet on the top light to remove any ugly spot reflections.

STEP 6

It's now time to add the all-important condensation that makes a bottle of wine look ice-cold and so irresistible. Mix up a solution of 50% water and 50% glycerin in a small mist-spray bottle or use a fine aerosol water spray. Spray this carefully at the wine bottle until the droplets of water form on the surface. Practice spraying the liquid to create the size of droplet you require—spraying lightly will create tiny droplets and more liquid will give you larger droplets.

STEP 7

In some situations, especially if the back light is very strong, the edges of the bottle may burn out (although this was not the case here). If this happens, simply add two vertical black cards (cut to the shape of the bottle), standing them either side, a few inches back. Adjust them for the perfect amount of soft, dark edge required.

STEP 8

Wait for the condensation to drip down. You can use continuous light sources, such as LED lighting, for this but I prefer flash as it ensures that any rising bubble or drip of condensation is caught with no movement blur. For the final image, I cut out the background and added a table-top reflection in Photoshop. After you have mastered the bottle shot, try photographing red wine pouring into a tilted glass. This is only achievable with flash as you need to capture the rolling movement of the wine as it pours into the bowl of the glass—some wonderful close-up images are possible.

Profile: Giles Christopher

BIOGRAPHY

After receiving a camera for his 13th birthday, Giles Christopher became hooked on photography. He pursued a career as a studio assistant, working mainly on posters and publicity campaigns. He then worked his way up into the film and TV business, finally becoming a director of photography. Twenty years ago, he formed Media Wisdom with his wife Abigail to shoot stills and video for the food and drinks industry. A winner of the prestigious Pink Lady Food Photographer of the Year Award, there are few photographers with Giles' knowledge and skill in this genre.

www.mediawisdom.co.uk

Q) What equipment do you regard as being essential for your photography?
A) A good tripod and lighting. The most expensive isn't always the best.

Q) What do you regard as the most important aspect of your work in terms of your approach to photography?
A) Listening to the brief and understanding it are essential. I like to get a mood board from the clients so I can get into their head, however crazy the idea. It's important to fulfil and hopefully exceed their expectations. I like to try to do a test shoot to make sure that everything works smoothly on the day.

Q) Can you give us a tip about lighting that you wish you had known when you first began photography?
A) Don't over-light things—learn to use shadows as much as light. Begin with your back light and work your way forward.

Q) What was your favorite job and why?

A) Having to shoot landscape views from a helicopter in Madeira for a big property client was exciting. I love a really technical shoot. We were asked to shoot and provide elevations and GPS references for each shot as the images were being mapped onto a computer-generated project. (It's not all food and drink, you know!)

Q) How important is postproduction to you and do you do your own?

A) Retouching is super-important for us. At our level, clients expect close to perfection for their products and a lot of things need polishing and enhancing in Adobe Photoshop. I try to do my own but we use a retoucher for elements outside my skill set.

Q) Which photographers or artists have influenced you and why?

A) While at college it was landscapes by Faye Godwin, but these days I like the lifestyle portrait work of Mark Tucker and Steve McCurry. I also like animal photography by Tim Flach and Sharon Monrose.

Q) Is there anything else you would like to add?

A) It's very important these days to choose a niche in photography and stick with it. It could be a hobby or a genuine interest. If you like motorsport then follow that path as a motorsport photographer. If you market yourself as a general photographer, you won't be found by potential clients when they run web searches for the type of photographer they're looking for. Be the best you can be and know your limits.

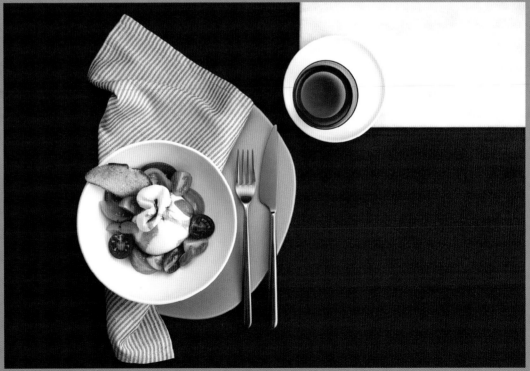

Chapter 8
Sets & Interiors

Back in the early 1980s, having left art college, I was training to be an art director at a small design agency. The agency sent me on my first proper assignment to work alongside a photographer shooting a wallpaper catalog. The job took about two weeks to complete and involved building several room sets in a studio. It was my introduction to the world of commercial photography and it literally changed my life.

In that time I learned that mastering the art of lighting was at the very heart of all great photography, and that it was what I wanted to do. For this reason, room-set photography will always be very special to me. It is, without doubt, one of the most demanding fields of photography and, again, lighting is critical to success.

Right: This was part of an advertising campaign for the postal service, creating a cartoon-like room set.

Focal length: 90mm

Aperture: f/16

Shutter speed: 1/60 sec.

ISO: 50

Telling A Story

Ultimately, all photography is about storytelling, and this is a fact that is never more relevant than when you are photographing room sets. Whether you are selling the items within the set, as with a furniture or interiors catalog, or using your set to sell an idea for an advert or magazine article, you are telling a story. The way that you light your set is the baseline to your story, so without good lighting you have nothing.

Most large cities have prop hire companies which can supply furniture and props for use in film, TV, and photography. You can employ set builders and interior stylists but it is your lighting that will define the story.

A good props stylist can be an invaluable member of your commercial team as they will know all the right places to go to get whatever you need for your brief, as well as ensuring that all the items co-ordinate when telling the story of your image. Learn to work with your set designer and your stylist to create an invincible creative team, but remember that you are in charge. The final decision is yours.

Above: This entire set was built around the studio flash units, with every dial and the ceiling being back lit. All the props were hired or made especially for the shoot.

Focal length: 24mm

Aperture: f/11

Shutter speed: 1/160 sec.

ISO: 50

Building A Studio Set

When building your set, don't forget your camera viewpoint—this is a critical factor for set design. The height of the walls can be very important. It's often a good idea to build the walls higher than you would normally think necessary, even heights of 10–12ft (3–4m) are normal in set design, especially in the far corner of the room as the camera framing will reveal the top of the set if the walls are too low. You can, of course, build a small area of ceiling over the corner to counter this problem but avoid building a full ceiling as it will restrict your access to lighting points.

If you are using a large studio then a floating ceiling is a great way to get soft, even room light. Many big hire studios have these and they are basically a very large, flat surface, usually constructed from a stretched white canvas, which can be lowered on pulleys and adjusted over the set. You can shoot a light into the flat area to reflect soft light down into the room, filling in deep shadow areas and creating a soft, natural light for the whole room set.

Once your set is built and propped, your lighting will help to define the style of the images, so it is important to understand what lights to use and how they affect crucial areas within the set. You need to learn the visual language of light. Observe and understand how the sunlight falls through a window in the morning, how it changes in a room during the day, how the light on a cloudy day is different from that on a sunny day, and how the light from an internal lamp cascades down a wall. These effects in the real world around you will form your own personal reference points for lighting design.

You can use continuous light sources or flash for room-set photography but you will need a fair amount of power as you will generally be shooting at small apertures to give a good depth of field throughout the image. HMI (hydrargyrum medium-arc iodide) or tungsten light sources are favored rather than LED lights simply because they offer

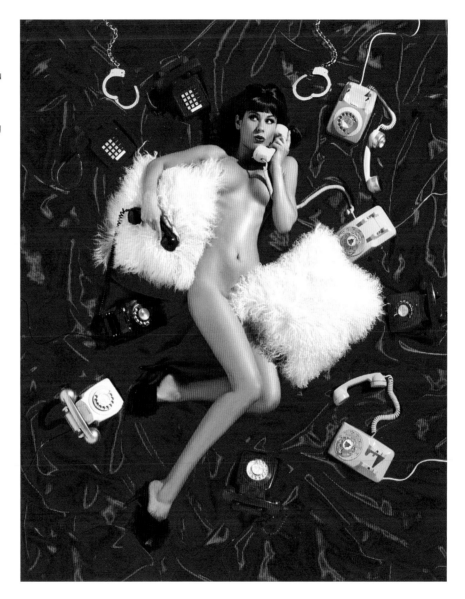

considerably more power. When choosing studio flash you will need larger power packs with separate flash heads, normally rated between 1000 and 4000 Ws. Larger, more powerful lighting systems can be very expensive to buy, but don't forget that you can always hire them if you absolutely need them.

Above: Choosing a viewpoint from above can prove interesting from a lighting perspective. This was lit with one large Fresnel spot (top right) and two 8x4ft (2.5x1.25m) white reflector boards.

Focal length: 120mm

Aperture: f/8

Shutter speed: 1/125 sec.

ISO: 50

Windows & Doorways

Having established your set and chosen your camera viewpoint, it is the windows and doorways that will become your primary light sources. The challenge is always to balance the lighting sufficiently to give the viewer a natural experience of a real room while also ensuring that everything within the room is well lit.

Begin with your largest light source. This is normally a window or an external doorway. Place the most powerful light so that it streams into the room through the window or doorway, and remember that the time of day will make a huge difference to the height and the direction of the light. Providing you are creating a daytime effect, this light source will always be the strongest in the image. If you over-light the interior, the window area will never look natural. Generally, avoid trying to show too much detail out of the window as this rarely looks convincing, unless you employ the most talented scene painters. It is better to use two lights at a window—one to stream into the room and another to light a large white reflector placed outside the window, giving the impression of a bright sunny day.

It is sometimes a good idea to choose to represent the effect of a cloudy day using a large softbox for a softer light effect at the window. You can even lay white, frosted material over the outside of your window frame as this can soften the effect of the light entering the room. The light will still stream into your room but it will be less focused and spread more evenly. Inevitably, this will provide less drama, so choose the lighting that best suits your image.

Strong, "sunny day" streaming light needs to be positioned some distance from the window so that it gives the linear light effect similar to that of the sun. You can also set your tungsten or HMI lights

from "flood" to "spot" or use adjustable "sunspot Fresnel" light shapers on flash units to achieve an authentic sunny effect. Do not be tempted to use two lights pointing in through the window from different positions as this will create double shadows and look unnatural.

Inside the room, you can use large softboxes for the overall fill and smaller harder light sources to accent the details. Try to think about where the lighting would come from and mimic that effect with your lights. A lamp just off-set could be responsible for adding a glow to a corner, a TV will add extra light, and a doorway to another room will have its own light source.

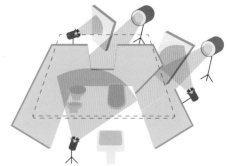

Above: This early morning bathroom set was lit with tungsten lighting. Two lights per window, with one to stream and the other to glow, plus a large floating ceiling to balance the shadows areas in the room.

Focal length: 150mm

Aperture: f/32

Shutter speed: 2 sec.

ISO: 200

Using Color Temperature Creatively

Above: Using a bluish filter on your flash will give the impression of TV lighting.

Focal length: 35mm

Aperture: f/16

Shutter speed: 1/125 sec.

ISO: 100

Above: In this image I combined several different colored tungsten light sources, including a handheld torch, to create a fantastic nighttime effect.

Focal length: 24mm

Aperture: f/11

Shutter speed: 10 sec.

ISO: 100

When showing the light through an internal doorway, it is a good idea to adjust the color temperature (see page 12). Most internal lighting is tungsten-based, at about 3200K as opposed to the daylight balance of around 5600K for your window light, so use gels to warm up the light, giving the effect of internal domestic lighting. This will make the scene appear much more realistic and create mystery and drama.

If you shoot a nighttime set you may choose to have the curtains closed or blinds down, but if not then use blue light to represent moonlight. This works well if used in a subtle way and will contrast wonderfully with the warmer interior lighting. You can dial up the colors if you want a more unreal or painterly feel to your image.

TIP

Remember to adjust the color temperature of internal and external lights to achieve realism and drama in your images.

Interiors On Location

Not all room-set photography is done in a studio. There are many requests for interior images, either using a location as the set or simply shooting the location in its own right. There is a thriving business in interior photography for architects, real estate agents, and the many other businesses that need high-quality industrial interior images of the workplace.

Lighting location interiors can be difficult as every environment is different, but the same basic rules apply as when shooting in a studio. If you have windows or external doorways in your shot then always ensure that the exterior lighting is stronger in value than any internal light you introduce. Over-lighting an interior gives an unnatural flash-lit appearance which looks terrible—it's more common to use flash for interior work as your lighting needs to be portable but still relatively powerful.

Mixing interior flash with external daylight can be a very effective creative tool, especially if you use an interesting location. It's a great way to shoot fashion and editorial images and provides a surreal atmosphere to your shots that is difficult to match in any other way. Be careful to balance your lighting convincingly—you can even place lights outside the windows to create artificial sunlight on a cloudy day. This technique is difficult to master but well worth trying out.

Battery-powered lighting is much more affordable now and far more powerful than ever before. Manufacturers like Godox, Elinchrom, Profoto, and Broncolor all produce mid-powered battery-operated flash units designed specifically for location use. Many of these lights can be used in the studio as well as outdoors. Although they generally cost a little more than mains-powered units, they offer much more versatility.

Don't forget you can always use your regular speedlights off-camera. As we've seen (see page 32), there are a number of modifiers available for speedlights as well as the all-important

transmitters to enable wireless control. Softboxes and just about every other type of light modifier can be purchased at very reasonable prices to fit speedlights, and they are a great way to cut your teeth on shooting with flash before you invest in more expensive, dedicated studio flash units.

Above: Combining flash with daylight is a delicate process, especially when there are shiny surfaces involved.

Focal length: 17mm

Aperture: f/20

Shutter speed: 1/250 sec.

ISO: 400

ROOM LIGHTS

Get creative with how you place your lights to create detailed interesting sets. Domestic lighting within the room, such as table lamps and even open fridge doors, should be treated carefully—there are all sorts of ways to use these effectively. Table lamps can be lit by shooting a light directly down from above, using a spot attachment or a snoot to restrict any unwanted spill. You can also use a small speedlight hidden within the lampshade on low power to act as the domestic bulb. Fridges require a battery-powered light carefully placed inside them, often with a mirrored reflector to bounce the light out.

TVs can be very effective as light sources and should be given a slightly bluish tone. If the TV is part of the set, then place a small softbox fitted with a honeycomb grid next to or above it, just off-set, to mimic the direction of light.

Finally, don't forget that people are also an important part of your room set, giving life and purpose to the images.

Above: This image was shot with a combination of daylight, flash, and tungsten lighting, which helped to create the surreal quality of the finished result.

Focal length: 28mm

Aperture: f/14

Shutter speed: 1/8 sec.

ISO: 400

Profile: Paul Goddard

BIOGRAPHY

Based in West Yorkshire, Paul Goddard runs a busy photographic studio, specializing in high-end room-set photography—with over 8000 square feet (743m²) of commercial studio space available. Studio HDTWO is one of the most respected room-set studios in the UK. With drive-in access, HDTWO have their own changing rooms, kitchen facilities, props, and set-building workshop. They are equipped with the best kit available for shooting stills and videos for international companies, while working alongside skilled stylists, editors, and art directors.

www.hdtwo.com

Q) What equipment do you regard as being essential for your photography?

A) I've always been a big fan of medium-format cameras, particularly when it comes to product and room-set photography. They offer a clarity and tonal range which separate them from most DSLR cameras. I've always worked with either Elinchrom or Profoto, while having a decent selection of modifiers, typically softboxes, reflectors, and grids.

Q) What do you regard as the most important aspect of your work in terms of your approach to photography?

A) For me, I always try and approach a shoot with fresh eyes. It's very easy in photography, especially with regular clients, to fall into the trap of doing what's easy or what works. I'm not saying rip up the handbook, but think about the product in a new way. Photographic styles and trends constantly change and being aware of them helps to keep you reinventing yourself as well as your photography practice.

Q) Can you give us a tip about lighting that you wish you had known when you first began photography?

A) Shoot into shadow—this rule really applies to room-set photography. You'll often see an image of a bed or a sofa with a window in the background providing the key light. By having the key light source behind the furniture, it gives the object a greater depth and so it appears to be more three-dimensional.

Q) What was your favorite job and why?

A) There are instances when a client brings an idea that poses challenges and I create the solutions to achieve their aim. This is what brought me into commercial photography and it's still the thing that makes every job enjoyable—the moment I bring the client's vision to life.

Q) How important is postproduction to you and do you do your own?

A) Luckily, during my early career I worked with photographers who had the mantra "get it right in-camera." This attitude has always stuck with me. Just because you can do it later on the computer, it doesn't mean you should. When postproduction is needed, I often do it myself with the use of my Wacom tablet.

Chapter 9
Cars & Vehicles

Unless you are lucky enough to own an airplane, a helicopter, or a boat, the most expensive purchase of your life will most likely be your car. Although social and environmental concerns will undoubtedly affect how we view them in the coming years, for the time being, we still love our cars.

The companies that sell cars spend huge sums advertising the latest models, with brochures, billboards, and adverts featuring the very best in photography. There are countless magazines, web sites and Instagram posts devoted to the adoration of cars and motorcycles, so the market for good vehicle photography has never been more diverse. But how do you begin to light a large, shiny, multifaceted, reflective box? In this chapter we cover the basics of getting the lighting right on location and in the studio.

Right: Commercial car photography provides among the very best and most creative work in the business. Whether in a studio or on location, it is the lighting that will define your car shoot.

Focal length: 55mm

Aperture: f/20

Shutter speed: 3 sec.

ISO: 100

On Location

The history of car photography goes back quite some way and the art of capturing amazing images of vehicles has changed a lot in recent years. Cars can be photographed in the studio but inevitably this involves a massive studio space and a lot of expensive lighting, but for most of us this is just not possible. Thanks to modern DSLR cameras, with their advanced technology, it is now practical for anyone to shoot professional-looking vehicle images with nothing more than a few reasonably priced pieces of equipment.

Dealing With Reflections

The problem with photographing vehicles is that they are pretty much covered in curved and shiny surfaces. It is the main challenge of all vehicle photography, covering everything from a motorcycle to an executive jet, to control surface reflections.

Controlling reflections is a huge challenge so choosing your location and the time of day you are shooting is critical. The sun will do a lot of the work for you, so it's a good idea to begin by simply shooting with natural light. Your reflector will need to be large because vehicles are large, so the bigger the reflector the better, and, as always, stick to silver on one side and white on the other—avoid gold or any other colors or patterns.

Lastolite makes a 6x4ft (1.8x1.2m) collapsible reflector that is easy to use and stash away, and the large California Sunbounce at 6.2x4.3ft (1.9x1.3m) comes with a rigid frame made of lightweight aluminum and is the standard for all regular location photographers. As ever, you can find many cheaper alternatives online, so research the options and build up your own kit to suit you.

Positioning the car in relation to the sun is key and, for the majority of situations, the sun should be behind or at least to one side of the vehicle. A good camera position is around the height of the

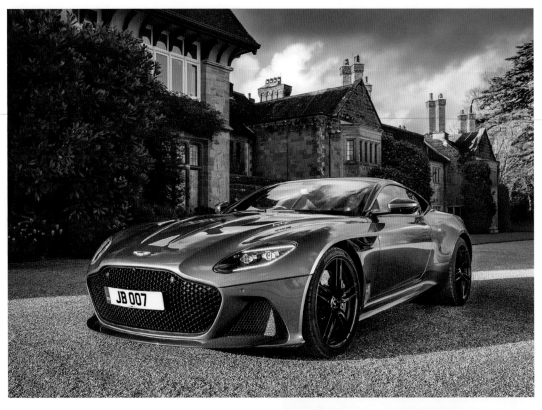

Above: Car photography is all about controlling the reflections on the surface of the vehicle.

Focal length: 45mm

Aperture: f/13

Shutter speed: 1/60 sec.

ISO: 400

car headlamps. You can then use your reflector to create beautiful reflections in the surface of the car or motorcycle.

There are occasions when you can light the car with your key light in a frontal position. Position the car's surface to face the sun, but only if you are able to reflect a golden sunset in its surface, for instance. You can then use your reflectors behind and to the side to create clean catch lights down the side of the vehicle. This approach does not work well with regular daytime sunshine, so stick

Above: When shooting on location, a large reflector and a willing assistant to hold it are both essential.

to times of sunrise and sunset. Remember that you can also place your reflector off the ground in front of the car as this will bounce the light up onto the lower side panels of the vehicle.

Right: This image would not have been possible without the use of a reflector.

Focal length: 35mm

Aperture: f/13

Shutter speed: 1/15 sec.

ISO: 125

Right & above: This image was taken from a moving van. I used the van's white side panel as a large reflector.

Focal length: 35mm

Aperture: f/11

Shutter speed: 1/80 sec.

ISO: 100

Polarizing Filter

There is another essential tool that every car photographer must have—a circular polarizing filter (CPL) will help to control reflections by cutting through any annoying reflective light patches on the car. As you turn the polarizer, you will see the reflections change—especially in the windscreen—so use this to isolate areas that are distracting. Don't forget that your polarizer will affect your exposure, darkening the image by up to about 2 stops, so adjust your exposure accordingly. It can also help to capture dramatic skies in the background of your image.

Flash

There are times when a simple reflector is just not enough to give you what you want, so you need to add some artificial lighting. Flash is definitely the best way to do this because trying to use continuous light sources to overpower the sun is simply not practical in most situations. Your humble speedlight will work, but you might want to choose a battery-operated studio flash unit if you want to get serious, as they are more powerful and easier to work with.

In the past, car photographers were forced to build immense softboxes, known as "swimming pools", to help them light cars on location. These could be many feet in length and required massive boom arms and teams of assistants to handle them—which is why serious car photography was once the preserve of only the most experienced professionals. However, the availability of digital cameras and cheap lighting now means that just about anyone can shoot a professional-quality car image.

Shooting with flash enables you adjust the balance between the ambient light and the flash. This means you can have rich, moody skies while the car is bright and pops right off the page, even when it is placed in shadow. You can do this because you can light the car separately to match the richness of the background setting. In fact, it's

a good idea to find a shaded spot in which to position the car—as with outdoor portraits, the shaded areas are easier to control without the harsh effects of partial or full sunlight falling on your subject. Shade will give you a good blank canvas to work with, so you can then add the lighting, step by step, to define the shape of the car and add drama to the image.

Most cars look best when they are lit primarily from above. You can use the same techniques as with still-life subjects (see page 108)—cars are basically the same, just a whole lot larger.

It is better to light motorcycles primarily from the side, as they are upright objects with large flat surfaces. You can of course light them in the normal way, with a single exposure using several lights.

However, many cars are best photographed using multiple exposures, which are then merged later in Adobe Photoshop in postproduction (see opposite page). This blending technique is popular with car photographers because of the physical size of the set-up and the complexity of using multiple light sources. Let's take you through the process.

Above: The sheer size of some vehicles makes them hugely challenging to light. Mixing natural daylight with battery-operated location flash will help you to light larger areas more consistently.

Focal length: 17mm

Aperture: f/11

Shutter speed: 1/125 sec.

ISO: 100

Blending Multiple Exposures

STEP 1

Begin by photographing a base layer using just the ambient light. Position the car in an area that is not too affected by the natural ambient sunlight—a shaded area or a landscape with the sun positioned behind the car works well as this can form a beautiful back light to the overall scene. Set up your camera on a sturdy tripod and connect a remote triggering device to the camera. Shoot a base frame which will form the basis of your image. Don't worry if the car is not lit well within the scene as you are exposing for the background.

Base image – focal length: 50mm, aperture: f/16, shutter speed 1/4 sec., ISO: 100.

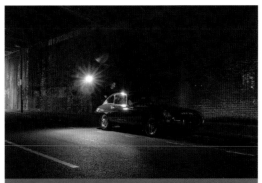

STEP 2

Now take a flash head mounted on a boom arm or painter's pole. You can fit any number of modifiers to the head, from large softboxes to simple, standard, smaller modifiers. Choose your angles carefully and think about which areas need light. Walk around the car, shooting the flash where needed. A good place to start is the top of the car and you can walk across the back of the car or lean in from the side to create a piece-by-piece top light that spans the entire length. We will stitch the shots together later to create one continuous highlight.

Flash images – focal length: 50mm, aperture: f/16, shutter speed 1/15 sec., ISO: 400.

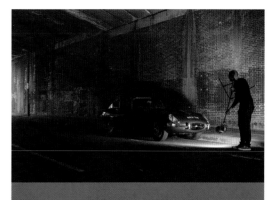

STEP 3

Shoot each visible corner of the car to ensure that you get a clean reflection from whatever light source you use.

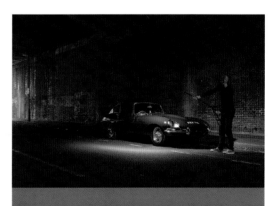

STEP 4

Now walk across the front side of the car, flashing as you go, and being careful not to include yourself in the reflections of the car that you are lighting. Maintain a consistent distance and angle to the car when shooting. You can do this at mid-height, level with the window line, and then at a low level for the side panels.

STEP 5

Next, shoot the wheels, one at a time. These will need some close-up lighting as the dark black tire rubber needs more light than the shiny surfaces of the car. You may choose to use a smaller, more precise light modifier for this, as harder, smaller spots of light work better.

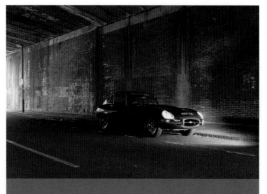

STEP 6

It's a good idea to shoot a frame with the car headlamps switched on, but remember not to shoot the car with anyone inside as this will move the level of the car down as the suspension compresses.

STEP 7

Import all the images into Adobe Lightroom and batch-process them to create a universal exposure and color grade. You may need to adjust the non-flash images individually but the others should be the same. Next, you will need to open the files with Layers in Photoshop for final editing.

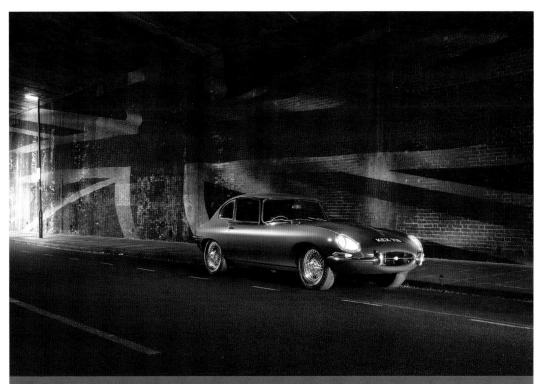

STEP 8

Select all the images using the Shift key and right-click to get the drop-down menu. Choose Edit In, and then click Open As Layers in Photoshop. This will open all the images as a layered file in Photoshop. Don't worry if this takes a while to open as it will be a large file. Position the base layer at the bottom, and arrange the others in a suitable order that makes sense to you. It's a good idea to name them for easy identification—for instance, "Top light 1," "Top light 2," "Front wheel," and so on. Select all the layers, then go to the Edit menu, and click Auto-Align Layers. This will ensure that any minor camera movements during shooting do not affect your final image. Set the layer blending mode to Lighten. This will show just the brightest part of each image, doing most of the blending work for you and giving a good impression of the final image. You will see now how the multiple flashes can combine into one consistent shot, but the image still needs some final editing.

STEP 9

Now add a layer mask to all but the base layer. Choosing a soft-edged black brush, paint out any areas in the mask that you do not want to see in each layer. These will include the actual light unit itself in the image, as well as the inevitable images of your feet or other elements you don't want to include in the image. Do this layer by layer, building up from the base layer, so you don't get confused—there may be a lot of layers. When you've used several flashes to form one long surface light, you may need to finesse the point at which they join or overlap each other. Brush back and forth with your black-and-white layer brush until you get the desired effect. You may now want to adjust your background layer and add the car headlamps to create an overall image which blends perfectly in exposure and tone. Adjust the image to create the level of drama you prefer. Finally, select the top layer and hold down Shift-Option-Command-E (for Mac) or Shift-Control-Alt-E (for Windows) to create a Stamp Visible Layer. This gives you a combined snapshot of all the layers. Go to Filters and select Camera Raw Filter. Make your final adjustments to grade your image and add any other creative effects.

Light Painting

If you are in a darkened space, such as a garage or outside at night, you can try another technique. Light painting has become very popular for car photographers, especially now that you can see the results instantly on the LCD screen on the back of your camera.

You can use a standard LED light—with or without a softbox—an ice light, light stick, or even a standard flashlight, but you will have to practice this as the results are never the same twice. You will need to develop a feel for the timing and positioning of the light, and the only way to do this is trial and error. Also, don't forget to set the camera's white balance to suit your light source (see page 12). Here are the basics.

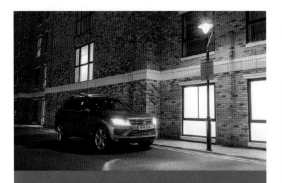

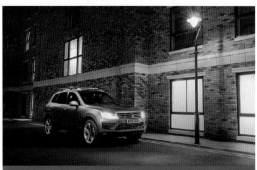

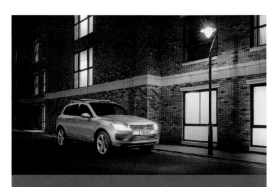

STEP 1

Position the car and shoot your base image. It is always a good idea to shoot several exposures with more or less brightness in the backdrop. You can choose which exposure you like the best at the postproduction stage, but always remember to vary the shutter speed and not the aperture as that would change the size of the image and the depth of field—neither of which can be changed later. Don't forget to shoot with and without the car headlamps on, to give you the options later on.

Base image – focal length: 35mm, aperture: f/11, shutter speed 1/10 sec., ISO: 400.

STEP 2

Open the shutter remotely in short bursts of several seconds, while using your flashlight to "paint" the vehicle with light. The key to this technique is to never stop moving. Using the light of the flashlight like a brush, follow the lines and features of the car for the best effect, defining the edges and the shoulder lines—think about the camera's viewpoint in relation to the light. Keep moving and don't be afraid to walk between the car and the camera—the camera will not record an image of you as long as you are moving, and you should be in shadow, so it will only see the reflected light on the vehicle. If your light is reflecting onto the car, it will register as a white line or patch on the car's surfaces. If you are able to position the light to not reflect it will simply lighten up the paintwork, adding depth and color, which you can later combine in Adobe Photoshop. Give extra attention to the wheels and tires, as the black rubber needs more light. Be careful not to point the light at the camera as this can cause flare, which is difficult to deal with, even in Photoshop.

Flashlight images – focal length: 35mm, aperture: f/11, shutter speed: variable, ISO: 400.

STEP 3

Repeat the stages in Adobe Lightroom and Photoshop as described on pages 137–139 (Steps 3–8). This technique is basically the same as using flash but uses a moving, continuous light source for a different effect. Remember to make a Visible Stamp Layer at the end and then use the Camera Raw Filter to finish—this is the final polish to the image that will really make all the difference.

Studio

Not all of us will get the opportunity to shoot a car or a vehicle in a studio as it requires a lot of space and some very expensive equipment. If you do get the chance, it can be great fun but you need to be prepared. Large hire studios are expensive so you don't want to be waiting around for a piece of kit to arrive because you forgot to bring it (see page 78).

Working In A Cove

Cove studios are very popular with car photographers as they enable you to control every aspect of the reflections, as well as light the car from all angles. A cove is a full or part wraparound white cave which has no corners, just curved edges—so they are ideal for any large, shiny object.

Regular studio car shooters tend to use either tungsten or HMI lighting. Basically, the technique is to point the lights at the cove and let the white reflection create the desired effect. It is very rare that a light is positioned to face the car. You can position the spot of the light to where it is required, carefully aligning it by viewing it on the camera. Often the light is then flooded to soften the effect and blend into the surface. It's pretty difficult to do this without an experienced assistant as you need to be previewing the result on the camera, watching the effect as it changes.

You can slowly build up a well-lit image by adding more lights, one by one. It is a slow process but you can create some superb images this way. Many cove studios have a ceiling hatch as well, and it is often nice to take an overhead image, particularly of open-top vehicles.

Floating Ceiling

Many coves do not have a built-in ceiling, but you can use a floating ceiling instead (see page 125). This is a large, white canvas-covered frame that can be lowered on ropes or pulleys. You can twist or tilt it as required, and use it to shoot a light, usually from behind the car or from the side, up and onto the ceiling. This gives a stunning top light reflection on the roof and bonnet of the car. You can lower the floating ceiling closer to the car for a more intense effect.

Below: Lighting a car in a cove environment is a skill learned over many years.

Focal length: 35mm

Aperture: f/12

Shutter speed: 1/6 sec.

ISO: 200

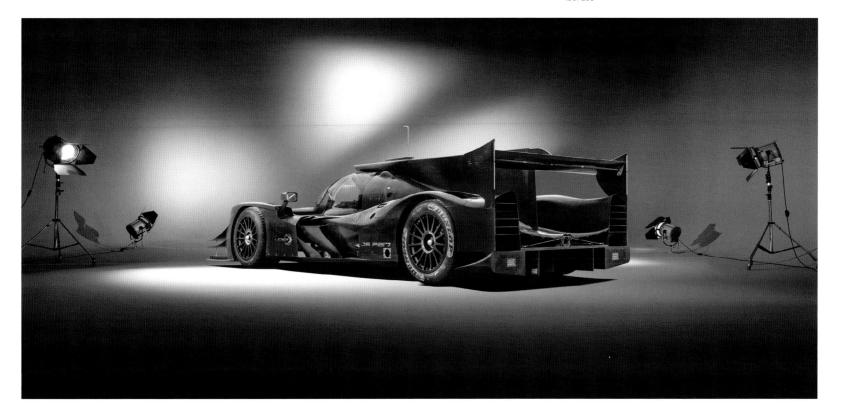

Accentuating The Shape Of A Vehicle

Once you understand the effects of reflected light you will learn how to position your lighting to bring out the shape of the panels. The shoulder of the car runs along the entire length of the car at roughly mid-height, and it is important to highlight this line to capture the shape of the car, so light it from above with a long line of reflection. You can also introduce shadow areas—a very large black velvet cloth can be useful for adding shape and depth to the paintwork. Use it in the same way as a reflector, but in reverse.

Rounded panels can be reflected into a large white surface, allowing the natural vignetting of the light pool's edge to define their curved shapes. Choose your lighting appropriately and spend some time learning about the different effects that using spot and flood lights can create.

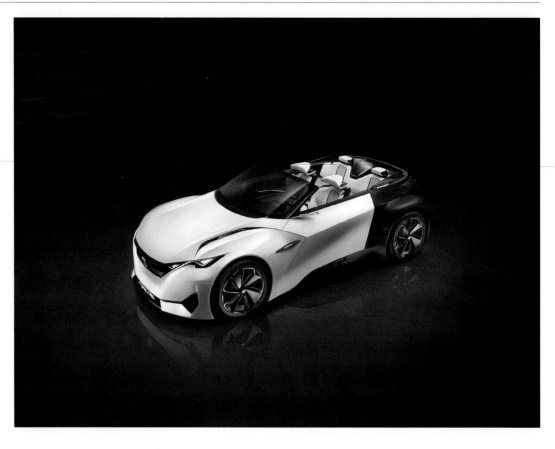

Above: White cars are generally regarded as the easiest to shoot, while metallic blacks can be very challenging.
Focal length: 70mm
Aperture: f/20
Shutter speed: 4 sec.
ISO: 100

Right top: Give special attention to the wheels and tires—the matt black rubber will soak up light and they will require as much as 2 stops more light.
Focal length: 24mm
Aperture: f/22
Shutter speed: 1/4 sec.
ISO: 100

Right bottom: Photographing a vehicle interior is almost as challenging as the outside. Here, the master car photographer Tim Wallace is shooting a futuristic Peugeot concept car interior.
Focal length: 17mm
Aperture: f/11
Shutter speed: 1/180 sec.
ISO: 6400

Wheels & Tires

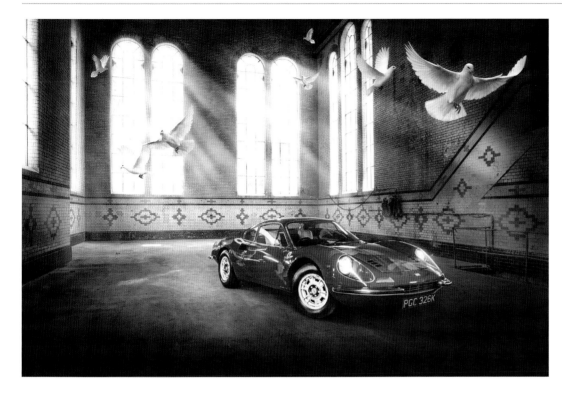

The wheels and tires require special attention when lighting vehicles—ignoring them will affect the overall look of the final image. Brightly lit wheels and tires make a car look clean and new. You can see this effect if you spend some time cleaning your own car tires—it has a transformative effect. Alloy wheels are often an expensive add-on for a car, so it's important they look their best.

Tires consist of matt black rubber and will soak up light and always look solid black in the final image unless you over-light them. You need to add about two stops more of lighting power for the tires than the rest of the car—do this by positioning small lights just off set and pointing them directly at each of the tires. Use a snoot or spot reflector to isolate the tires from the panels.

Interiors

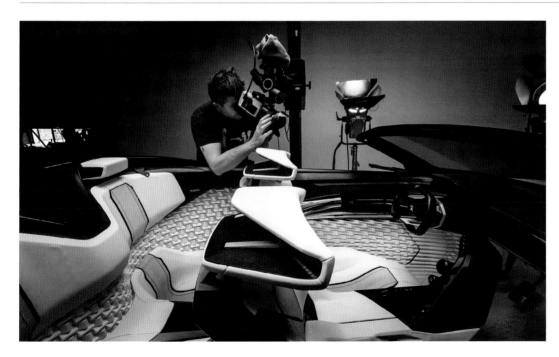

Clients will usually require images of the car's interior for a brochure or magazine article. Car interiors are basically room interiors in miniature (see pages 122–129)—but it's more difficult to get you, your camera, and your lighting equipment into position in the car.

Position your camera within the car and frame the image—you don't need to be inside the car as you can shoot remotely, so set up the camera securely using a clamp stand, such as a Joby GorillaPod. You can also attach a flexible LED light to the roof liner with Velcro to provide a soft, controllable, natural-style light from above.

Profile: Tim Wallace

BIOGRAPHY

Tim Wallace is quite simply one of the very best automotive photographers in the world. He is a true master of the art of lighting, working with cars, trucks, boats, and aircraft around the globe. Tim's enviable client list includes prestige brands such as McLaren, Aston Martin, Peugeot, and Lexus, among many others. He has photographed everything from sports cars to the iconic Supermarine Spitfire and is revered for his dramatic lighting both on location and in the studio. When world-renowned photography trainer Scott Kelby wanted someone to teach the art of automotive photography, he chose Tim to demonstrate his techniques on his worldwide educational channel. Tim's course on Car & Motorcycle Photography has become a best-seller on the Scott Kelby channel and can be accessed at https://members.kelbyone.com/author/twallace/

www.ambientlife.co.uk

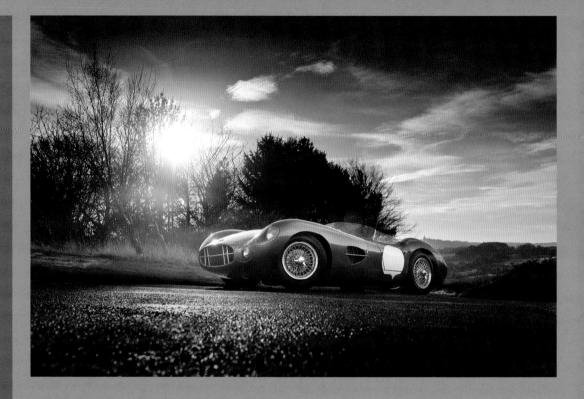

Q) What equipment do you regard as being essential for your photography?
A) To get great automotive images you must have a really solid, heavyweight tripod. Nothing is more important. I use lighting from many different manufacturers but I have to have a stable base to work from.

Q) What do you regard as the most important aspect of your work in terms of your approach to photography?
A) The best lens is your heart. There is a place for clever CGI images but my clients want my vision, and it's still the case that I can produce far more perfect images in a day than any CGI artist can. There's still no replacement for live photography.

Q) Can you give us a tip about lighting that you wish you had known when you first began photography?
A) Don't buy loads of kit. Buy one light and one reflector and learn everything there is to know about working with just that one light. The complex stuff will follow on naturally after that.

Q) What was your favorite job and why?
A) I can tell you what my least favorite is... anything in metallic black—it's a nightmare. You are basically trying to light something that is black and also show the subtle metallic finish. White cars are the easiest. I once had to photograph a secret concept car with a dashboard made from a one-piece convex mirror... now that is a lighting challenge I will never forget.

Q) How important is postproduction to you and do you do your own?
A) I like to do all my own postproduction whenever possible—it's a very personal thing. It's always best to get the image right in-camera but good postproduction is an essential aspect of automotive photography, where every detail has to be perfect.

Q) Which photographers or artists have influenced you and why?
A) I try not to be influenced by other photographers, which I believe keeps my work looking fresh and original. Having said that, I love Marco Grob's portrait work... beautiful!

Q) If you could shoot in any specialist field other than your own, what would you choose?
A) I'd love to be a food photographer. I have a very good friend who photographs food pretty much all the time and it's an area that really fascinates me.

Q) Is there anything else you would like to add?
A) Try taping up the screen on the back of your camera. Most photographers spend far too much time checking the back of the camera rather than viewing the subject and making decisions based on the lighting that's in front of them. Learn to read the light and have faith in your decisions.

Chapter 10
Specialist Techniques

As a photographer, it is important to strive for new ideas and approaches, and to challenge yourself creatively all the time—and the possibilities in lighting are endless. One way to find inspiration is by adopting a technique commonly used in one photographic genre and applying it to a completely different one. For instance, a food photographer may have little in common with a fashion and beauty photographer, but many of the same techniques are used by both.

Trying out different, specialist techniques is one way to push yourself and your art, and in this chapter we look at just some of the techniques which you may not have thought about but can help to increase your knowledge and improve your skills in the art of lighting for photography.

Right: If you want to capture action with flash outdoors then you have to learn about high-sync (HS) and high-speed sync (HSS) techniques.

Focal length: 24mm

Aperture: f/16

Shutter speed: 1/800 sec.

ISO: 400

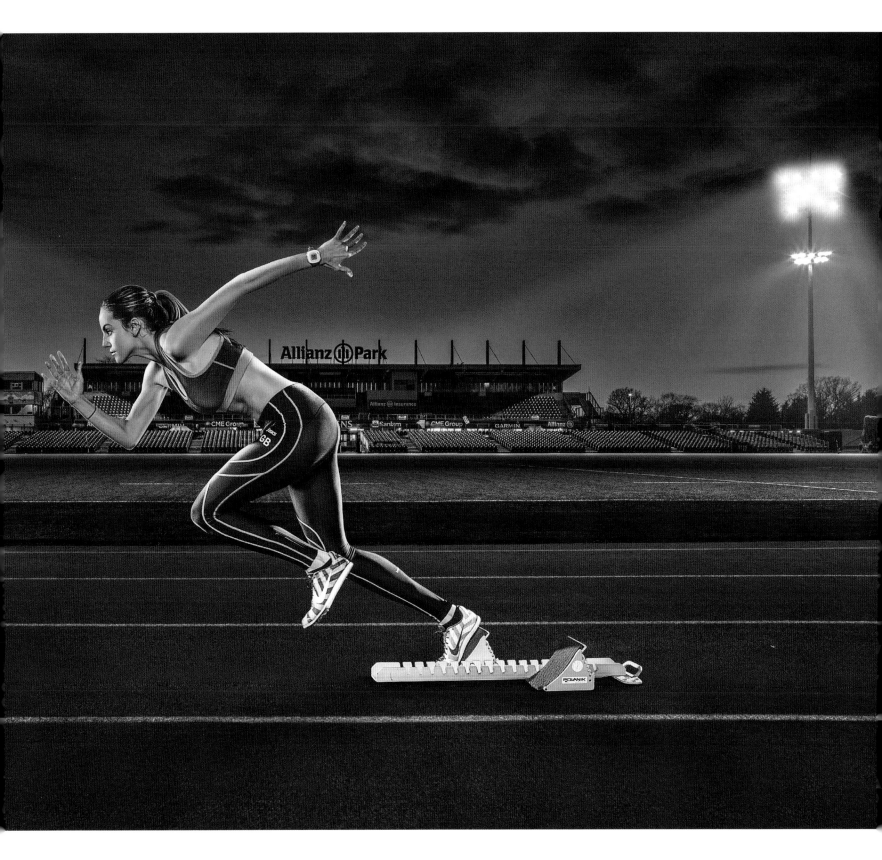

Flash Sync

A standard DSLR or mirrorless camera uses a focal plane shutter to make an exposure. As we've seen, these have a restriction when shooting with all types of flash, from speedlights to studio flash units (see page 32). They are only able to operate in synchronization with a flash unit up to and including their maximum shutter speed, also known as the "sync" speed. This is different for each camera, but is usually about 1/200 sec.

This means that if you want to capture a subject moving quickly within a well-lit environment, such as an outdoor scene during the day, you would be in trouble—for instance, a running person would be blurred if photographed at 1/200 sec.

If you try this with regular flash, you will find that the image of the person is in fact sharp but there is "ghosting"—trails of light—stretching from the image of the person and across the frame. This is because part of the exposure is the image captured by the flash, and a second, blurred image has been captured by the ambient light. The flash shooting within that 1/200 sec. window has flashed at, say, 1/4000 sec. duration (this will vary with power settings) so the image is sharp, but natural light has created a blurred image as well at 1/200 sec.

There are two ways to overcome this. Firstly, you can use leaf shutter lenses, which have the shutter built into them and use a fast-moving iris to sync with the flash, meaning they can sync much faster and with absolute accuracy with a flash at up 1/1600 sec. in many cases. The problem with leaf shutter lenses is that they are not available for many camera systems and they are expensive.

The other way to overcome the fast flash issue is to use high-speed sync (HSS) or high-sync (HS) techniques. The focal plane shutter in your camera works when you press the shutter button. A front curtain is lowered to reveal the sensor and a rear curtain then comes down to close it—they then both return to the start position, ready for another exposure. At speeds up to the sync speed, the

Above: Leaf shutter lenses can sync with flash at up to 1/1600 sec. but they are very expensive.

front curtain is fully open and the rear curtain comes down after the front one has fully opened. During that opening time there is a window of time for the flash to fire, exposing the sensor evenly. To achieve speeds above the sync speed (often called the "X" sync speed), the rear curtain has to begin closing before the front curtain has fully opened, so it is actually scanning the sensor through a letterbox shape. It does this so quickly that is hardly perceptible. If the flash goes off during this scan, only a part of the sensor is visible during the flash duration, which is why, with an incorrectly set camera, you often get a black bar covering part of the image.

High-speed sync (HSS) or high-sync (HS) flash works by synchronizing the flash with that scan—the flash unit outputs a flash that lasts as long as the fast sync speed. If the duration of the flash is long then it will cover the scan of the shutter evenly and give an equally exposed result. HSS works by splitting the flash into several small flashes that fire consecutively as the scan moves down the sensor.

As well as stopping fast action, you can also use this feature to reduce the overall lighting, so you can shoot with a wider aperture and a shallower depth of field. This means you can create flash images with beautiful bokeh without the use of neutral density (ND) filters.

There is a price to pay, however. As you are splitting the effect of the flash, you will obviously lose some power. This will affect the amount of final flash power available as the shutter will move down the sensor in a scan, and you can lose up to 2 stops overall.

There can also be a vignetting effect on the image, particularly with high-sync flash. Every flash unit has a power curve so, as the flash is fired, it climbs up to full power then trails off as the flash finishes. This curve is recorded by the scanning shutter—that part of the sensor gets more light than the other. You can adjust your high-sync triggering device to take account of this but it's all about timing. The effect normally appears as a darker vignette toward the base of the sensor, so one option is the turn the camera upside down when shooting in landscape format so the sky gets a little less exposure, much like using a graduated ND filter.

TIP

Take care, as many flash manufacturers quote their units' flash duration speed as a figure taken at t0.5 (the top 50% of the power curve), showing them to be very fast. The true duration is measured at t0.1, which measures 90% of the entire curve and gives a more accurate figure—helpful when you want to find the fastest duration to freeze in-studio action.

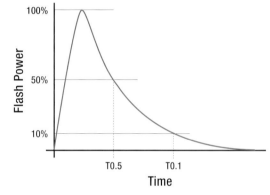

Above: When shooting with regular flash you are restricted to the camera's maximum sync speed, so you can only choose an aperture designated by the strength of the flash.

Focal length: 150mm

Aperture: f/10

Shutter speed: 1/100 sec.

ISO: 400

Above: High-speed sync (HSS) or high-sync (HS) flash enables you to choose both the aperture and shutter speed, so you can now shoot wide open to create the beautiful, blurred "bokeh" background effect.

Focal length: 150mm

Aperture: f/2.8

Shutter speed: 1/800 sec.

ISO: 400

Above: Here, you can see the flash curve dying off as the shutter is lowered. This will give you a subtle, dark vignette at the base of the image.

Painting With Light

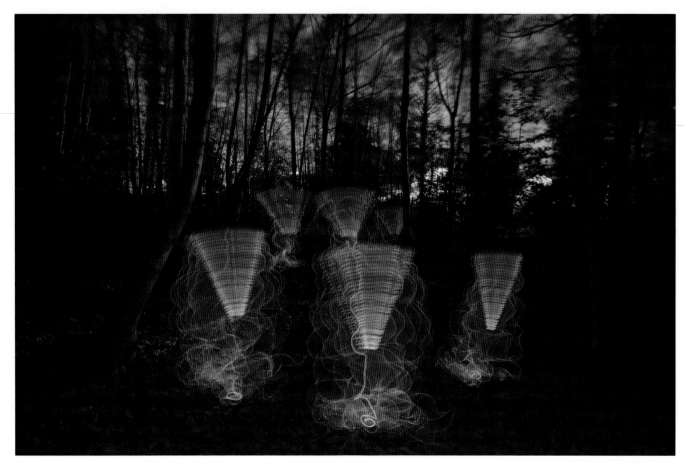

Left: Some extraordinary results can be achieved by artists using a variety of handheld light-painting flashlights.

Focal length: 11mm

Aperture: f/2.8

Shutter speed: 1 min. 60 sec.

ISO: 160

We have already discussed the use of light painting in car photography (see page 140) and you can use the same or similar techniques for interior, exterior, and still-life images. You can use an ordinary flashlight to achieve this effect.

I adapted a small unit by fitting it with a larger bulb, adding a battery pack, and making a snoot end for it, made of black card and gaffer tape— a cheap set-up which is very effective. I've since added a more powerful flashlight, and set of larger-sized LED lights, which I use for light-painting cars and motorcycles.

If you are working in a studio you first need to build your set and plan your camera angle. This is critical as you need to have a strong plan when working in this way. The image shown on the opposite page was shot on film, so it was created entirely in-camera, in one take with no retouching.

Firstly, turn the lights off in the studio but have one studio flash unit on low power, pointing at the ceiling. Open the shutter and pop off the flash. This does nothing more than to fill in the background of the image so that the blacks are not too dense. It should hardly register as an image in its own right but it adds a useful wash to the overall exposure.

When your eyes have adjusted to the dark, walk onto the set and begin painting with light. Have a plan in your mind and think about the direction of the light. Don't point the light at the camera, and switch the shutter on and off as you go with a handheld remote shutter control. You can expose for each part of the image and count the amount of seconds that you spend on any area.

With experimentation, and practice, you will get a feel for how long you need to paint each area. It's remarkable how your muscle memory will help you remember each pass and the time you spent on it. You can create several versions and develop your timing as you go until you achieve the desired result. No two images are ever exactly the same, but they will have the same basic exposure.

The goal is to create the entire image in one frame without any need for postproduction but there's nothing wrong with a bit of finessing in Adobe Photoshop at the end.

Above: This image was shot in one take with my faithful Maglite torch and is completely unretouched. Be patient and the results can be incredible.

Focal length: 150mm

Aperture: f/8

Shutter speed: 30 sec.

ISO: 50

Colored Lighting

Using colored lighting is another way to find new creative possibilities in your work. It can add authenticity to a composite image or act as the main creative theme behind a fashion or portrait shoot.

You can, of course, use colored lighting to define the style of your image. It pays to know a little bit about color theory. Take a look at the color wheel and you will see that complementary colors work well together. It's a good starting point in color theory to stick with this principle. Green and red, yellow and purple, and so on. A favorite combination is teal blue and orange. This combination is commonly used in many movies and TV sets. It looks good because the orangey-yellow reminds us of morning sunsets and the blue feels like blue skies, oceans, or moonlight.

Setting up in the studio with a standard gray or white seamless backdrop will ensure that your background absorbs the colors of the lighting, maintaining the correct palette. Light your subject with a standard clam shell light and then add two accent lights behind, slightly above, and to the side of the subject. Fit the back lights with a standard reflector and a honeycomb grid so that there is less light spillage, and ensure you are lighting the two sides of the subject's hairline with each.

Now add a teal filter sheet to one light and a yellowy-orange one to the other. Some lighting systems have dedicated filter holders but you can simply hang the colored sheet on the front of the modifier using clips or gaffer tape. Try to avoid any light spillage from the sides of the gel as this will wash out the effect and reduce the color intensity.

It pays to choose a collection of gels from the same manufacturer as they will be of similar density and light characteristics—Lee and Rosco, for example, both offer multi-packs of gels to fit most lighting systems. Photo gels are heat-resistant but it's still worth taking great care to avoid the gel melting onto the hot reflector or the light.

Left: The color wheel showing tertiary colors. Colors that sit opposite each other are complementary and ones next to each other are analagous.

It is important to shoot a test to ensure you're using the best power setting for each light. The gel will reduce the power output by up to 2 stops so you need to compensate for that.

The other factor is the saturation. It is not the case that the stronger the light the more the color comes through. If you overpower the light it will wash out the color effect, so you need to find the power setting sweet spot that provides enough power to light the area but not too much so the color shows rather than the sheer brightness of the light.

Different gels often need different power settings—reds show very well while blues are more subtle. Also, if you increase the power of the front light it will wash out the color effect overall, so balance is the key. Placing large black reflector boards either side of the face will increase the depth of the color and cut out any general fill lighting caused by unwanted reflections.

You can get some amazing still life images by mixing the effects of colored gels and shallow depth of field. As the focus point changes and two colored lights overlap they will also combine to make new colors, so experiment with lights and different shots to see what effects you can create.

TIP

The color intensity of a light can appear washed out if it has too much power—try to find the sweet spot, where the color of the light is at its strongest.

All images: These brightly colored still-life shots are enhanced by the bokeh effect. All were shot with the same settings.

Focal length: 100mm

Aperture: f/2.8

Shutter speed: 1/160 sec.

ISO: 50

Multicolored Light Filters

Once you understand the physics of light, you can play around with the light spectrum and achieve some very creative effects.

After some experimentation I have been able to isolate the exact Red, Green, and Blue (RGB) spectrums of my flashlight as expressed by my camera's filtration. After experimenting with lots of different combinations, I finally arrived at one part Red, two parts Green, and two parts Blue. The result of this is that I can now shoot an image either with one unfiltered exposure, or five separate exposures, each one colored with a filter (one Red, two Green, and two Blue) that make up the neutral white light.

This is useful for capturing a moving object on set with one exposure, for instance, when you don't have the option of shooting separate exposures and creating a composite. Using five separate colored lights creates one single exposure of the correct color. In this way I can produce interesting and unique-looking images with the colors I choose.

Above: This is a five-part exposure, all produced in camera. As the streamers move, they only get a single colored exposure, while anything still is neutrally exposed.

Focal length: 35mm

Aperture: f/11

Shutter speed: each exposure at 1/60 sec.

ISO: 50

Creating A Composite Portrait

Sometimes it's difficult or even impossible—because your subject is too busy or because of cost constraints—to shoot portraits on location. You can overcome this by shooting a background image and the portrait separately, and then creating a convincing composite image of the two. Using colored lighting can help.

This is how to create a nighttime composite portrait, following the techniques I used to create the image on this page. Find a suitable backdrop, such as a street scene at night. Shoot with a timed exposure and, as I did for this image, use high dynamic range techniques to create greater depth and detail.

After carefully studying the resulting background image, set up the portrait at a location to suit your subject—in their office, your studio, or any room which is large enough. Erect a simple mid-gray backdrop and a lighting set-up which matches the one you used on location—make a lighting diagram to help you use exactly the same positions for your equipment in both shoots.

Use a set of colored lighting gels to color the accent lights to match the lighting on the subject as they would have appeared in the scene if they had been on the street when you shot the background image. Remember that you will also need to match the noise (or grain) in the two images, so make sure you shoot the background and portrait images at the same ISO.

After the shoot, open the portrait image in postproduction, and carefully cut out the portrait image, before dropping it in seamlessly onto the background image. The composite will be convincing if you take great care to match the color gels to the neon lights of the nighttime street backdrop.

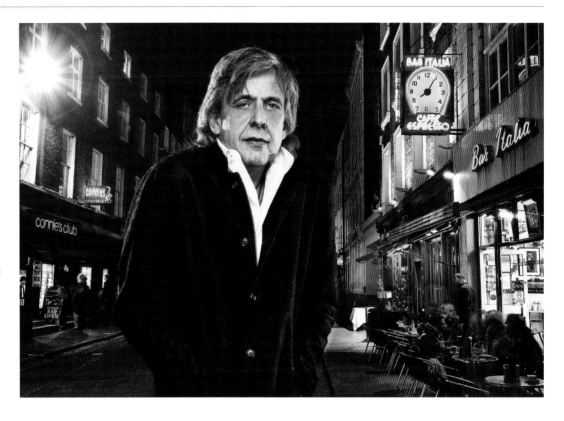

Above: You can use colored lighting as one of the elements that make a composite as convincing as the real thing.

Focal length: 200mm

Aperture: f/8

Shutter speed: 1/60 sec.

ISO: 50

Specialist Techniques In Practice

It's important to remember that there is a lot more to a great photograph than just the technical aspects. Learning about specialist techniques will undoubtedly be useful to you as you develop your skill set but these techniques in themselves will not make you a great photographer. Choosing the right subject, the right location, and, most importantly, having a great idea will ultimately define the value and quality of your photography.

It's also true that, without having a good grasp of the techniques required to produce your photographs, you will never attain the polished results that you want. Photography is an art form but if you don't know how to use the process to create your vision, you will never be a great photographer. It isn't good enough to just envisage an image—you have to use your technical knowledge and skills to produce it.

Over the years I have used and developed many specialist photographic techniques using cameras, postproduction, and of course lighting to help to create interesting, different, and innovative results. I am aware that, during this process, it is easy to become obsessed by the technical aspects rather than concentrating on the quality of the final result. A bad photograph is still a bad photograph regardless of how cleverly it was produced.

One of the most important elements of learning about advanced photographic techniques is that they often explain how the basic techniques combine to create your image. Once you understand how high-speed sync actually works, for instance, you will understand how your focal plane shutter works and how the flash curve is created every time you fire your flash. When you know these things then you are free to use them to create better images in ways that may not have been explored before. At the very least, you will understand what has happened when things go wrong and your images don't turn out the way you wished them to.

In this respect, photography could be seen as a close reflection of the principles taught in the Renaissance art world. In the time of Leonardo da Vinci, science and art were seen as almost one and the same thing, and I believe this is still true— you can't have one without the other.

In my experience, there are many great technicians who are bad photographers, but there are very few great photographers who are bad technicians.

Right: This image combines several specialist techniques, capturing a moment that would otherwise be impossible to photograph. It's worth noting, though, that the model and athlete Brooke Garcia really did have to stand on the banks of the Thames in the pouring rain in January.

Focal length: 24mm

Aperture: f/16

Shutter speed: 1/200 sec.

ISO: 200

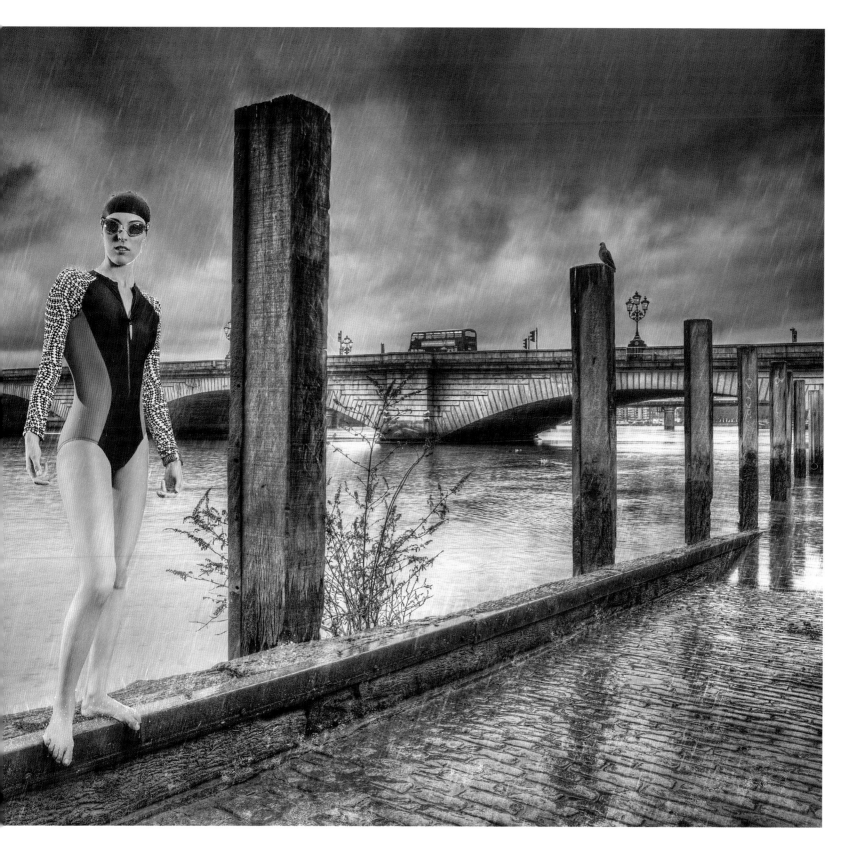

Chapter 11

Postproduction

The essence of great lighting technique will always be based on what happens in front of your lens, using both available and artificial light to describe the subject according to your artistic judgement. In days gone by, what happened live in front of your camera lens was the only way to define your lighting style. It is still the case that good lighting is the best way to achieve great results, but there are now ways to make changes after the shoot is done.

The availability of postproduction platforms, such as Adobe Photoshop, now enable photographers to make as many creative decisions after taking the shot as before it.

Good retouching opens up a whole world of creative possibilities, helping to repair as well as enhance existing light sources. We can now create lighting scenarios that were just not feasible in the real world, providing more drama and giving you more control over your imagery than ever before. There are many ways in which Photoshop can help to produce better lighting in your imagery. This chapter covers just some of the ways you can edit images to improve your lighting.

Right: This image was shot with ambient light and no lighting from street lamps or the motorcycle. All the lighting was created within Adobe Photoshop using the techniques in this chapter.
Focal length: 28mm
Aperture: f/16
Shutter speed: 1 sec.
ISO: 400

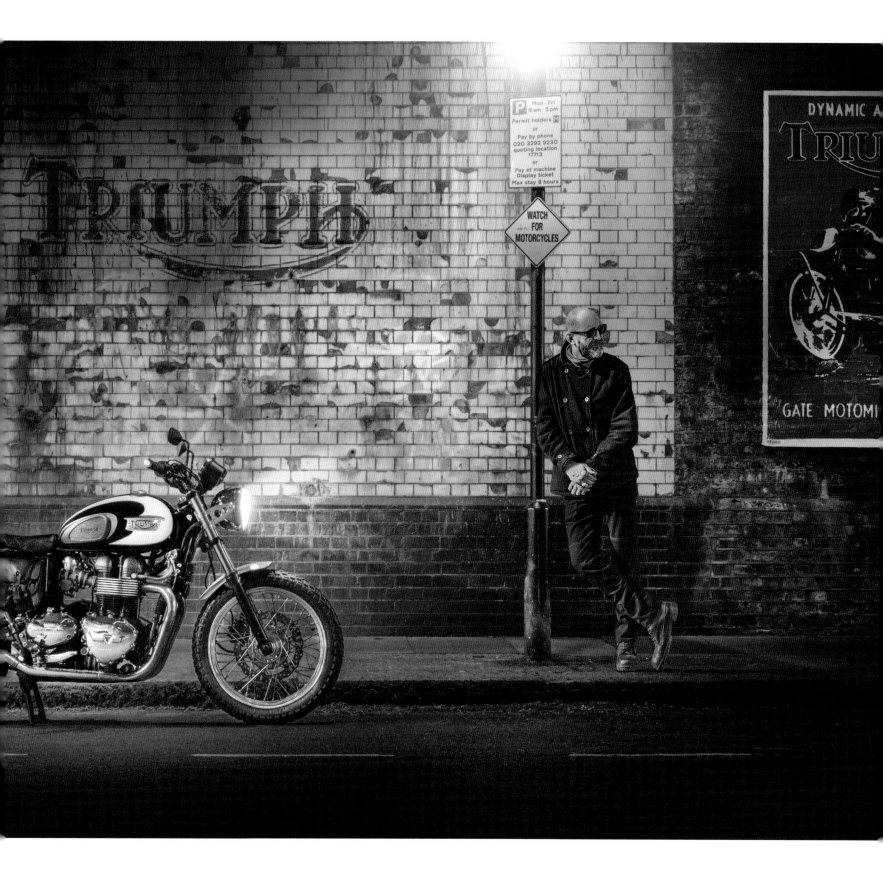

Basic Lighting Effects

When it comes to using a photo editing program—such as Adobe Photoshop or Lightroom, or Phase One Capture One—to adjust the lighting in your image, you should first look at standard adjustment layer techniques. These can be used to create or enhance the lighting within your image, either as an overall effect or as a localized source. Fundamentally, it is fairly simple to brighten or darken a given area of your image in a non-destructive way.

Starting with a correctly exposed image, you may wish to add brightness to one side to create the impression of a light source positioned off-camera. This can add interest to your image, especially if the actual scene was captured in dull or uncontrollable lighting conditions. These are the steps for achieving this effect in Adobe Photoshop.

This same technique can be used to create enhanced light sources within a scene, such as street lamps or light from doorways, adding highlights and shadows where needed. Like many Photoshop techniques you will need to practice to achieve the perfect result, but it will soon become second nature. Learn to master the mask-out and brush-back-in technique for superb, realistic lighting effects.

FINAL IMAGE

STEP 1

This image is correctly exposed but lacks drama straight out of the camera.

STEP 2

At the bottom of the Layer panel click the Black & White circle to bring up the adjustment layer options, and choose Brightness/Contrast. Move the Brightness slider to +75. You can now see the adjustment icon and next to it is a white Layer Mask box. The whole image will now look too bright and bleached out.

STEP 3

With your foreground color set to black, go to Edit-Fill-Foreground Color. The image will now return to normal as you have masked out the brightness effect. Change your foreground color to white and use the paintbrush to paint the brightness where you want it. If you enlarge the brush and set the opacity to 50%, you can touch the brush down off the edge of your image and the brightness will spread naturally from one side of the image, giving the impression of a real light source.

STEP 4

To enhance the effect, you need to pay attention to anything within the scene that would naturally be affected by the light source. Repeat the previous steps to create another Brightness adjustment layer with a mask filled in black. Choosing the magic wand tool, select the post within the scene. With a soft-edged white brush, paint down the line of the post to create a suitable highlight.

STEP 5

Repeat Step 2, but this time move the Brightness slider to -100. This will make the whole image dark. Repeat Step 3 to fill in the mask. Now choose the Rectangular Marquee tool and draw a thin horizontal box from the base of the post on the left to the edge of the image. Now go to Select-Modify-Feather, and feather the radius by about 8 pixels. This box will form the basis of your shadow. Choose a large soft brush in white at 30% opacity and paint along the box, from the base of the post to the outer edge, creating a shadow that slowly fades as it gets further from the base. Keep the selection box live, go to the first adjustment layer and paint a dark shadow at the post's base with a black brush.

Creating Beams Of Light

BEFORE

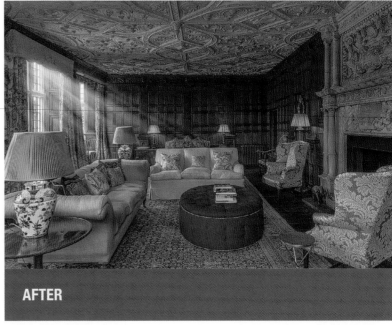

AFTER

There are many occasions when creating a beam of visible light within a scene is extremely useful—it can enhance an image to provide a beautiful, dramatic effect. Even if you have complete control of the lighting on a shoot, it can often be very difficult to control this effect, especially if you need to ensure that your subject is not completely obscured by the intensity of the beam. There are several ways to produce a convincing beam of light in Photoshop, so let's explore the most effective.

Above: The light was not intense enough in this interior to create real beams of light, so they had to be added.

Focal length: 20mm

Aperture: f/22

Shutter speed: 1/16 sec.

ISO: 50

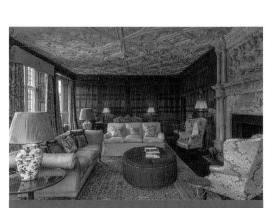

STEP 1

This is the image of the room in its original state. It was created using five merged exposures, using the high dynamic range (HDR) technique, to ensure total sharpness and detail throughout.

STEP 2

Create a New Layer, ensuring it is set to Black & White boxes with black on top. Go to Filter-Render-Clouds. This will give a black-and-white cloud effect all over the image. Next, go to Filter-Blu-Radial Blur-Zoom. Set the strength to 100% and move the central point of the blur to the point where you want the beams to be streaming from—in this case, the windows at the top left of the image. Click Good Quality. Repeat this stage and you now have a black-and-white beam effect all over the image.

STEP 3

Change the layer blending mode to Screen. Create a Levels layer and select Clip to Layer. Now move the three sliders towards the center to increase the beam effect. You can also add a Hue/Saturation layer if you want to change the color of the beams.

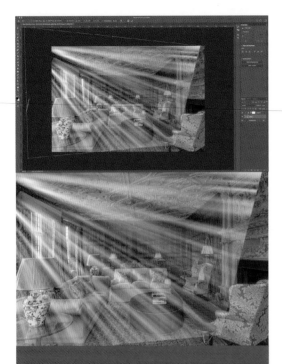

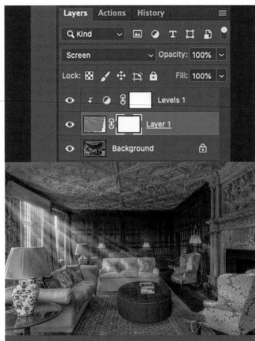

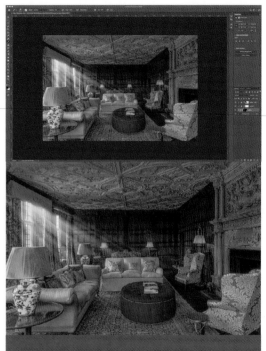

STEP 4

Clicking back on the beams layer, go to Edit-Transform-Distort, and pull the beams off the edge of the image until you find a good natural place for the beams to be in relation to the window.

STEP 5

Add a layer mask and, with a large soft brush set to 30% opacity, simply paint away the beams where required. Remember where the light is coming from and concentrate on blocking out any beams which are not in the correct position. Always use a soft brush and take your time to use it slowly. If you make a mistake, then switch the brush to white and it will restore the original beams.

STEP 6

Moving to the top of the layer stack, add a brightness adjustment layer and again clip it to the layer below. Use the slider to increase the brightness to the level you think is right, then paint black onto its mask to brush the brightness away where needed. You can now brush the masks of the three layers individually to finesse your finished image.

Adding A Glow To Eyes

BEFORE

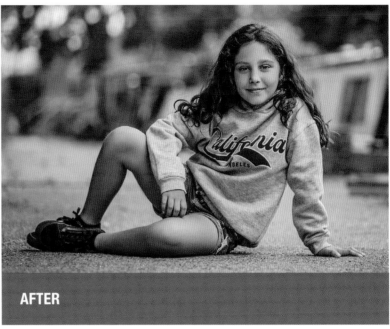

AFTER

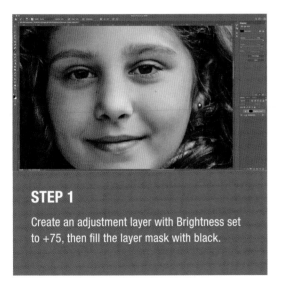

STEP 1

Create an adjustment layer with Brightness set to +75, then fill the layer mask with black.

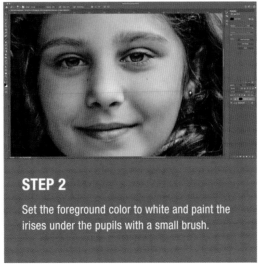

STEP 2

Set the foreground color to white and paint the irises under the pupils with a small brush.

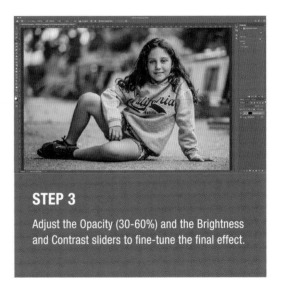

STEP 3

Adjust the Opacity (30-60%) and the Brightness and Contrast sliders to fine-tune the final effect.

Here is a simple Photoshop lighting technique designed to add that final sparkle of light to your studio portraits.

To add that all-important under-light to the eyes of your subject, simply use the brightness and masking technique in the steps above. This gives the effect of a strong under-light but avoids the problem of having to position a low light or reflector which may create nasty horror film-style up-lighting on the face.

Creating Flare Effects

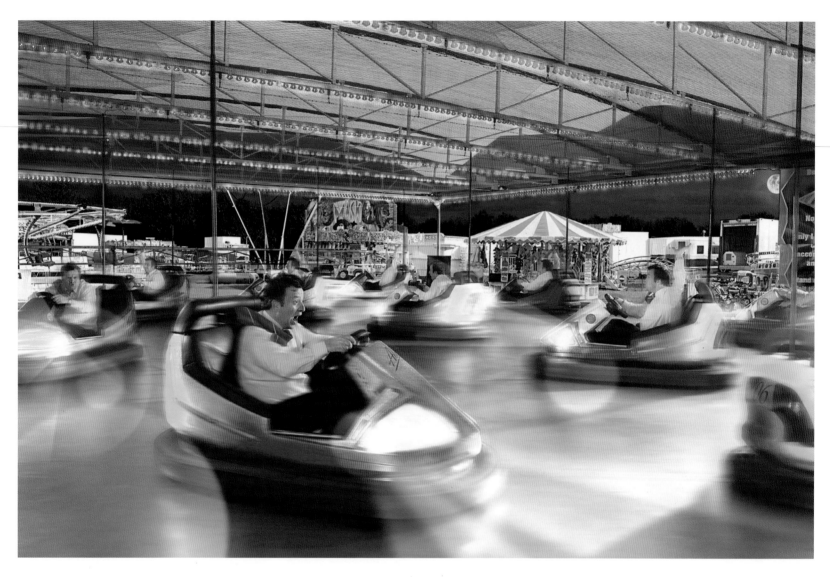

It is true to say that retouched digital photography can often look a little sterile and too perfect. For this reason, Adobe Photoshop provides ways to recreate some of the "unwanted" effects that film camera lenses give you. For instance, photographers spend a lot of time trying to avoid flare, but Photoshop enables you to add flare creatively to an image, and actually make it look more authentic.

Adding a lens flare effect is very simple in Photoshop. Simply go to Filter-Render-Lens Flare. You then can apply the type of flare you want and position the point source and strength of the flare. The problem is that this effect is final and the image cannot be adjusted afterwards, as it is not available as a separate layer. But there is a way to make your flare filter non-destructive.

Above: This image was a multi-part photo-comp with the flare and light beams added in Adobe Photoshop.

Focal length: 20mm

Aperture: f/16

Shutter speed: 1/200 sec.

ISO: 400

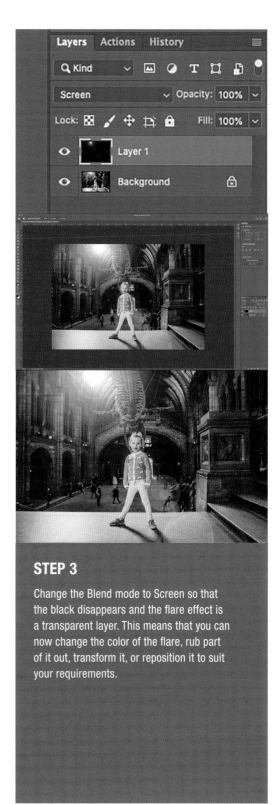

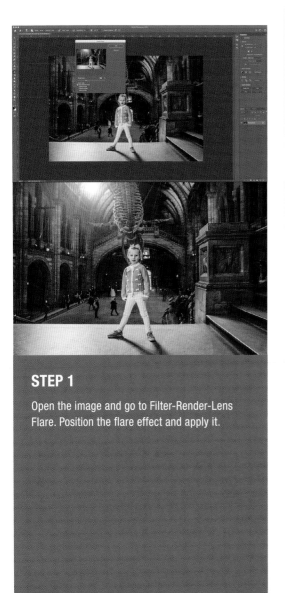

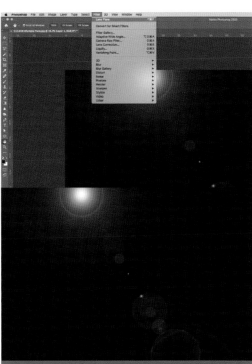

STEP 1

Open the image and go to Filter-Render-Lens Flare. Position the flare effect and apply it.

STEP 2

Now in History, undo what you have done— or click command Z in MacOS, or Ctrl Z in Windows, to undo the last effect. Create a new layer and fill with black. On the new layer, go to Filter but don't go down to Render. Just click the Lens Flare shown at the top of the drop-down menu. This will repeat the last use of lens flare, so it will be in the perfect position. You will now have a black image with the filter effect crossing it.

STEP 3

Change the Blend mode to Screen so that the black disappears and the flare effect is a transparent layer. This means that you can now change the color of the flare, rub part of it out, transform it, or reposition it to suit your requirements.

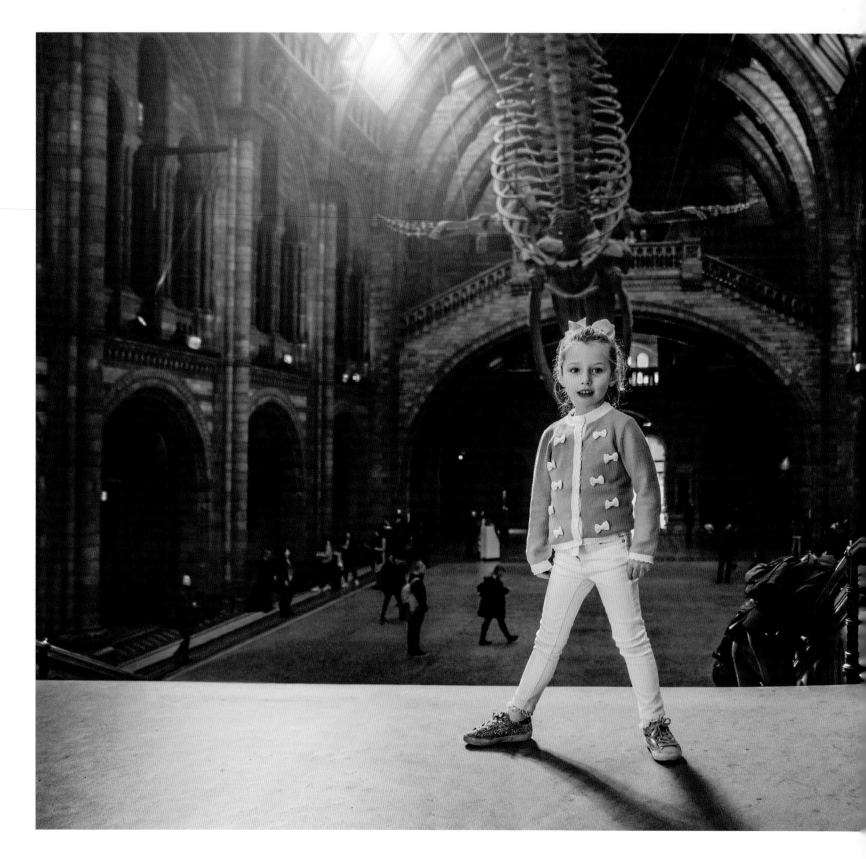

Left: This final version is more precise. The flare is where I wanted it to be and there's a little less of it— a much better result overall.

Focal length: 28mm

Aperture: f/2.8

Shutter speed: 1/200 sec.

ISO: 800

Glossary

Aberration An imperfection in a photograph, usually caused by the optics of a lens.

Angle of view The area of a scene that a lens takes in, measured in degrees.

Aperture The variable opening in a camera lens, measured in f/stops, which regulates the amount of light passing through the lens. The aperture setting is also one of the main factors in determining depth of field.

Aperture priority A camera mode that allows the photographer to set the aperture, with the camera automatically choosing the appropriate shutter speed for the correct exposure.

Blue hour The period just before sunset through to just after sunset, when the sky turns a deep blue.

Boom arm A horizontal stand used to support lights above a subject.

Bracketing The process of taking a sequence of images at varying degrees of exposure (both under- and overexposed). These images can then be combined in postproduction.

Bulb (B) A manual exposure mode which provides complete control over how long the shutter remains open.

Camera shake A leading cause of blurred images; occurs when the camera is accidentally moved or disturbed while making an exposure.

Center-weighted metering An exposure-metering pattern that determines the exposure from the central part of the image frame.

Chromatic aberration A digital color defect that can appear around the edges of high-contrast image elements. Caused when a lens fails to bring all wavelengths of light to focus at the same point.

Color temperature The color of light, measured in degrees Kelvin (K).

Continuous lighting Any artificial light which is not flash, such as LED, tungsten, and fluorescent.

Contrast The range between bright and dark areas in a scene or image.

Crop factor The size of the camera's sensor measured in reference to a 35mm piece of film or full-frame digital sensor.

Depth of field (DOF) The area in an image in front of and behind the focus point that appears acceptably sharp. The extent of the depth of field is determined by the aperture setting, focal length, and camera-to-subject distance.

Digital workflow The process or processes required after your shoot to develop and present your final image files.

Distortion An optical defect whereby straight lines appear curved in an image.

DSLR (Digital Single Lens Reflex) A camera which uses an internal mirror to reflect the scene from the lens up to the photographer's eye. During the instant that the exposure is made, this mirror flips up and out of the way just as the shutter opens, allowing light to reach the image sensor.

Dynamic range The range from light to dark in a scene; also the range that can be recorded by a camera in a single exposure.

Exposure The amount of light allowed to hit the digital sensor, controlled by aperture, shutter speed, and ISO. Also, the act of taking a photograph, as in "making an exposure."

Exposure compensation A manual control which allows you to increase or reduce the camera's recommended exposure.

f/stop The fractional representation of the size of the aperture, based on the focal length of the lens divided by the diameter of the aperture.

Filter A piece of colored or coated glass, or plastic, placed in front of the lens.

Flash Studio or location lights that employ a flash tube as their light source.

Flash duration The time it takes for a flash to fire and produce its full effective power.

Flash sync The process of synchronizing a flash with the shutter speed of a camera, which is normally restricted to around 1/200 sec.

Focal length The distance from the optical center of a lens, where the light rays converge to create a sharp image, and the film or sensor.

Full frame A digital camera sensor format which is the same size as 35mm film frame (36x24mm).

Ghosting An effect created when a subject remains still for just long enough to be recorded and then moves quickly to another position, mid-exposure, resulting in a ghost-like appearance.

Golden hour The hour after sunrise and before sunset when the light is warm and golden.

Hard light Direct light which creates deep dark shadows and bright highlights with a sharp edge.

HDR (High Dynamic Range) A method for combining a sequence of exposures covering a wider dynamic range than can be captured in a single frame.

High key Image style which is characterized by a bright or colorful appearance.

Highlights The brightest part of an image.

High-speed sync (HSS) Method or shooting a flash image at faster than the camera's normal sync speed, using a technique of firing multiple small flashes in milliseconds to form one exposure.

High sync (HS) Method or shooting a flash image at faster than the camera's normal sync speed, using a technique of synchronizing the flash curve to the camera's moving shutter.

Histogram A graphical representation of the tones in an image, from pure white to pure black.

HMI (hydrargyrum medium-arc iodide) light A type of continuous light which is daylight-balanced.

Inverse square law The effect of a light's power which diminishes or increases in power in inverse proportion to the square of the distance from the original source.

Infrared (IR) remote Remote control unit used to control multiple flash units.

ISO The numerical values that represent the sensitivity of the camera's sensor to light.

JPEG A file format where data processing of the image (such as sharpening) is performed internally by the camera, which then compresses the file to save data space.

Kelvin (K) Measurement of color temperature.

Lens flare An optical artifact caused by non-image-forming light entering the lens.

Live View A viewing mode which allows images to be viewed and framed using the LCD on the back of the camera, rather than the viewfinder.

Location flash Flash lighting powered by a rechargeable battery, usually used on location.

Low key Image style which is characterized by dark and soft appearance with deep, subtle tones.

Megapixel One megapixel is equal to one million pixels.

Metering The act of measuring the light falling on a scene to determine the exposure required.

Mirrorless Common name given to a camera that doesn't have a reflex mirror (*see* DSLR). The photographer views a live image streamed from the digital sensor to an LCD.

Mirror lock-up The option on some DSLR cameras that enables the mirror to be flipped up and locked in place prior to releasing the shutter. In doing so it minimizes any vibration that may introduce blur into an image.

Multi-zone metering An exposure-metering pattern that divides the frame into zones or segments that are measured individually and then brought together to determine the best overall exposure. Known by various proprietary names, including Evaluative (Canon) and Matrix (Nikon).

Neutral density (ND) filter A filter which limits the amount of light passing through it and into the camera. Commonly used to extend exposure times.

Noise Digital interference that is recorded as a non-image-forming texture.

Overexposure An exposure that is overly bright, often leading to highlight areas being recorded as pure white, with no recoverable image data.

Prime A lens with a fixed focal length.

Radio remote Radio remote control unit used to control multiple flash units.

Raw A file type that records the data captured straight from the image sensor, without applying any processing to this information.

Reflector Any form of flat board or material (usually silver or white) used to reflect the available light.

Ring flash A circular flash tube light that is located around the camera lens.

Shutter priority A camera mode that allows the photographer to set the shutter speed, with the camera automatically choosing the appropriate aperture for the correct exposure.

Shutter speed The time that the shutter is open for during an exposure. Adjusted manually or by the camera in automatic modes.

Slave cell The photo cell found on most flash light units that reads the flash from another light unit, telling it to fire in sync.

Softbox A box-shaped lighting attachment with a translucent fabric front to soften and direct light. Can be square, rectangular, or multisided.

Soft light Light that has soft-edged shadows and gradual, blended highlights.

Speedlight The brand name used by Nikon for its range of small hotshoe-mounted flash units, but commonly used to refer to any hotshoe-mounted flash, regardless of manufacturer.

Spot metering An exposure-metering pattern that determines the exposure based on a small and precise part of the image.

Stop The unit of measurement used to indicate a halving or doubling of light in an exposure.

Studio flash Flash lighting requiring mains power, essentially used indoors.

Swimming pool Huge horizontal softbox light, often used in large car photography studios.

Tungsten light Continuous light source used in household lighting and more powerful versions in studio lighting.

Underexposure An exposure that is overly dark, often leading to shadow areas being recorded as pure black, with no recoverable image data.

Vignette The darkening of the corners and edges of an image. Although it can be an optical defect in a lens, or caused by a physical obstruction in front of the lens ("mechanical vignetting"), it is also often applied in postproduction as a creative edit.

White balance An in-camera control that allows a particular color temperature of light to be recorded without a color cast.

Zoom A lens with a variable focal length.

Zone System A method for adjusting exposure when printing to create more detailed images.

Useful Web Sites

Cameras & Lenses

Canon www.canon.com
Fujifilm www.fujifilm.com
Hasselblad www.hasselblad.com
Laowa www.venuslens.net
Leica www.leica-camera.com
Nikon www.nikon.com
Olympus www.olympus-global.com
Panasonic www.panasonic.net
Pentax www.ricoh.com
Sigma www.sigma-photo.com
Sony www.sony.com
Tamron www.tamron.com
Tokina www.tokinalens.com
Zeiss www.zeiss.com

Lighting & Accessories

B&H www.bhphotovideo.com
Bowens www.bowens.co.uk
Broncolor www.broncolor.swiss
Elinchrom www.elinchrom.com
Godox www.godox.com
Lastolite www.manfrotto.com
Lowepro www.lowepro.com
Manfrotto www.manfrotto.com
Mefoto www.mefoto.com
Pixapro www.essentialphoto.co.uk
Lencarta www.lencarta.com
Profoto www.profoto.com
Rotolight www.rotolight.com
Wex www.wexphotovideo.com

Photography Publications

Ammonite Press www.ammonitepress.com
Black + White Photography magazine www.blackandwhitephotographymag.co.uk
Outdoor Photography magazine www.outdoorphotographymagazine.co.uk

Printing

Epson www.epson.com
Hahnemühle www.hahnemuehle.de
Harman www.harman-inkjet.com
HP www.hp.com
Ilford www.ilford.com
Kodak www.kodak.com
Marrutt www.marrutt.com

Software

Adobe www.adobe.com
Capture One Pro www.phaseone.com
DxO PhotoLab www.dxo.com
Photomatix www.hdrsoft.com

Index

Acknowledgments

Writing this book was hard work, but it has been a true labor of love. It is the culmination of more
than 30 years' experience of shooting both personal and commercial images,
in studio and on location, throughout the world.

I want to thank several people, without whom it would not have been possible: my editor Rob Yarham,
who kept me on the straight and narrow; designer Robin Shields for putting together the pieces;
and my assistant Phoebe Bowdige for research, image finding, video editing, and modeling.
Most of all, I want to thank my wife Alli for allowing me to do rewrites during our holiday,
and for her support and encouragement throughout the entire writing process.

AMMONITE
PRESS

www.ammonitepress.com